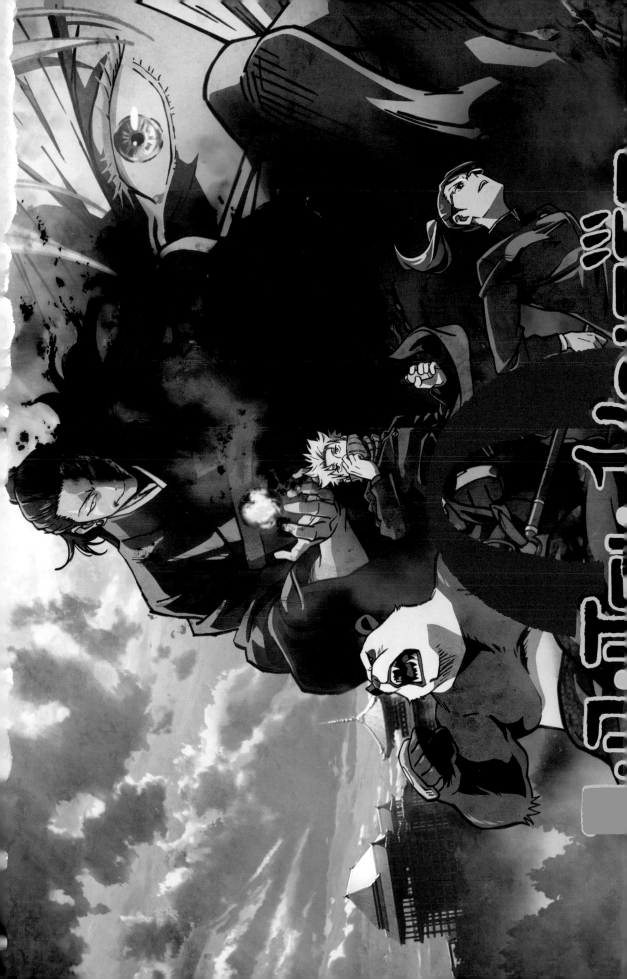

Jujutsu Kaisen

The Official Anime Guide: Season 1

ORIGINAL STORY BY

Gege Akutami

with the *Jujutsu Kaisen* Production Committee

JUJUTSU KAISEN

The Official Anime Guide: Season 1
Shonen Jump Edition

ORIGINAL MANGA BY **Gege Akutami**

TRANSLATION **David Evelyn**
LETTERING **Erika Terriquez**
DESIGNERS **Kam Li** and **Shawn Carrico**
EDITOR **Amanda Ng**

Printed in China

Library of Congress Cataloging-in-Publication Data available.

ISBN: 978-1-9747-4081-9

Published by VIZ Media, LLC
P.O. Box 77010
San Francisco, CA 94107

10 9 8 7 6 5 4 3 2 1
First printing, September 2023

viz.com

This guide is packed with animation reference sheets and information to provide a new perspective and deeper insights when rewatching the first season of the *Jujutsu Kaisen* anime.

TABLE OF CONTENTS

INSERT BONUS #1
(FRONT) *Jujutsu Kaisen* Anime's Third Key Visual
(BACK) Special Visual for *Jujutsu Kaisen: The Official Anime Guide: Season 1*

INSERT BONUS #2
(FRONT) Key Visual for *JUJUTSU KAISEN 0*
(BACK) Teaser Visual for *JUJUTSU KAISEN 0*

Opening / Ending Gallery

Chapter Guide
006

Episodes 1–24 of the anime split into eight chapters, introducing character references, art references, art boards, and prop references, as well as the "Carefully Selected! Killer Jujutsu" corners and Juju Stroll reference material.

Episode 24: "Accomplices"
Storyboard Gallery and Director Sunghoo Park Interview
118

Special Messages from the Cast
131

Staff Interviews

Illustration Gallery
154

Information on *JUJUTSU KAISEN 0*
165

*This book contains details about episodes 1–24 of the *Jujutsu Kaisen* anime. Please be forewarned of spoilers.
*The ages of all characters with confirmed birthdays are as of October 19, 2018 (within the story.)

Opening Animation

Storyboard/Direction: Shingo Yamashita Chief Animation Director: Tadashi Hiramatsu Color Script: Moaang
First Part Opening Theme: *Kaikai Kitan* by Eve Lyrics/Composition: Eve Arrangement: Numa (TOY'S FACTORY)

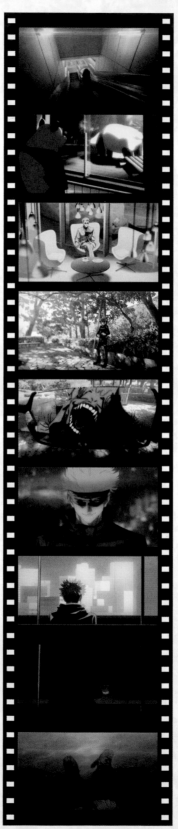

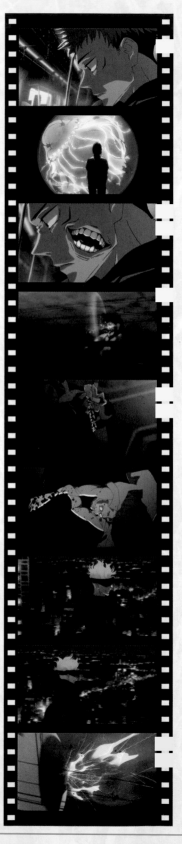

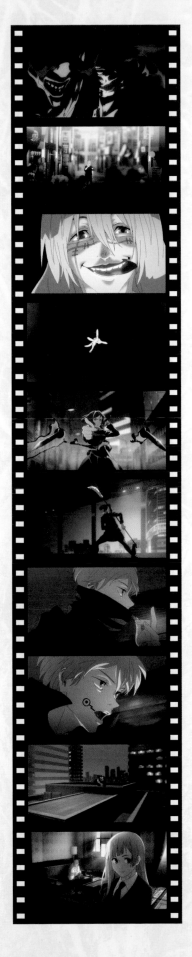

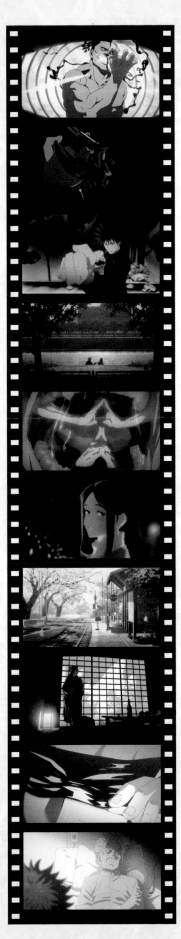

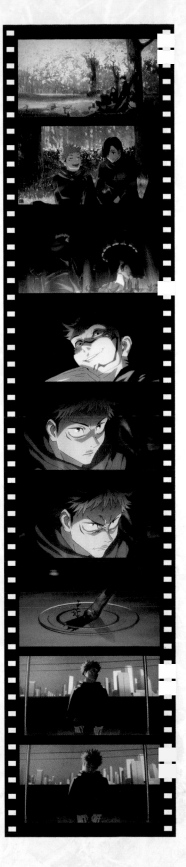

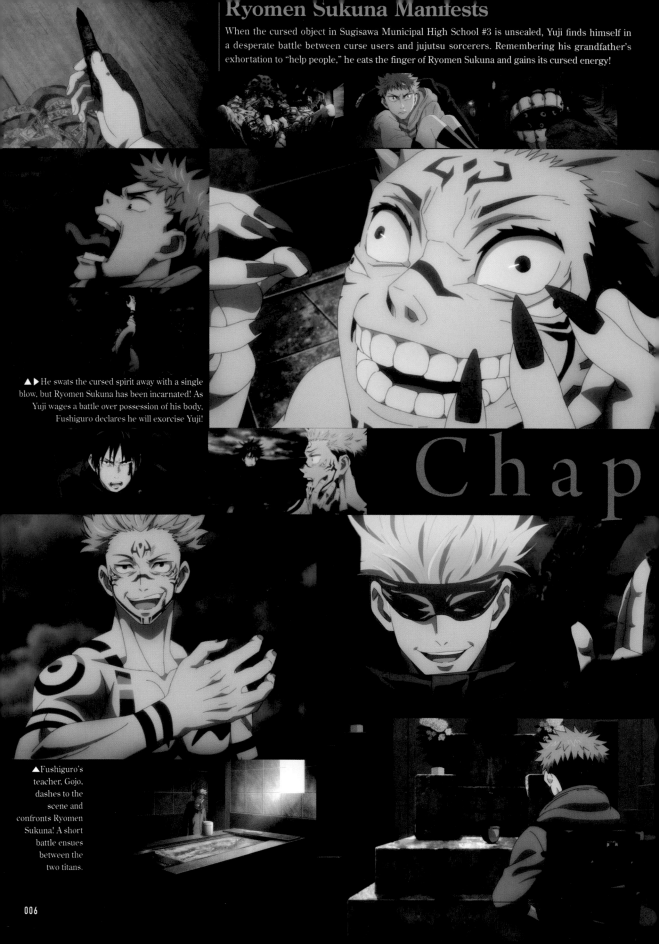

Ryomen Sukuna Manifests

When the cursed object in Sugisawa Municipal High School #3 is unsealed, Yuji finds himself in a desperate battle between curse users and jujutsu sorcerers. Remembering his grandfather's exhortation to "help people," he eats the finger of Ryomen Sukuna and gains its cursed energy!

▲▶ He swats the cursed spirit away with a single blow, but Ryomen Sukuna has been incarnated! As Yuji wages a battle over possession of his body, Fushiguro declares he will exorcise Yuji!

Chap

▲Fushiguro's teacher, Gojo, dashes to the scene and confronts Ryomen Sukuna! A short battle ensues between the two titans.

Yuji Itadori Goes to the World of Jujutsu

After burying his grandfather and saying goodbye to his hometown, Itadori goes to Tokyo to become a jujutsu sorcerer. He visits Jujutsu High School and interviews with the principal, Yaga. When Yuji is asked why he has come to the school, he is hesitant and unable to come up with a firm answer. After a round of fighting and questions, he gives a resolute response!

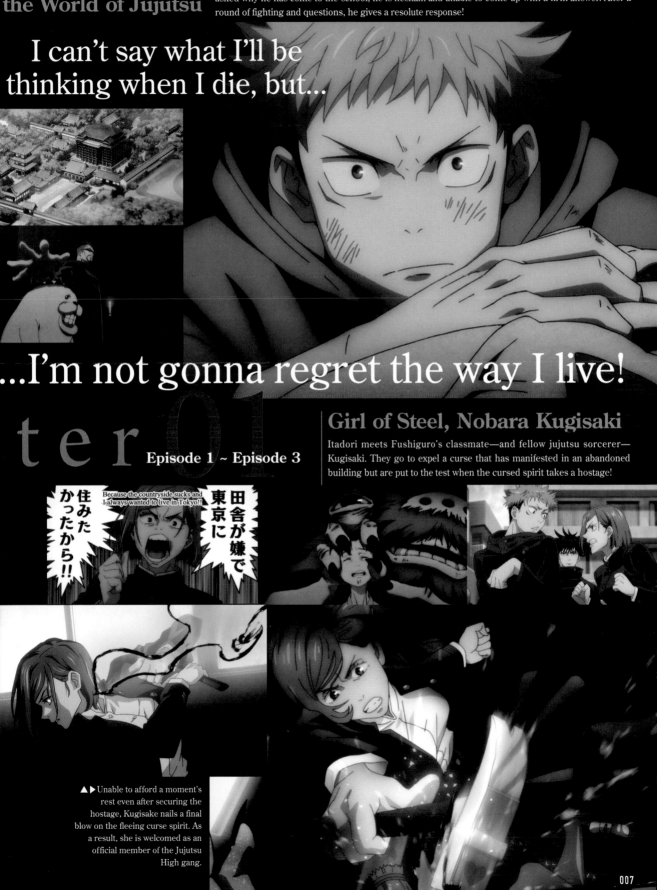

I can't say what I'll be thinking when I die, but...

...I'm not gonna regret the way I live!

t e r 0 1

Episode 1 ~ Episode 3

Girl of Steel, Nobara Kugisaki

Itadori meets Fushiguro's classmate—and fellow jujutsu sorcerer—Kugisaki. They go to expel a curse that has manifested in an abandoned building but are put to the test when the cursed spirit takes a hostage!

▲▶ Unable to afford a moment's rest even after securing the hostage, Kugisake nails a final blow on the fleeing curse spirit. As a result, she is welcomed as an official member of the Jujutsu High gang.

YUJI ITADORI

Voiced by: Junya Enoki

Profile

Age: 15
Birthdate: March 20
Hobbies/Special Skills: Karaoke, Watching TV, Impersonations

Yuji is a once-in-a-millennium individual capable of ingesting the fingers of Ryomen Sukuna without dying. He uses his unique natural-born physical abilities to fistfight cursed spirits into submission. He continues to grow stronger over the course of countless ordeals and flings himself into battle to prevent "unnatural deaths."

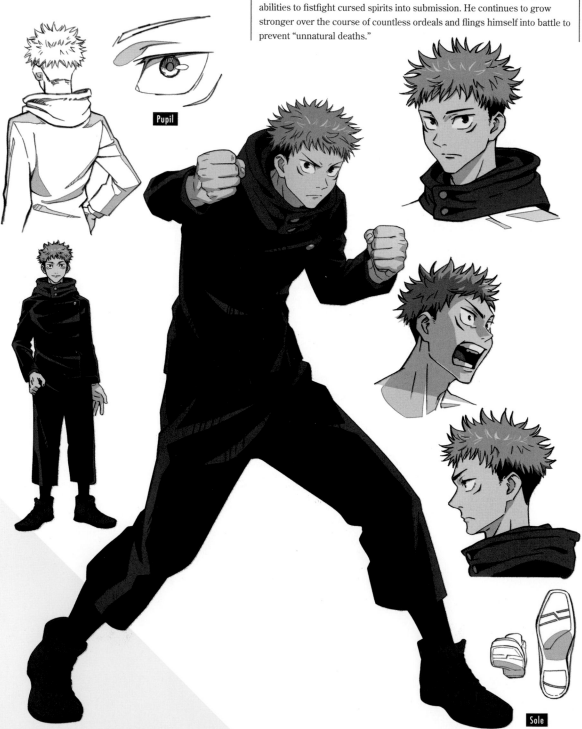

Pupil

Sole

Episode 1 Hoodie

Casual Clothes

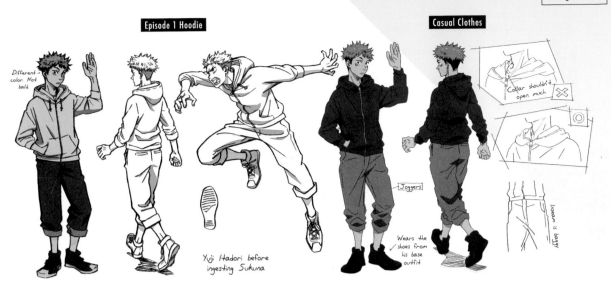

Different color. Not bald.

Collar shouldn't open much

Joggers

Inseam is baggy

Wears the shoes from his base outfit

Yuji Itadori before ingesting Sukuna

Sukuna Appearance Pattern

Sukuna appears on Yuji's face and hand

Hadori at the start of episode 1

Sukuna's eyes lie underneath his regular eyes, solid lines

In the beginning of episode 1, add battle damage under eyes to make it harder to tell

During Secret Execution

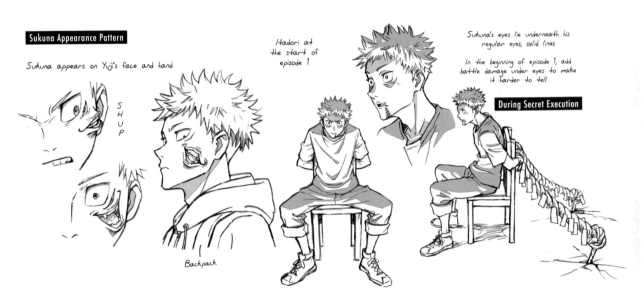

S H U P

Backpack

Sigil on the tongue

*Please make sure not to include the slits under his eyes for scenes before he ate Sukuna's finger or flashback scenes

Expressions

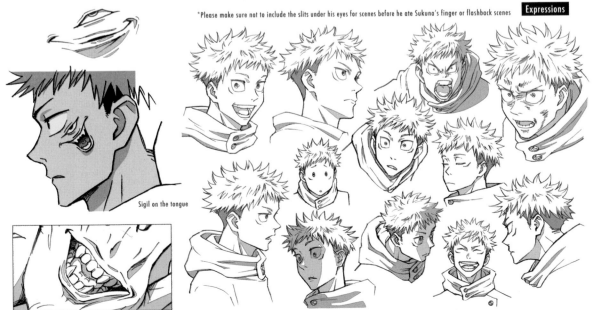

MEGUMI FUSHIGURO

Voiced by: Yuma Uchida

Profile

Age: 15
Birthdate: December 22
Hobbies: Reading

User of the Ten Shadows technique, Fushiguro's ability allows him to control ten shikigami by way of shadows. He bears latent potential great enough to interest both Gojo and Ryomen Sukuna. Led by his conscience, he goes on daily missions to protect as many people as possible.

Expressions

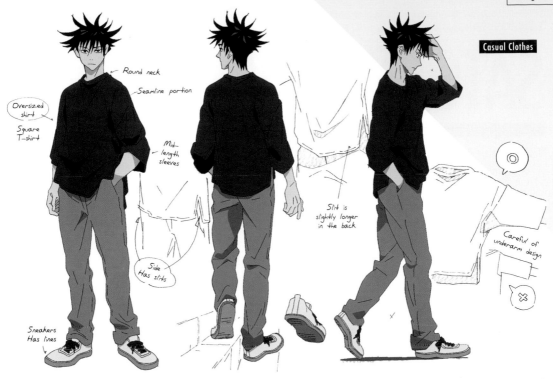

Casual Clothes

Round neck

Seamline portion

Oversized shirt

Square T-shirt

Mid length sleeves

Slit is slightly longer in the back

Side Has slits

Careful of underarm design

Sneakers Has lines

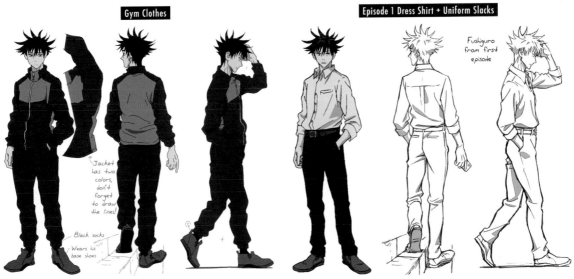

Gym Clothes

Episode 1 Dress Shirt + Uniform Slacks

Jacket has two colors, don't forget to draw the lines!

Black socks

Wears his base shoes

Fushiguro from first episode

Shikigami: Divine Dogs Kuro (Black) and Shiro (White)

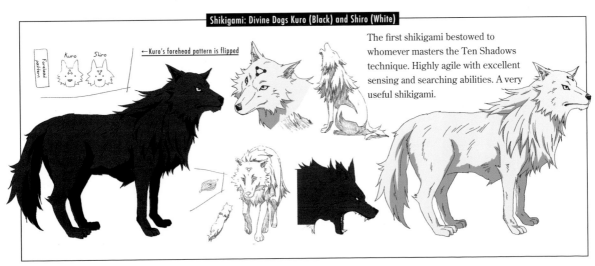

Kuro Shiro

Forehead pattern

←Kuro's forehead pattern is flipped

The first shikigami bestowed to whomever masters the Ten Shadows technique. Highly agile with excellent sensing and searching abilities. A very useful shikigami.

SATORU GOJO

Voiced by: Yuichi Nakamura

Profile

Age: 28

Birthdate: December 7

Hobbies/Special Skills: None (because he can do pretty much anything)

The strongest of all active special grade jujutsu sorcerers, Gojo is the master of the Limitless cursed technique. He is the teacher in charge of the Tokyo branch of Jujutsu High's first-year class and has his eyes on the future of the jujutsu world by cultivating the next generation so they can serve as strong allies. He marches to the beat of his own drum and frequently messes with everyone around him.

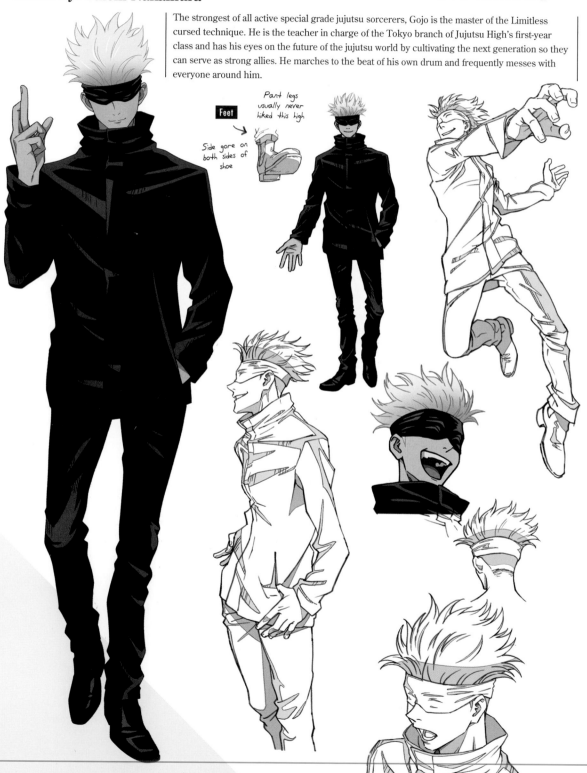

Pant legs usually never hiked this high

Feet

Side gore on both sides of shoe

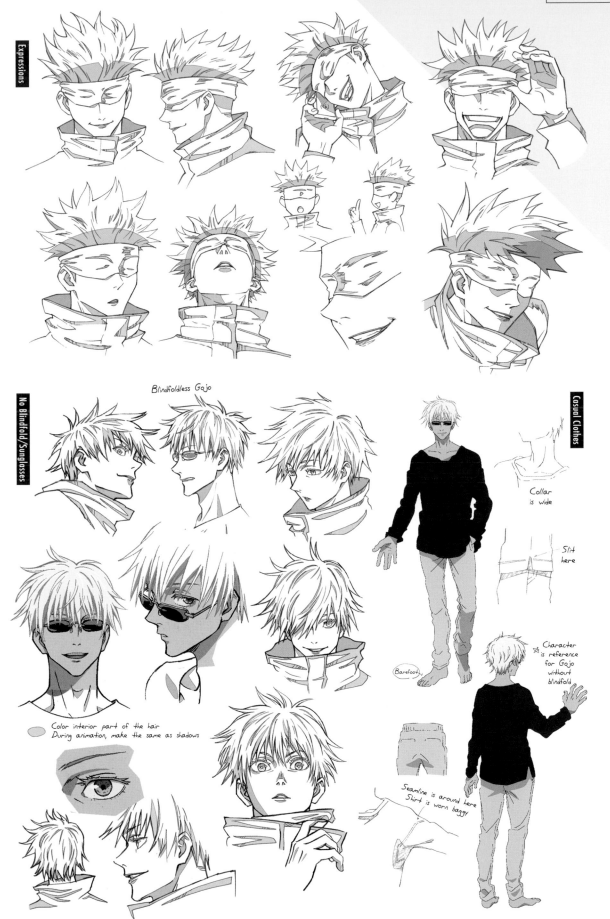

Expressions

No Blindfold/Sunglasses

Blindfoldless Gojo

Casual Clothes

Color interior part of the hair
During animation, make the same as shadows

Collar
is wide

Slit
here

Barefoot

Character
is reference
for Gojo
without
blindfold

Seamline is around here
Shirt is worn baggy

Tokyo Prefectural Jujutsu High School

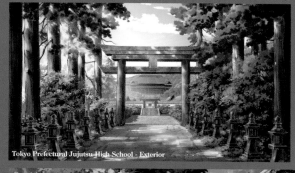

Tokyo Prefectural Jujutsu High School - Exterior

Interior of Yaga's Hall

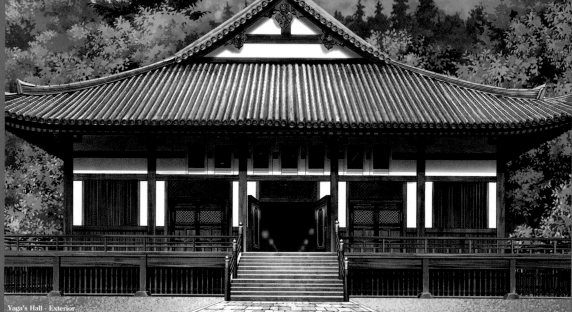

Yaga's Hall - Exterior

Dorms - Fushiguro's Room

Dorms - Hallway

Dorms - Itadori's Room

Tokyo Prefectural Jujutsu High School Principal

MASAMICHI YAGA

Profile

Age: 47
Hobbies: Collects sunglasses,
Likes cute things

Voiced by: Takaya Kuroda

Yaga was once the supervising teacher for Gojo and his class. He is an expert on cursed corpses—dolls infused with cursed energy—and renowned as the foremost figure in puppet manipulation jujutsu study. With his mantra, "Education includes helping students make realizations," he poses questions to his students to see if they have what it takes to be a jujutsu sorcerer.

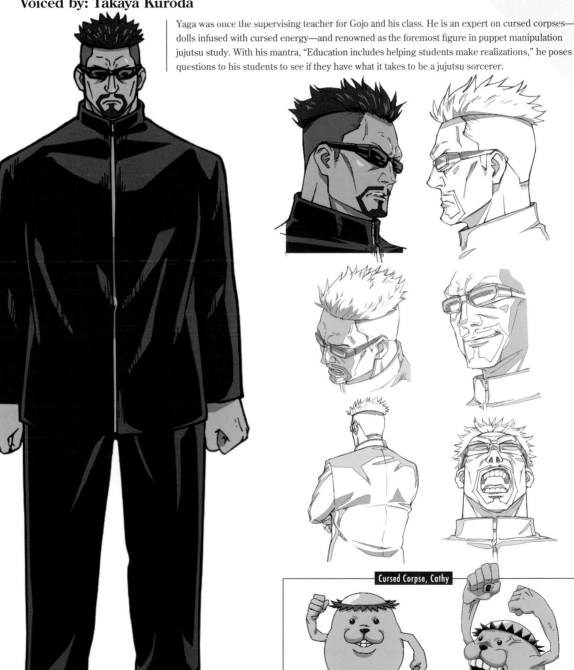

Cursed Corpse, Cathy

One of the cursed corpses created by Yaga. Despite its cute appearance, it beats up its enemies with a combination of swift movements and hard strikes.

Tokyo Prefectural Jujutsu High School First-Year Student

NOBARA KUGISAKI

Profile

Age: 16
Birthdate: August 7
Hobbies: Shopping

Voiced by: Asami Seto

She fights using a cursed technique that employs nails and an effigy called Straw Doll technique. Nobara gained experience as a jujutsu sorcerer in the countryside but took the opportunity to come to Tokyo for high school. She values her identity and boasts that she will even risk her life to ensure that she can be herself.

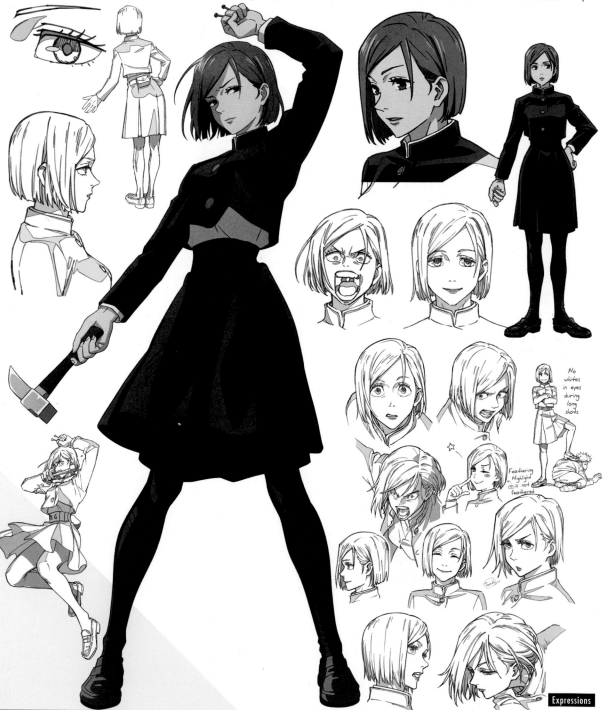

No whites in eyes during long shots

Feathering Highlight is not feathered

Expressions

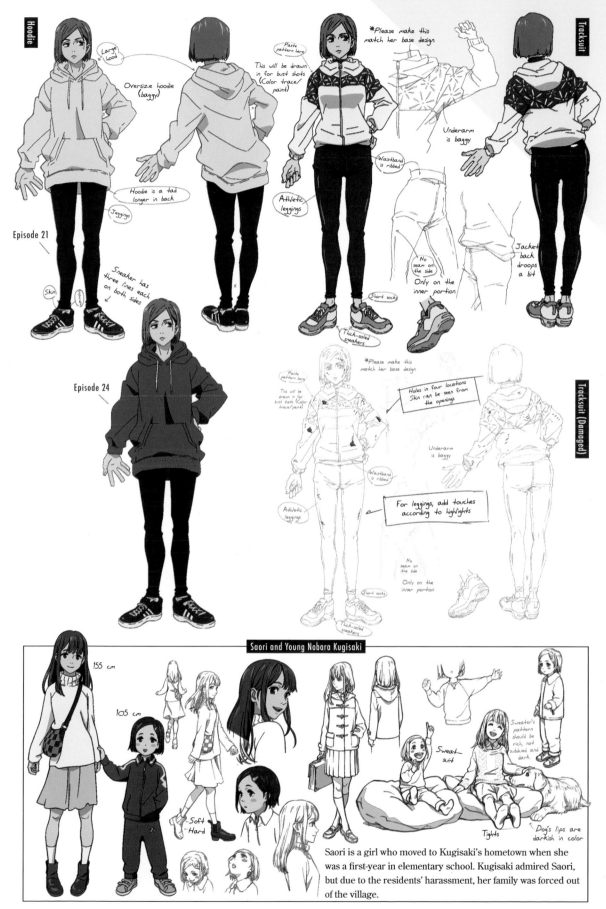

Saori is a girl who moved to Kugisaki's hometown when she was a first-year in elementary school. Kugisaki admired Saori, but due to the residents' harassment, her family was forced out of the village.

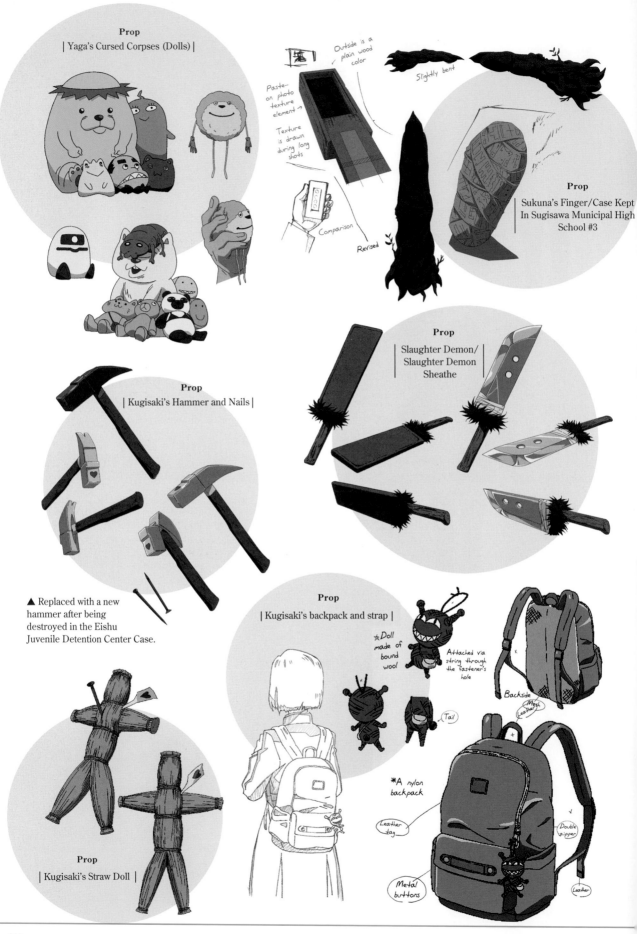

Prop

| Yaga's Cursed Corpses (Dolls) |

Outside is a plain wood color

Paste-on photo texture element →

Texture is drawn during long shots

Comparison

Revised

Slightly bent

Prop

Sukuna's Finger/Case Kept In Sugisawa Municipal High School #3

Prop

Slaughter Demon/ Slaughter Demon Sheathe

Prop

| Kugisaki's Hammer and Nails |

▲ Replaced with a new hammer after being destroyed in the Eishu Juvenile Detention Center Case.

Prop

| Kugisaki's backpack and strap |

☆Doll made of bound wool

Attached via string through the fastener's hole

(Tail)

Backside

(Mesh) (Leather)

*A nylon backpack

(Leather tag)

(Double zipper)

(Metal buttons)

(Leather)

Prop

| Kugisaki's Straw Doll |

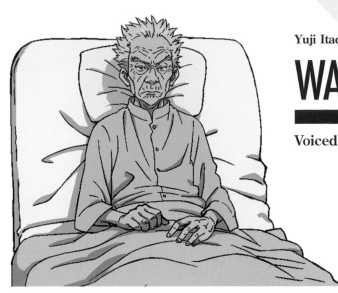

Yuji Itadori's Grandfather

WASUKE ITADORI

Voiced by: Shigeru Chiba

Sugisawa Municipal High School #3

CLASS PRESIDENT

Voiced by: Yoshiki Nakajima

Sugisawa Municipal
High School #3
Second-Year

IGUCHI

Voiced by:
Takahiro Sumi

Sugisawa Municipal High
School #3 Teacher

TAKAGI

Voiced by: Kenji Sugimura

Sugisawa Municipal
High School #3
Second-Year

SASAKI

Voiced by: Mariya Ise

Itadori, Fushiguro, and Kugisaki are dispatched to deal with an emergency inside a juvenile detention center. When Kugisaki suddenly disappears, a special grade cursed spirit silently materializes before Itadori and Fushiguro! To let his teammates escape, Itadori takes on the special grade cursed beast alone!

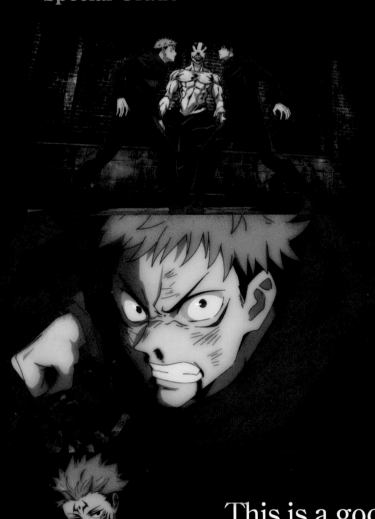

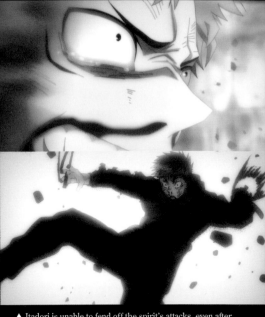

▲ Itadori is unable to fend off the spirit's attacks, even after sacrificing his hand. He laments his weakness and is about to give in to death when the signal that Fushiguro has escaped the domain reaches him.

Chap

This is a good opportunity, so I'll teach you true jujutsu sorcery.

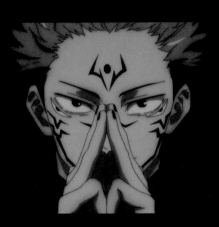

Domain Expansion, Malevolent Shrine!

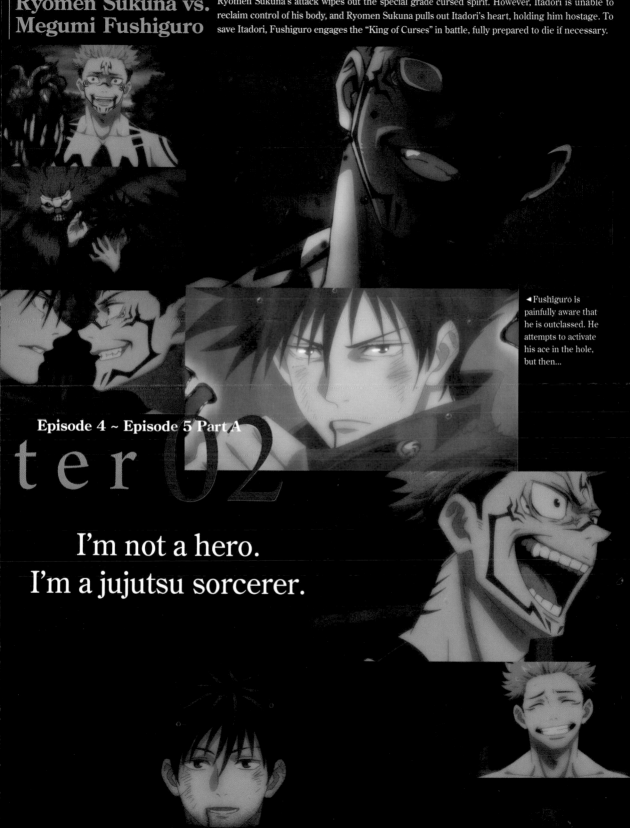

Ryomen Sukuna's attack wipes out the special grade cursed spirit. However, Itadori is unable to reclaim control of his body, and Ryomen Sukuna pulls out Itadori's heart, holding him hostage. To save Itadori, Fushiguro engages the "King of Curses" in battle, fully prepared to die if necessary.

◄ Fushiguro is painfully aware that he is outclassed. He attempts to activate his ace in the hole, but then...

Episode 4 ~ Episode 5 Part A

ter 02

I'm not a hero.
I'm a jujutsu sorcerer.

Tokyo Prefectural Jujutsu High School Assistant Director

KIYOTAKA IJICHI

Voiced by: Mitsuo Iwata

The man in charge of backup operations at the high school. This includes sending jujutsu sorcerers to hot spots, creating a curtain with barrier techniques, and relaying mission information to sorcerers. Stuck between the higher-ups and Gojo's group, his hardships never end.

Profile

Age: 27
Special Skills: Excel

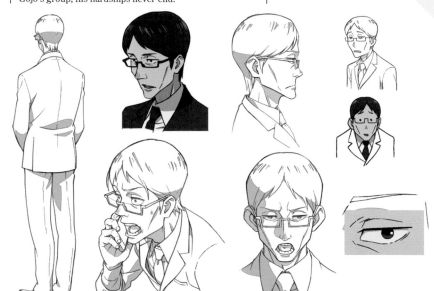

Eishu Juvenile Facility's Special Grade

CURSED SPIRIT

The first special grade cursed spirit Itadori's group squares off against. It fights by unleashing cursed energy, and its outstanding power is enough to overwhelm Itadori and the others.

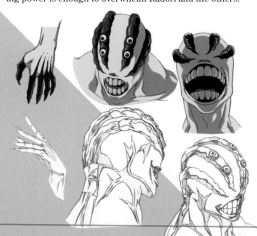

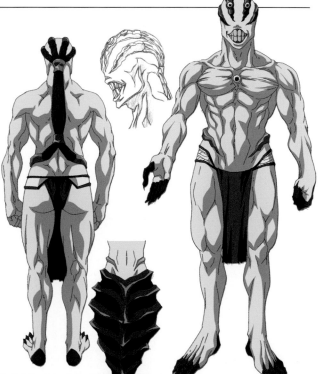

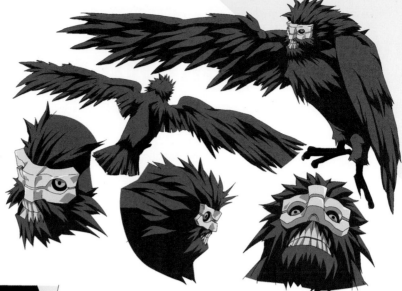

Ten Shadows Technique Shikigami

NUE

As it is capable of flight, it is frequently summoned for aerial combat or as a means of transportation. Whether it's wrapping itself in electrified cursed energy or shielding Fushiguro with its wings, it is characterized by its wide array of abilities.

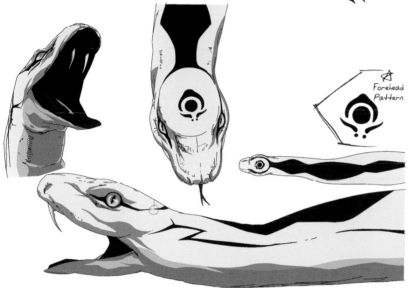

Forehead Pattern

Ten Shadows Technique Shikigami

GREAT SERPENT

A monstrous snake shikigami that devours enemies with its gigantic mouth and huge fangs. In the fight with Ryomen Sukuna, it seemed to immobilize Sukuna for a moment, but it was quickly destroyed soon after.

Ten Shadows Technique Shikigami

TOAD

A gigantic toad shikigami that is great at extending its long tongue to save allies from danger or attacking and immobilizing enemies. It can keep human beings in its mouth.

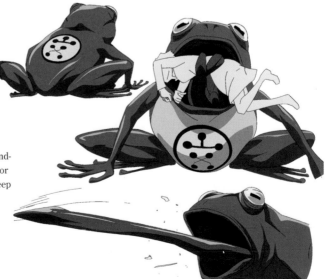

Special Grade Cursed Object

RYOMEN SUKUNA

Voiced by: Junichi Suwabe

Profile

Likes/Interests: Eating

Dislikes: Nothing in particular (Doesn't care about anything other than himself)

Appearance in the Innate Domain

The King of Curses incarnated inside Itadori's body. He is more conceited than anyone else and is guided only by his pleasures and displeasures. He was originally a human who existed over a thousand years ago in the golden age of jujutsu. After his death, his corpse turned into a cursed object and was spread across the land.

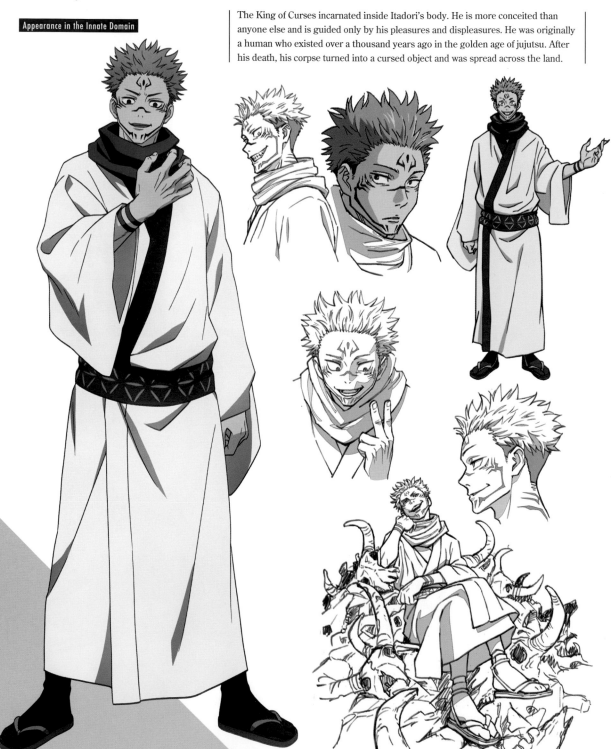

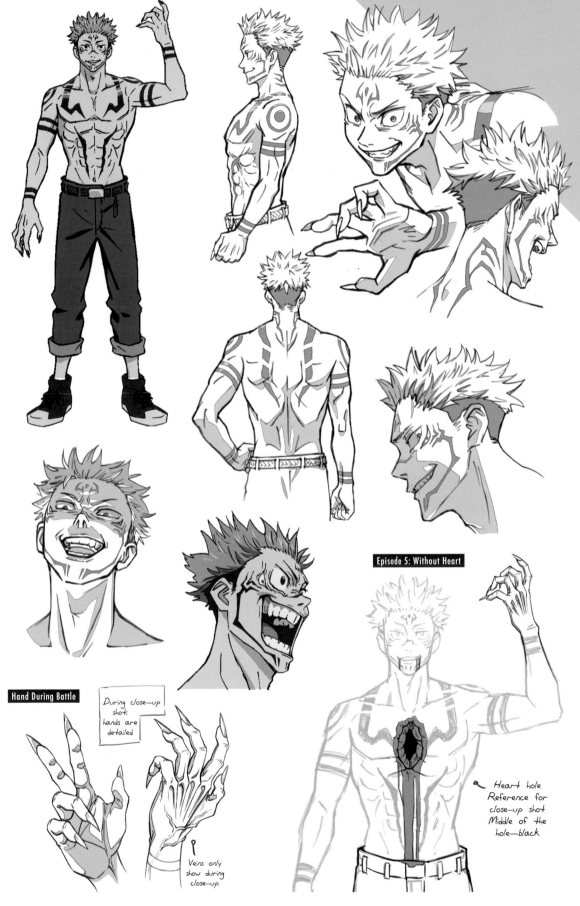

Episode 5: Without Heart

Hand During Battle

During close-up shot: hands are detailed

Veins only show during close-up.

Heart hole
Reference for close-up shot
Middle of the hole—black

Art Board / Art Material — Innate Domain Expanded in the Eishu Juvenile Detention Center

Innate Domain Expanded in the Eishu Juvenile Detention Center

Domain Expansion, Malevolent Shrine

Juju Stroll

What is "Juju Stroll"?

Juju Stroll are animated shorts made from storyboards created by the manga author, Gege Akutami, which are redrawn by the animation studio, MAPPA! They detail slices of each character's life not seen in the main anime.

After Episode 3's Ending ◄◄◄

1 Kugisaki: "Sushi, huh? Guess we can go to the usual place in Ginza."

Kugisaki: "Gin-za, yahoo!"

2 Itadori: "I want revolving sushi!"

3 Kugisaki: "Hmm?"

4 Itadori: "Sushi's a meal, but revolving sushi is a leisure activity! Like a theme park! Or Tokyo Disneyland!"

5 Gojo: "My favorite is Sushi Go, but I'd go with Splendid Sushi for someone's first time."

Itadori: "You get it, Sensei!"

6 Itadori: "Kugisaki, listen closely. At Splendid Sushi...the sushi comes to you on a bullet train."

7 Kugisaki: "Wha?!"

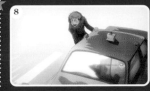

8 Itadori: "Driver, this girl's never had revolving sushi. Take us to the Splendid Sushi with the huge-ass parking lot!"

JUJU STROLL

After Episode 4's Ending ◄◄◄

1 Kugisaki: "You bow while on the phone, Mr. Ijichi."

Ijichi: "I just get so wrapped up in creating the feeling of 'I'm on the phone!' while on a call..."

2 Kugisaki: "I know what you mean. I've hurt my neck several times dealing with ingrown hairs while depilating. Of course, I've hurt my pores, too."

Itadori: "Is that really the same?"

3 Itadori: "You're often irritated when you're on the phone, Fushiguro."

Fushiguro: "That's because of Gojo Sensei, less the phone."

4 Kugisaki: "You often wander around when you're on the phone, Itadori."

5 Ijichi: "Speaking of phones, can you all stay on a call while holding the phone against your shoulder?"

6

7

8 Kugisaki: "Ah!"

Kugisaki: "Aaaaaaaaah!"

9

Respective Decisions

Fushiguro and Kugisaki are distraught over Itadori's death. The goodwill event with the sister school in Kyoto is close at hand so the two undergo special training with the upperclassmen. Unbeknownst to the others, Itadori has resurrected himself and has vowed to become stronger so he can save others. He begins training under Gojo.

I will...

I will...

...become stronger. I'll do whatever it takes.

Chap

◀ Itadori and Sukuna battle, with Itadori's revival on the line.
▼ Gojo hides the fact that Itadori has been revived and trains him in the school's basement.

I want to be stronger. Please teach me how to be the **strongest.**

Jogo's Raid

Jogo, a special grade cursed spirit, assaults Gojo but Gojo battles him effortlessly. The disparity in power between the two hurts Jogo's pride, so he activates his domain expansion, Coffin of the Iron Mountain. In response, Gojo unleashes his domain!

Domain expansion! Coffin of the Iron Mountain!

▲▶ Jogo calls Gojo foolish for bringing Itadori with him, but Gojo retorts, "We should be good. You're so weak, after all." This ignites Jogo's rage.

ter03

Episode 5 Part B ~ Episode 8

Kyoto School's Visit

Two students from Kyoto, Todo and Mai, appear before the Tokyo students. Fushiguro and Kugisaki's tempers flare when Mai calls Itadori a "monster."

◀▲▼Mai aims a gun at Kugisaki, immobilizing her. Fushiguro has a tough time against Todo's overwhelming speed and power.

So weak. Both your body and taste in women.

SUGURU GETO

Profile

Hobbies/Special Skills: Martial arts

Voiced by: Takahiro Sakurai

Geto is the most heinous of curse users, who once cursed over a hundred civilians to death and advocates for creating a paradise for jujutsu sorcerers. He colludes with cursed spirits to seal off Satoru Gojo and tries to bring Sukuna's vessel, Itadori, over to his side.

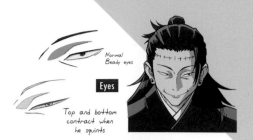

Normal Beady eyes

Eyes

Top and bottom contract when he squints

Expressions

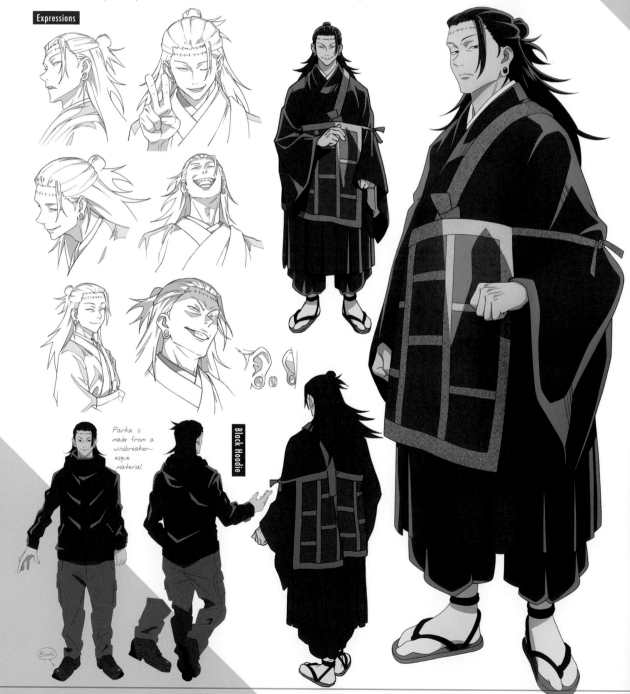

Parka is made from a windbreaker-esque material.

Black Hoodie

Boots

Special Grade Cursed Spirit

JOGO

Profile
Likes/Interests: Collecting cursed tools
Dislikes: Humans, especially Gojo

Voiced by: Shigeru Chiba

A curse from the earth, Jogo can expel fire and magma from craters situated on his palms to burn people to cinders. He believes himself to be a "true human" since he was born from unfeigned emotions like hatred and bloodlust, and thinks all "fake humans" should be destroyed.

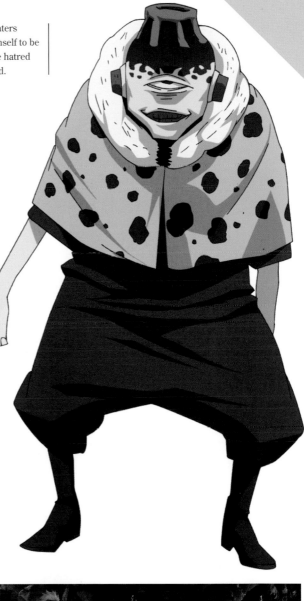

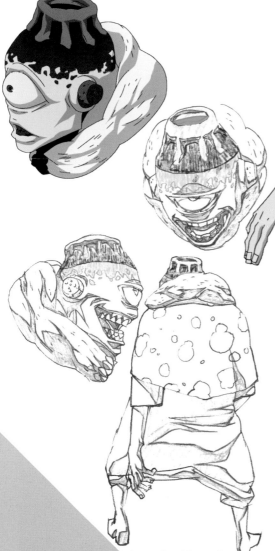

Domain Expansion, Coffin of the Iron Mountain

Expands a domain that is as scorching hot as the inside of an active volcano's crater. Any regular jujutsu sorcerer would burn to a crisp the second they enter the space. Its superhigh-temperature follow-up attacks vaporize targets, not even leaving ashes in their wake.

DAGON

Likes/Interests: Swimming, Hanami

Dislikes: Humans

Dagon is a water cursed spirit that travels with Geto and the others. Its ability is unknown, and it's unclear whether it is capable of human speech, but it seems very attached to Hanami.

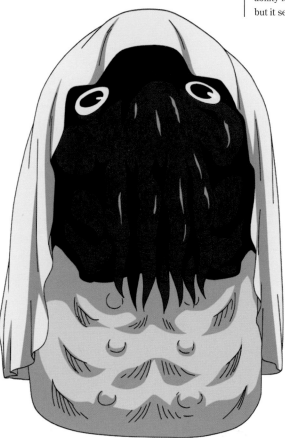

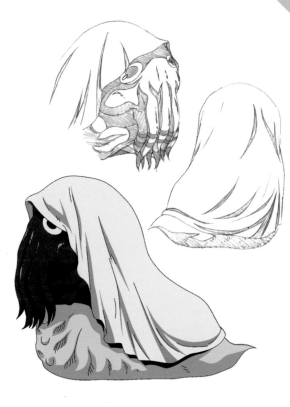

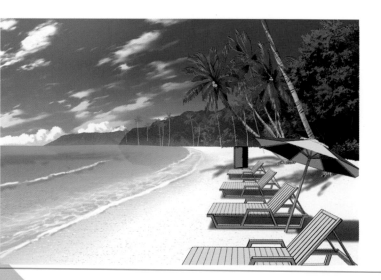

Art Board
Art Material

Dagon's Innate Domain

An innate domain that resembles a beautiful beach resort. Geto and the others use it as a sort of recreation area and hideout.

Tokyo Prefectural Jujutsu High School Physician

SHOKO IEIRI

Profile

Age: 28
Birthdate: November 7
Hobbies/Special Skills: Alcohol

Voiced by: Aya Endo

Shoko Ieiri is the doctor who singlehandedly cares for the sick and injured at Jujutsu High. She cures wounds by using a technique called "reverse cursed technique," where she casts negative cursed energy on negative cursed energy, producing positive energy as a result. She also occasionally acts as a coroner, performing autopsies on corpses involved in curses.

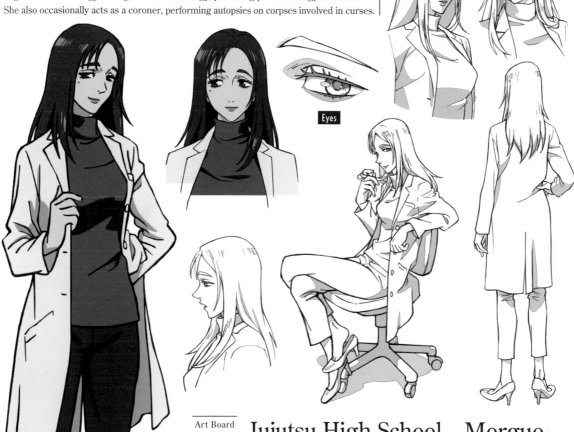

Eyes

Art Board
Art Material Jujutsu High School—Morgue

Tokyo Prefectural Jujutsu High School Second-Year Student

MAKI ZEN'IN

Profile

Age: 16
Birthdate: January 20
Special Skill: Crushing empty cans

Voiced by: Mikako Komatsu

Born into an elite jujutsu sorcerer family, Maki neither possesses cursed energy nor can she see curses. However, to make up for her lack of cursed energy, she has high physical strength and is widely acclaimed as the best student in terms of combat with cursed weapons. She works hard to prove the Zen'in family wrong.

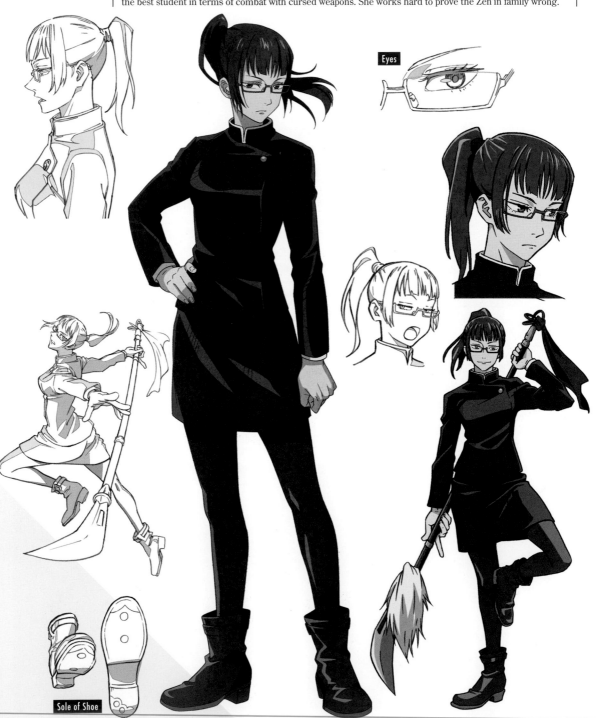

Eyes

Sole of Shoe

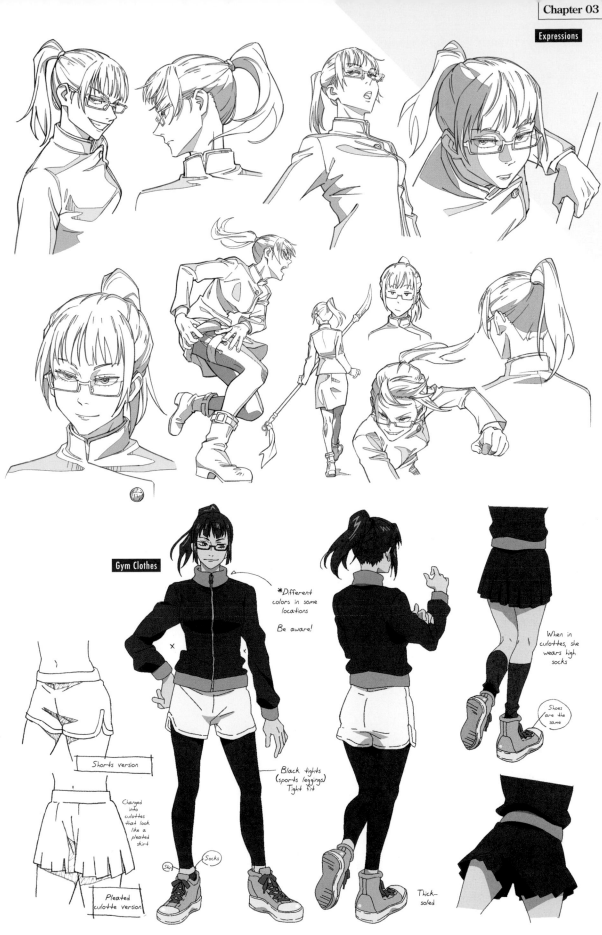

Gym Clothes

*Different colors in some locations

Be aware!

When in culottes, she wears high socks

Shoes are the same

Shorts version

Changed into culottes that look like a pleated skirt

Black tights (sports leggings) Tight fit

Shoe

Socks

Pleated culotte version

Thick-soled

TOGE INUMAKI

Profile

Age: 16
Birthdate: October 23
Hobbies: YouTube

Voiced by: Koki Uchiyama

Toge is from a family of cursed speech users, a technique in which one can use words as cursed weapons. To avoid accidentally cursing others, he converses in daily life using only the names of rice ball ingredients. Strong words tend to have big recoil that damages his throat, so he always keeps throat medicine on him.

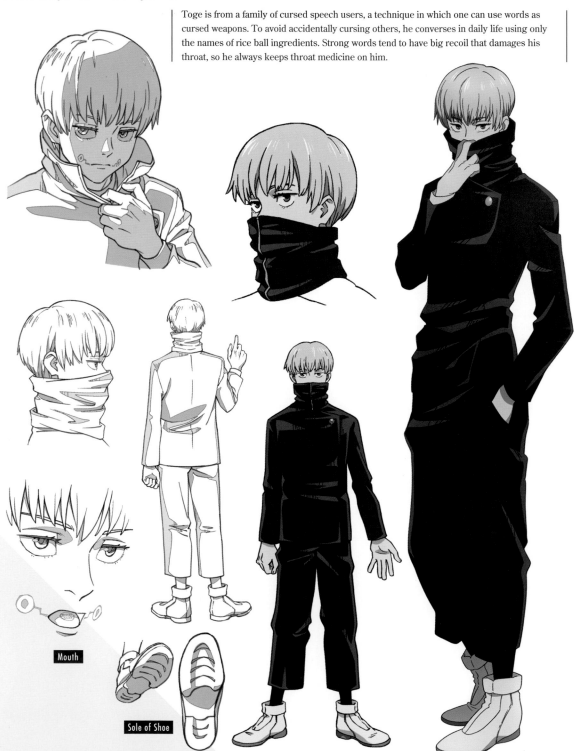

Mouth

Sole of Shoe

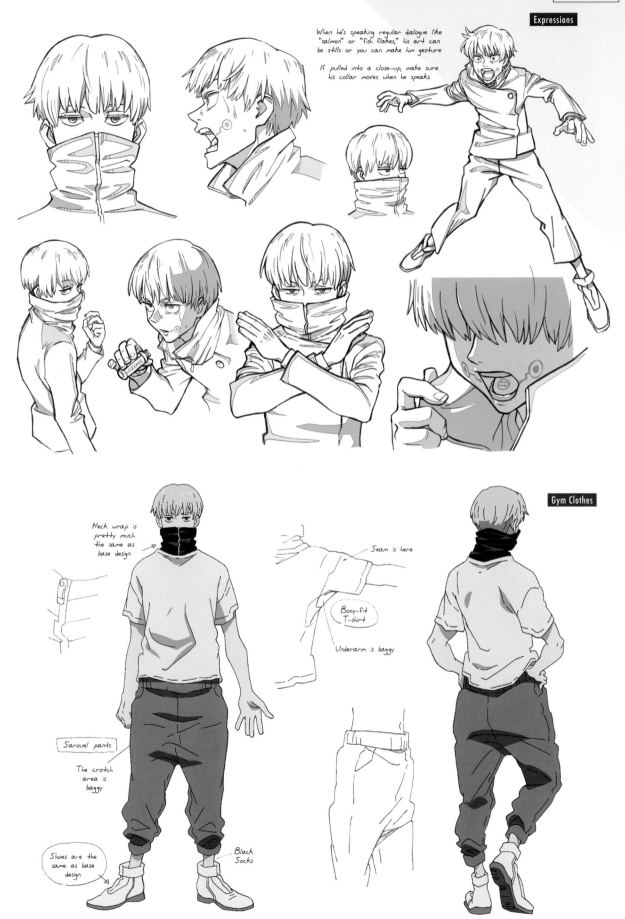

Expressions

When he's speaking regular dialogue like "salmon" or "fish flakes," his art can be stills or you can make him gesture

If pulled into a close-up, make sure his collar moves when he speaks

Gym Clothes

Neck wrap is pretty much the same as base design

Seam is here

Boxy-fit T-shirt

Underarm is baggy.

Sarouel pants

The crotch area is baggy

Shoes are the same as base design

Black Socks

PANDA

Voiced by: Tomokazu Seki

Profile

Birthdate: March 5

Hobbies: Collecting panda goods

Looks like an ordinary panda, but he is really an "abrupt mutation cursed corpse" made by Principal Yaga. Usually, a corpse can only have one "core," but he possesses three, meaning he can swap out his main core for another and convert his body into a different form.. Very caring and pretty much serves as the second-year students' peacemaker.

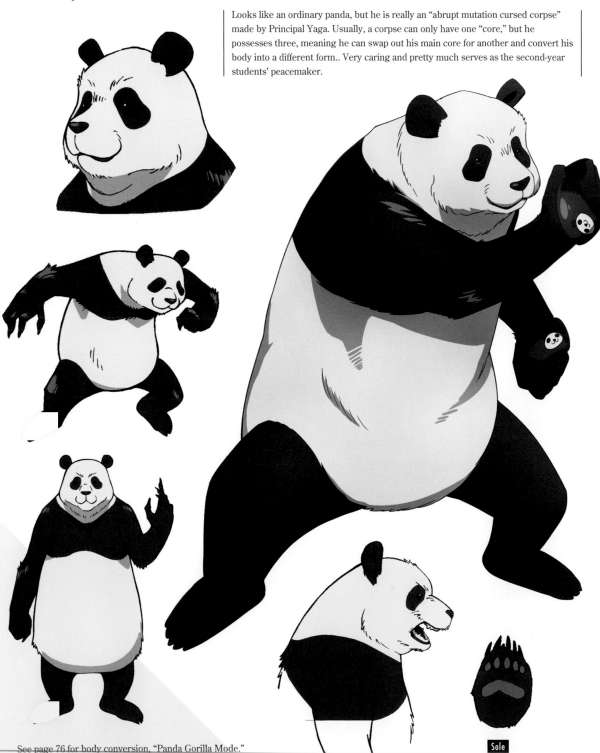

Sole

See page 76 for body conversion, "Panda Gorilla Mode."

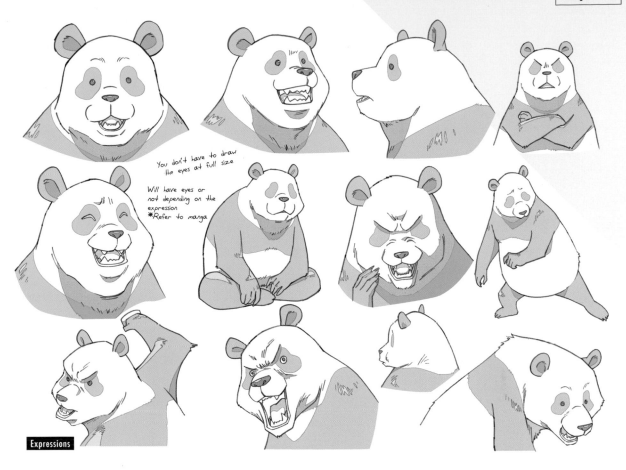

You don't have to draw the eyes at full size

Will have eyes or not depending on the expression
*Refer to manga

Expressions

I ♥ 🐼

Nothing is drawn on the back when viewed from the side

I ♥

I ♥ 🐼

Ryomen Sukuna's Innate Domain

Full View

Atop Bone

Art Board
Art Material

Jujutsu High School • Basement

Cursed Corpse

TSUKAMOTO

A cursed corpse used for Itadori's cursed energy–channeling training, made by Yaga. Unless you pour a certain amount of cursed energy into it, it wakes up and attacks. In the original manga, its name was never stated, but Gege Akutami revealed it during the anime's production.

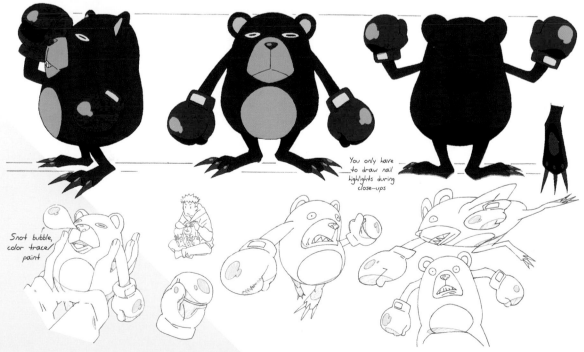

You only have to draw nail highlights during close-ups

Snot bubble, color trace paint

Carefully selected!
Killer Jujutsu

Domain Expansion,
—— Satoru Gojo

Opponents are dragged inside the Limitless where functions such as perception and communication are forced to operate infinitely. They are overwhelmed and unable to do much while slowly dying.

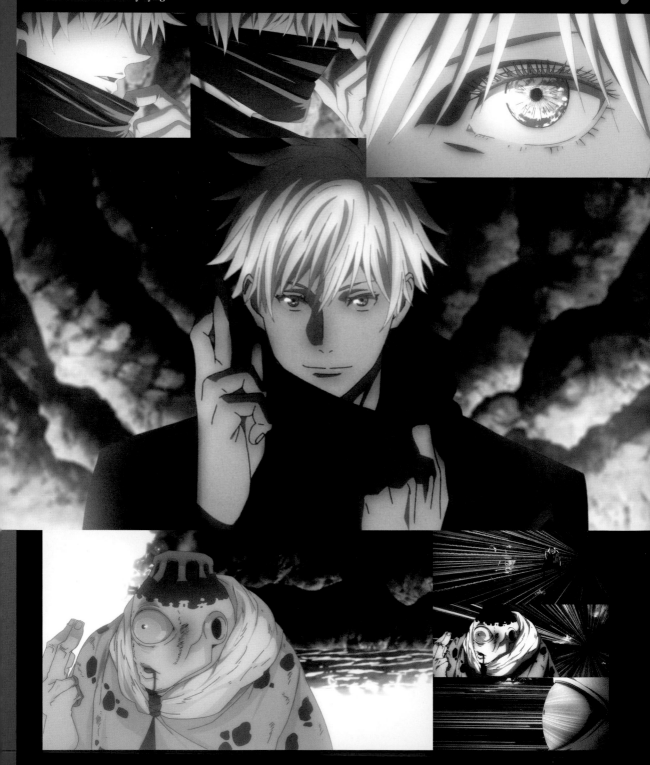

Unlimited Void

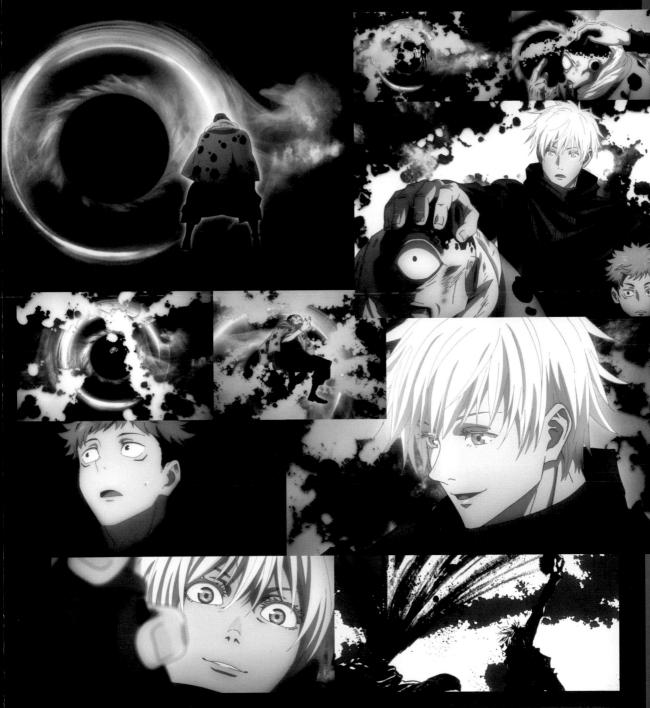

A scene gives more clarity to Gojo's character — Sunghoo Park's Comment

I knew it would be hard to depict Gojo's tremendous strength. In the original manga, his domain was depicted as a blank void with an expanding swath of the universe. However, I envisioned it being more of a "godly domain." To depict that, I consulted with Akutami Sensei several times and received ideas that lead to the finished product. And since Gojo removes his blindfold for the first time when activating the technique, I think this scene also helps give Gojo's character more clarity.

AOI TODO

Voiced by: Subaru Kimura

Profile

Age: 18
Birthdate: September 23
Likes: Takada

The strongest man at the Kyoto school, specializing in hand-to-hand combat. Todo has a habit of asking his opponents about their taste in women before battle. His cursed technique is called Boogie Woogie, a technique that allows him to swap places with his target. A passionate fan of the tall idol Takada.

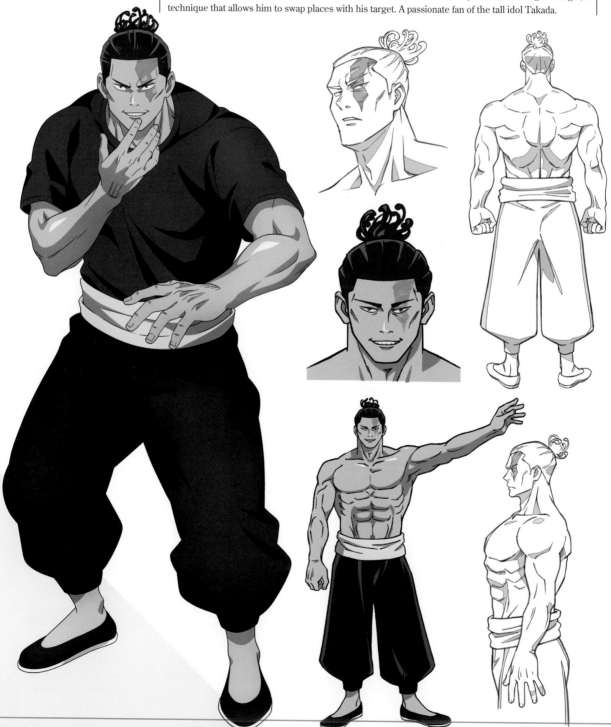

Expressions

T-shirt

Uniform

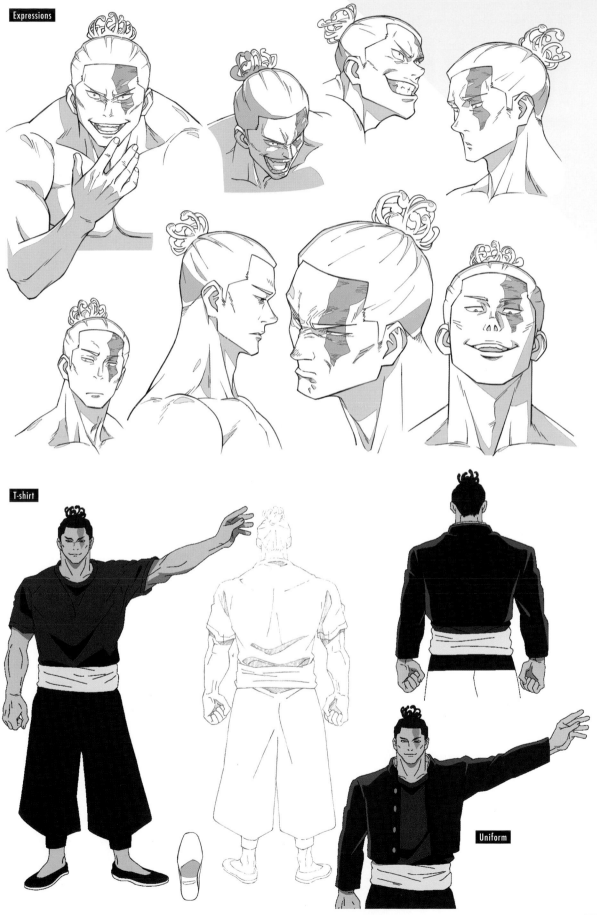

MAI ZEN'IN

Voiced by: Marina Inoue

Profile

Age: 16
Birthdate: January 20
Likes: Cactus

Daughter of the acclaimed Zen'in jujutsu sorcerer family and Maki's twin sister, Mai often provokes her opponents. She can concentrate cursed energy into objects and specializes in gun-based combat. As a master of the "construction" cursed technique, she can construct substances out of nothing by using her own cursed energy.

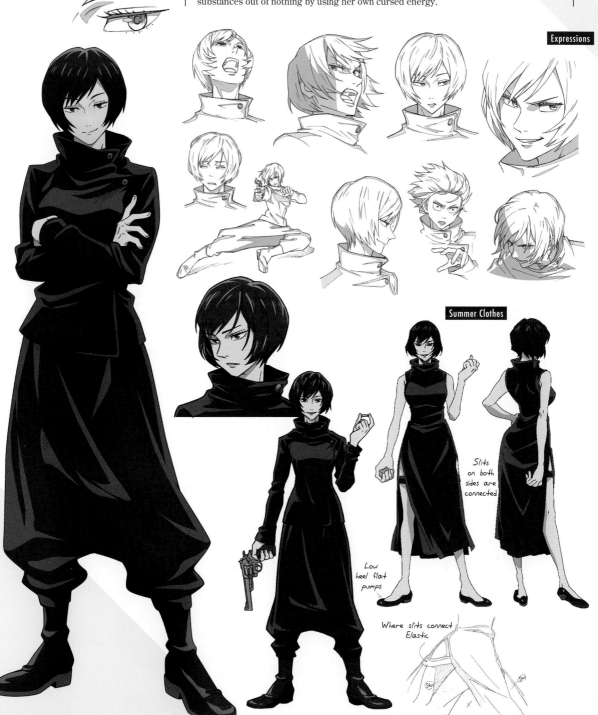

Eye

Expressions

Summer Clothes

Slits on both sides are connected

Low heel flat pumps

Where slits connect Elastic

Art Board Art Material Jujutsu High School, Near Battle Area of Fushiguro vs. Todo

Upper Floor

Base

Vending Machine Passage

Full View

Shikigami (Extension Technique)

THE WELL'S UNKNOWN ABYSS

A shikigami borne of an expansion technique that combines Nue and Toad. Since it's an extension technique, even if it is completely destroyed, it can be re-manifested. Its body is smaller than both Nue and Toad, but it's possible to summon multiple copies at the same time.

KASUMI MIWA

Age: 17
Birthdate: April 4
Special Skill: Saving money

Voiced by: Chinatsu Akasaki

Master of the New Shadow Style. Despite the Kyoto school having a host of eccentric personalities under its roof, Miwa is very down-to-earth and honest. Since her family is poor, she is self-reliant as a jujutsu sorcerer and strives to increase her grade so that she can help her family's finances. She is also a faddist and a secret Gojo fangirl.

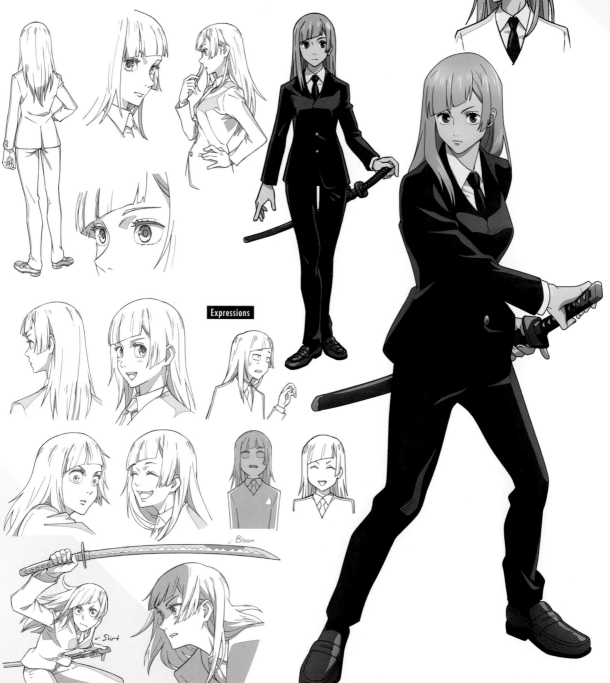

Expressions

Bloom

Shirt

Kyoto Prefectural Jujutsu High School Principal

YOSHINOBU GAKUGANJI

Voiced by: Mugihito

Profile

Age: 76
Hobbies/Special Skills:
Guitar (can play any light musical instrument)

Principal Gakuganji is the conservative leader of the jujutsu world. He finds Itadori, Sukuna's vessel, to be an inconvenience and plots to erase his existence. Uses a cursed technique that allows him to amplify the tunes he produces via guitar and shoot them as cursed energy.

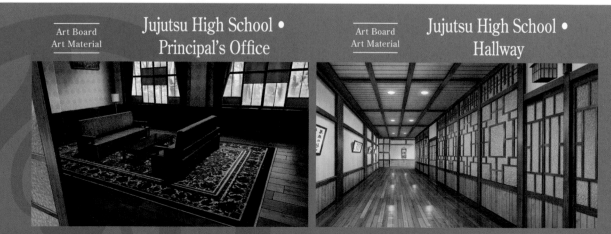

Art Board
Art Material

Jujutsu High School •
Principal's Office

Art Board
Art Material

Jujutsu High School •
Hallway

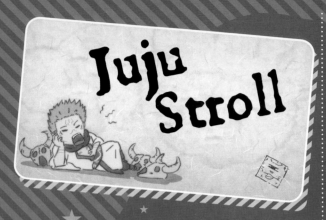

Juju Stroll

Panda: "I don't like getting wet. But unlike you guys, I don't sweat and I use Febreze every day. So I don't stink."

Maki: "So that's what happened. You guys try taking a whiff."

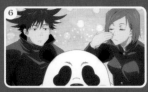

Fushiguro & Kugisaki: "Whiff, whiff. Sniff, sniff. Whiff, whiff. Sniff, sniff."

After Episode 5's Ending ◀◀◀

Maki: "You stink."
Panda: "I do not stink."
Maki: "You stink."
Panda: "I don't stiiiiiink!"

Fushiguro: "He doesn't really stink. Sort of smells like the Sun."

Panda: "Why are you treating me like an animal?"
Maki: "Because you're a panda."

Maki & Kugisaki:
"Sunshine?!"

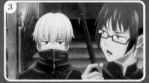

Toge: "Mustard leaf."
Maki: "You smell like an animal. I keep telling you to take a bath and you never do."

JUJU STROLL

After Episode 6's Ending ◀◀◀

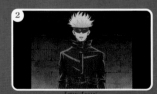

Satoru Sensei

Gojo: "Today, we're at my alma mater, Tokyo Jujutsu High School."

Gojo: "Let's give him some advice."

Yuji

Gojo: "Oh? We already have a boy in trouble. Is he a new student?"
Itadori: "..."

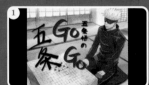

Gojo: "You're walking down a narrow path. Before you is a row of college boys. They haven't noticed you at all. You want to kill them, don't you? So you..."

Title: "Gojo Satoru's Go Go Gojo!"

Gojo: "It looks like he can't produce cursed energy very well."

Itadori: **"Shut up."**

After Episode 7's Ending ◀◀◀

1 Geto & Mahito: "One, two, three, four... One, two, three, four..."

Jogo: "What are you doing?"

Geto: "Brazilian calisthenics."

Geto & Mahito: "Three, four..."

2 Mahito: "I think we're nice and warmed up now."

Geto: "Yeah."

3 Mahito: "Heads up, Geto!"

4

5 Geto: "Shoot!"

6 Geto: "Here it comes, Mahito!"

7 Mahito: "Overhead Shoot!"

8

9 Jogo: **"I'm going to kill these two later!"**

JUJU STROLL

After Episode 8's Ending ◀◀◀

1 Fan #1: "Hey, that hot lady is looking at us like we're garbage!"

Fan #2: "Don't get turned on..."

2 Todo: "Mai, sorry to keep you waiting. What's wrong? Did something unpleasant happen?"

Mai: "Why don't you ask yourself that?"

3 Todo: "So this moment has finally come..."

Mai: "What's that?"

Todo: "For the next meet-and-greet. You should experience how wonderful Takada is in person."

4 Mai: (This is just plain annoying.)

Todo: "This is my duty as a fan... As a future husband."

5 Mai: (And that's just plain creepy. But if I reject his offer, he'll get even more annoying.)

Todo: "What's the matter?"

6 Takada: "Wow, a girl! It's your first time, right?"

Mai: "Yeah..."

Takada: "What's your name?"

Mai: "Mai."

7 Takada: "Heh heh, Mai, are you tired? Did you wait long?"

Mai: "It was more the people than the line..."

Takada: "Then come back again when you're feeling better. I'll remember you, Mai."

8 Todo: "You're back, Mai? How was it?"

Mai: "Fine."

9 Todo: "True, Takada isn't a woman that can so easily be put into words."

Mai: "She's not bad..."

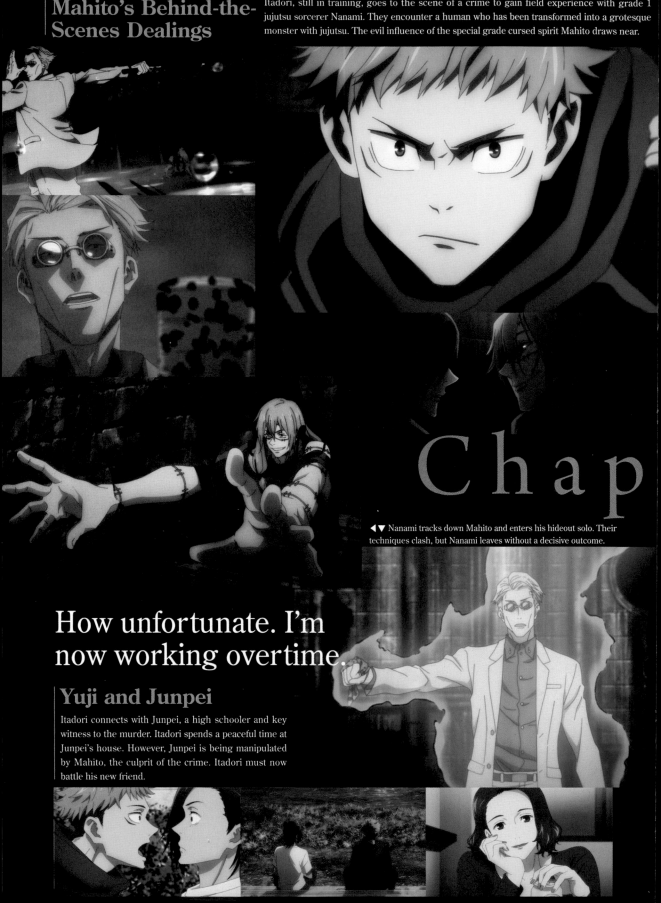

Mahito's Behind-the-Scenes Dealings

Itadori, still in training, goes to the scene of a crime to gain field experience with grade 1 jujutsu sorcerer Nanami. They encounter a human who has been transformed into a grotesque monster with jujutsu. The evil influence of the special grade cursed spirit Mahito draws near.

Chap

◀▼ Nanami tracks down Mahito and enters his hideout solo. Their techniques clash, but Nanami leaves without a decisive outcome.

How unfortunate. I'm now working overtime.

Yuji and Junpei

Itadori connects with Junpei, a high schooler and key witness to the murder. Itadori spends a peaceful time at Junpei's house. However, Junpei is being manipulated by Mahito, the culprit of the crime. Itadori must now battle his new friend.

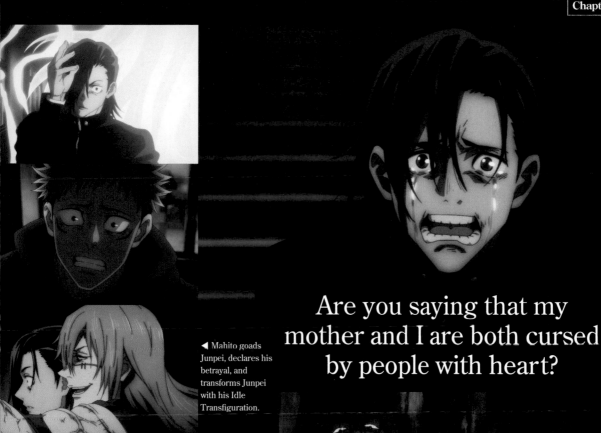

◀ Mahito goads Junpei, declares his betrayal, and transforms Junpei with his Idle Transfiguration.

Are you saying that my mother and I are both cursed by people with heart?

ter 04

Episode 9 ~ Episode 13

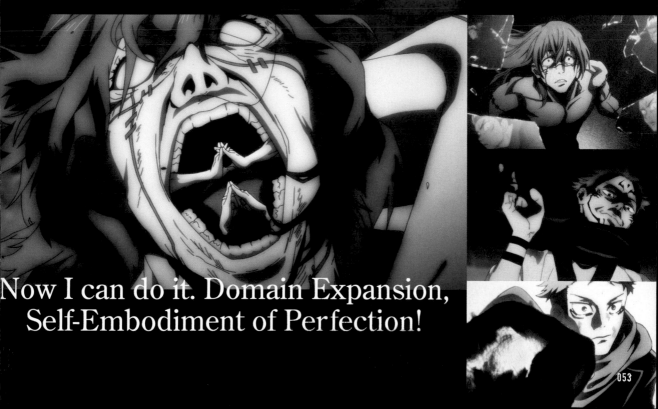

Now I can do it. Domain Expansion, Self-Embodiment of Perfection!

KENTO NANAMI

Voiced by: Kenjiro Tsuda

Profile

Age: 28
Birthdate: July 3
Likes/Special Skills: Alcohol, Cooking for one

A jujutsu sorcerer who is a former salaryman and Gojo's underclassman. In school, he learned that jujutsu sorcerers were idiots. In the general business world, he learned that working was just as idiotic. Consequently, he decided to take the lesser of the two evils and became a jujutsu sorcerer. He uses the Ratio Technique, which divides the target into lines and creates a weak spot at the ratio point of seven to three.

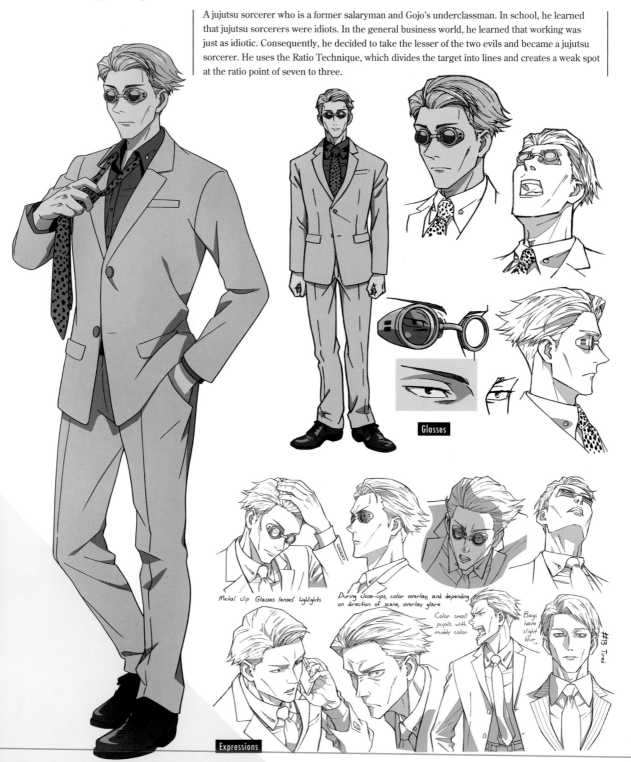

Glasses

Metal clip. Glasses lenses' highlights

During close-ups, color overlay, and depending on direction of scene, overlay glare

Color small pupils with muddy color

Bags have slight blur

#3 Tired

Expressions

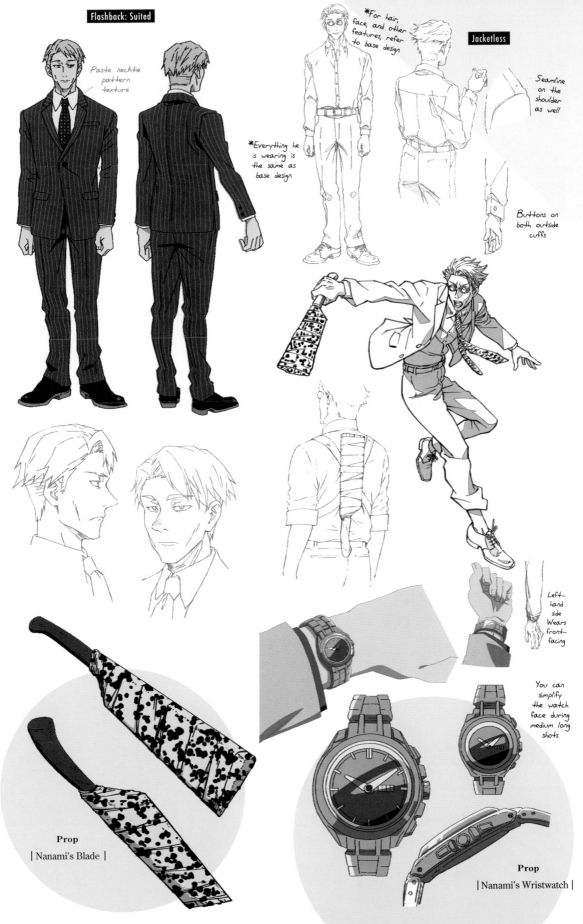

Flashback: Suited

Paste necktie pattern texture

*For hair, face, and other features, refer to base design

Jacketless

Seamline on the shoulder as well

*Everything he is wearing is the same as base design

Buttons on both outside cuffs

Left hand side wears front-facing

You can simplify the watch face during medium long shots

Prop

| Nanami's Blade |

Prop

| Nanami's Wristwatch |

Divergent Fist
— Yuji Itadori

After Itadori hits an opponent with his fist, a delayed wave of cursed energy crashes into them so the strike has double the impact. It's a tricky attack that's hard to guard against.

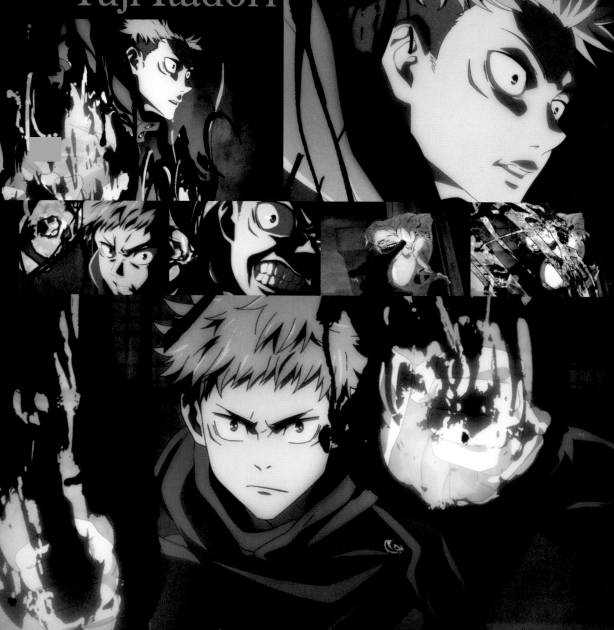

Divergent Fist

Sunghoo Park's Comment — Drawing it straight, frame by frame

For the Divergent Fist scene, we focused on matching the manga's portrayal of the move. In the manga, Akutami Sensei employed brushlike strokes, so we followed suit. Also, we drew the entire sequence straight, frame by frame, using as little camerawork as possible. Lastly, we gave the letters of the attack name a brushstroke quality to match the tone.

Grade 2 Jujutsu Sorcerer

TAKUMA INO

Voiced by: Yu Hayashi

Ino is a jujutsu sorcerer affiliated with Jujutsu High. He has admired Nanami ever since he helped him on a mission in the past. He is looking for his chance to gain a promotion to grade 1 via Nanami's recommendation and to inherit his wristwatch as a hand-me-down.

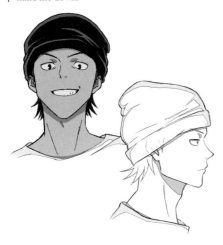
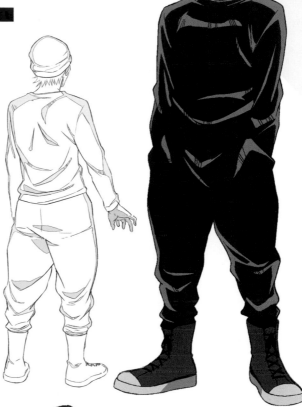

Satozakura High School
Second-Year Student

ITO

Voiced by: Takamasa Mogi

Satozakura High School Teacher

SOTOMURA

Voiced by: Akira Harada

BAKERY GIRL

Voiced by: Chihiro Ueda

Satozakura High School Second-Year Student

JUNPEI YOSHINO

Voiced by: Yoshitaka Yamaya

Profile

Age at death: 17
Hobbies/Special Skills: Watching movies

Junpei is a high school student who decided to drop out because of bullying. He meets the cursed spirit Mahito, who lures Junpei into committing crimes under the guise of friendship. After learning jujutsu from Mahito, Junpei was able to use the shikigami Moon Dregs to enact his revenge.

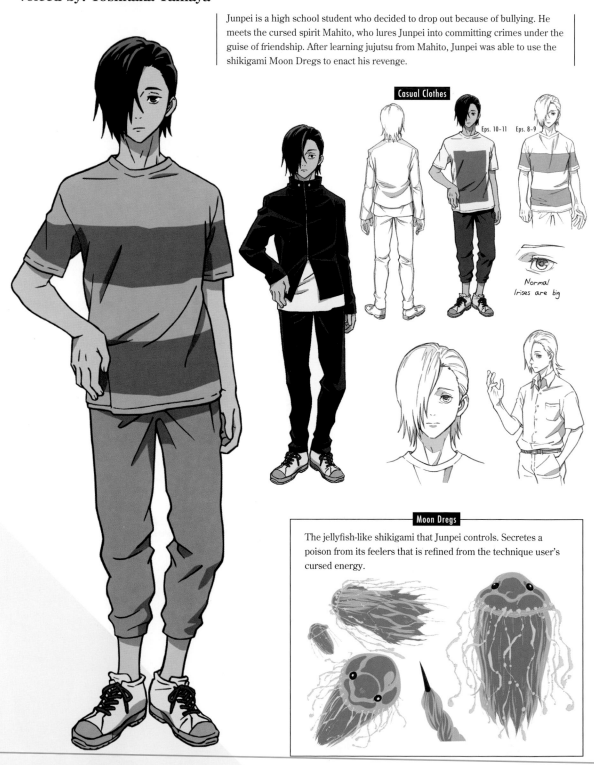

Casual Clothes

Eps. 10-11 Eps. 8-9

Normal irises are big

Moon Dregs

The jellyfish-like shikigami that Junpei controls. Secretes a poison from its feelers that is refined from the technique user's cursed energy.

Expressions

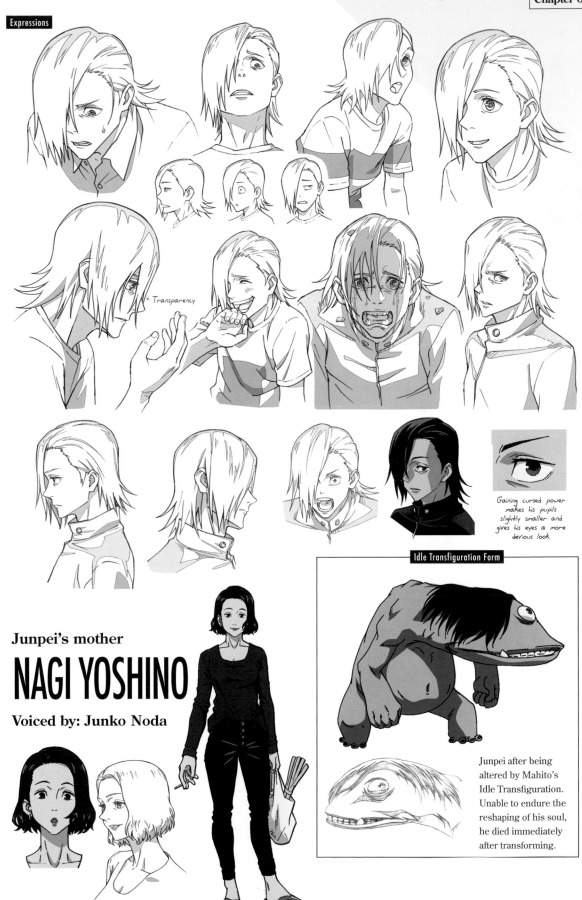

← Transparency

Gaining cursed power
makes his pupils
slightly smaller and
gives his eyes a more
devious look

Idle Transfiguration Form

Junpei after being
altered by Mahito's
Idle Transfiguration.
Unable to endure the
reshaping of his soul,
he died immediately
after transforming.

Junpei's mother

NAGI YOSHINO

Voiced by: Junko Noda

Special Grade Cursed Spirit

MAHITO

Voiced by: Nobunaga Shimazaki

Profile

Likes/Interests: Harassment, Humans
Dislikes: Humans

A cursed spirit created from the negative emotions of humans fearing other humans. Uses the cursed technique Idle Transfiguration, which allows him to touch a person's soul and freely reshape their physical body. He has only recently been birthed into existence, which may explain why he is overly interested in his abilities and naively conducts repeated experiments on human bodies.

Fully Nude

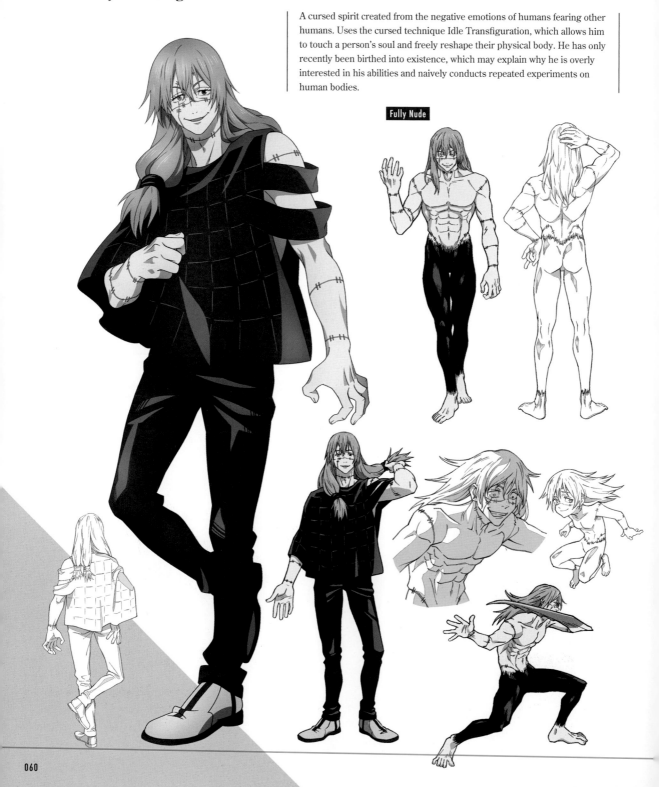

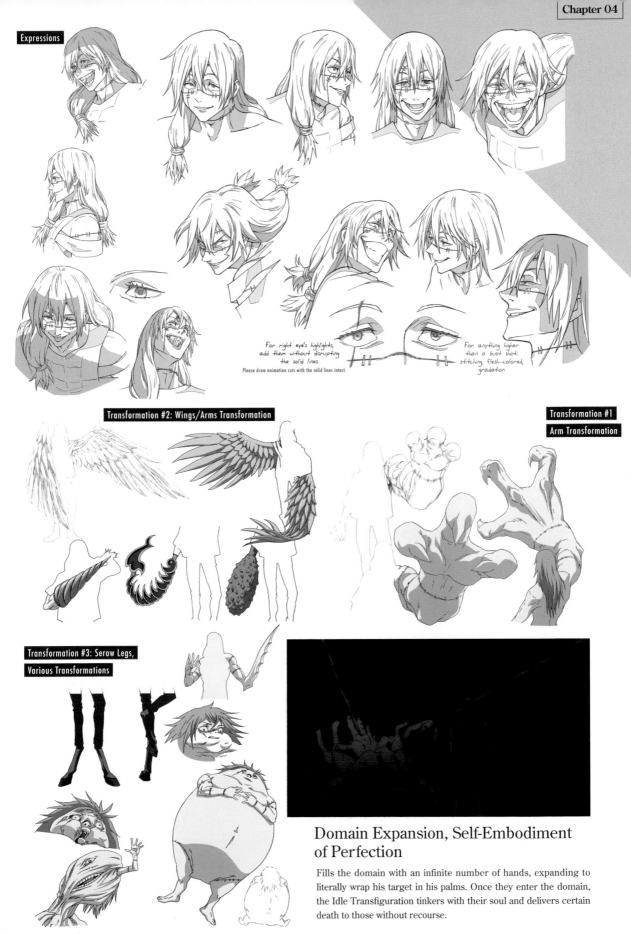

Expressions

For right eye's highlights, add them without disrupting the solid lines. Please draw animation cuts with the solid lines intact.

For anything higher than a bust shot: stitching, flesh-colored, gradation

Transformation #2: Wings/Arms Transformation

Transformation #1 Arm Transformation

Transformation #3: Serow Legs, Various Transformations

Domain Expansion, Self-Embodiment of Perfection

Fills the domain with an infinite number of hands, expanding to literally wrap his target in his palms. Once they enter the domain, the Idle Transfiguration tinkers with their soul and delivers certain death to those without recourse.

Juju Stroll

3

Gojo: "No, seriously, I have something important to talk to you about!"

Nanami: "Oh, how awful."

Gojo: "I haven't said anything yet!"

4

Gojo: "Hmmm..."

5

6

7

8

To Nanami

After Episode 9's Ending ◀◀◀

1

Gojo: **"Naaanami! Let's go out together!"**

2

Nanami: "No, I'll pass."

JUJU STROLL

After Episode 10's Ending ◀◀◀

1

Kugisaki: "Fushiguro! Have you seen my uniform jacket?"

Fushiguro: "No, I haven't." ★

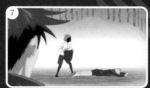

6

Inumaki: **"Fish flakes!"**

2

Kugisaki: "Oh, Panda Senpai, have you seen my uniform?"

Panda: "Hmm... I haven't seen it."

7

Kugisaki: "Geez, you're both trash."

Fushiguro: **"This image is crazy."**

3

Kugisaki: "Really? I wonder where it could have gone."

8

Kugisaki: "Huh? These are Maki's."

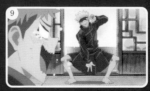

4

Kugisaki: "Hey, my skirt's not here, either. That's a line that can't be crossed."

9

Gojo: "Hello! Nobara Kugisaki here!"

Itadori: "Bwa ha ha ha ha!"

5

Inumaki: **"Mustard leaf!"**

After Episode 11's Ending ◀◀◀

1

Narration: The apartment layout is nice.

2

Narration: The three-burner stove portends death.

3

Narration: Burn it, burn Mt. Hiei to the ground! Matsutake for aroma, shimeji for flavor!

4

The tones of autumn fade away! Along with the tears of their beloved...

5

Next time on *Jujutsu Kaisen*, episode 12:
"Bloody Autumn Leaf-Viewing!"
The hunt is on for your heart...

— JUJU STROLL —

After Episode 12's Ending ◀◀◀

— JUJU STROLL —

After Episode 13's Ending ◀◀◀

1

Kugisaki: "Is it ready yet?"
Inumaki: "Salmon, salmon."

2

Maki: "These meatballs are great. Who made them?"
Fushiguro: "Oh, I did. They're easy to make."

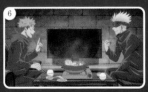

3

Ingredients:
Ground chicken
Finely chopped green onions
Ginger paste
Egg yolks (you can use the whites too, if it's too much hassle)
Salt and pepper

4

Kugisaki: "Fushiguro, you can cook for yourself, huh? Not that surprising, actually."
Fushiguro: "No, Itadori taught me how to make these."

5

Kugisaki: "I see... Itadori's... legacy..."
Maki: "I don't think that's right."

6

Itadori: **"Achoo!"**
Gojo: "These meatballs are great."
Itadori: "Yeah, and they're super easy to make."

7

Itadori: "Even Fushiguro can make them. I taught him how."

8

Itadori: "I can't wait to see those two again."

Ending Animation

Storyboard/Direction/Editing: Masatsugu Nagasoe Key Framing: Yuki Igarashi
First Part Ending Theme: LOST IN PARADISE feat. AKLO by ALI Lyrics: LEO, LUTHFI, ALEX, AKLO
Arrangement: ALI (MASTERSIX FOUNDATION)

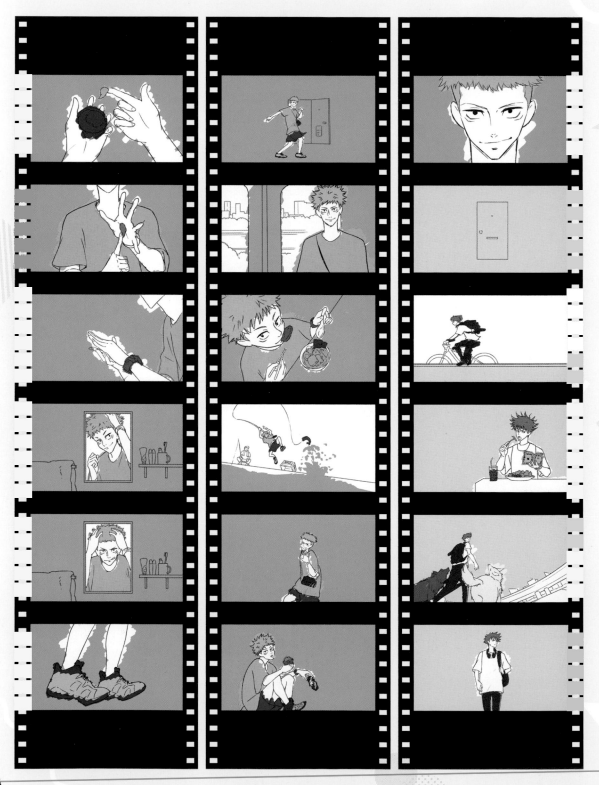

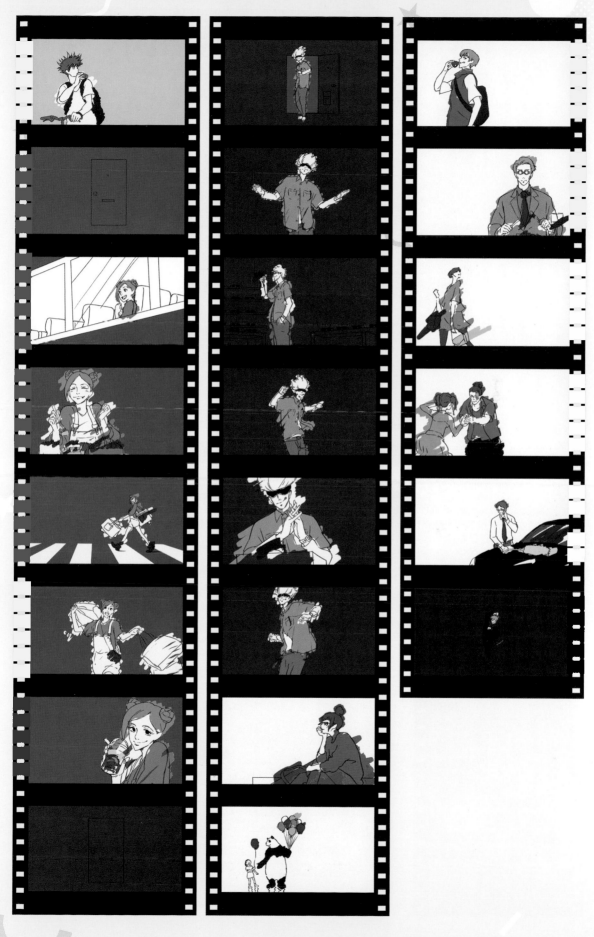

Opening Animation

Storyboard/Direction: Shingo Yamashita Chief Animation Director: Tadashi Hiramatsu Animation Director: Moaang
Second Part Opening Theme: Vivid Vice by Who-ya Extended Lyrics/Composition/Arrangement: Who-ya Extended (SME Records)

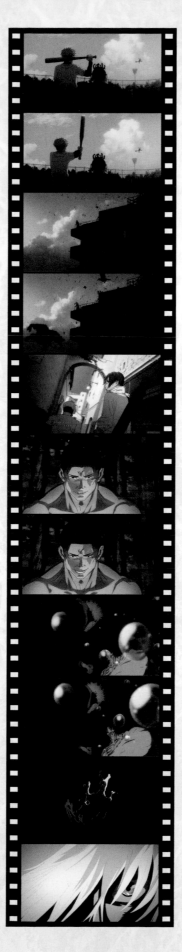
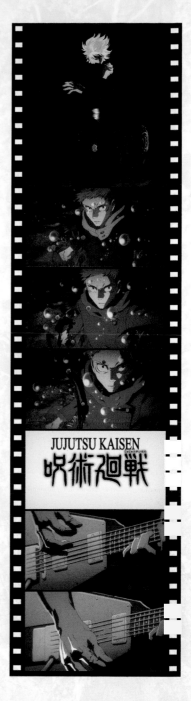

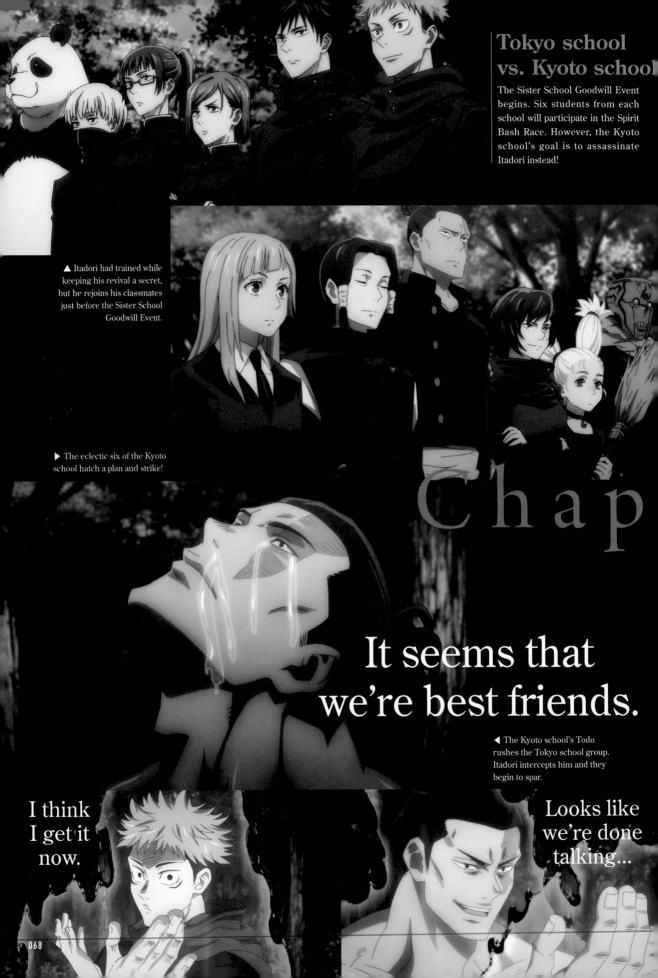

Tokyo school vs. Kyoto school

The Sister School Goodwill Event begins. Six students from each school will participate in the Spirit Bash Race. However, the Kyoto school's goal is to assassinate Itadori instead!

▲ Itadori had trained while keeping his revival a secret, but he rejoins his classmates just before the Sister School Goodwill Event.

▶ The eclectic six of the Kyoto school hatch a plan and strike!

C h a p

It seems that we're best friends.

◀ The Kyoto school's Todo rushes the Tokyo school group. Itadori intercepts him and they begin to spar.

I think I get it now.

Looks like we're done talking...

Don't you compare me to some average cursed corpse!

Damn puppet, what do *you* know?!

Women jujutsu sorcerers aren't expected to be *skilled*. They're expected to be *perfect*.

ter05

Episode 14 ~ Episode 18 Part A

I'm *Nobara Kugisaki!*

How about you call me *big sis*, *little sis?*

I want you all to myself.

Sleep

Zzz. Zzz.
Zzz. Zzz.

MOMO NISHIMIYA

Voiced by: Rie Kugimiya

Profile

Age: 18
Birthdate: July 7
Special Skill: Remixed recipes

Momo is small and cute, but has a sharp tongue when you get on her bad side. She loves and respects Mai, who has to live as a jujutsu sorcerer while dealing with constant hardships. Not only can she ride her broom to fly in the sky, she blows away her opponents with gusts of cursed energy and pelts them with dirt and gravel from the surrounding area.

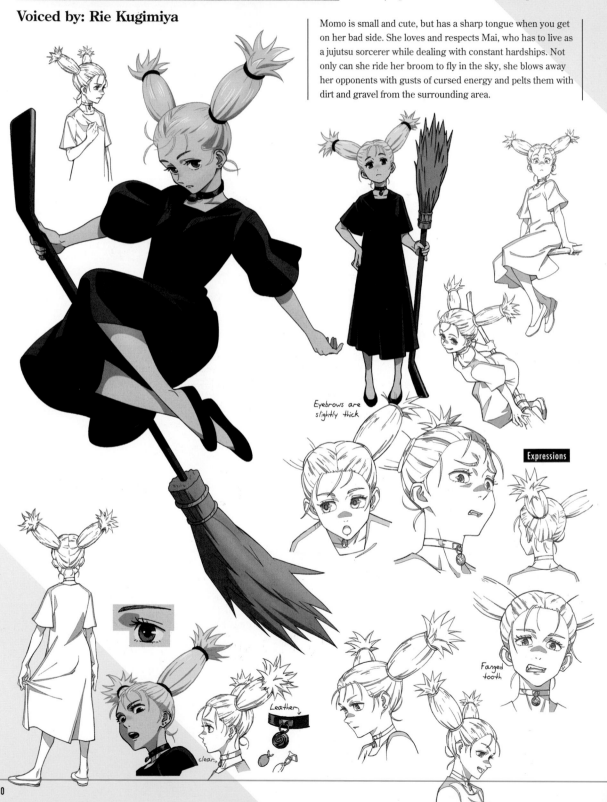

Eyebrows are slightly thick

Expressions

Fanged tooth

Leather

clear...

Kyoto Prefectural Jujutsu High School Third-Year Student

NORITOSHI KAMO

Voiced by: Satoshi Hino

Expressions

Profile

Age: 18
Birthdate: June 5
Hobbies/Special Skills: Studying
(currently trying to reach the 900s for
the TOEIC English proficiency exam)

Noritoshi is a jujutsu sorcerer belonging to the main house of the Kamo Family, one of the three major sorcerer families. He usually speaks and conducts himself in a docile manner, but he also has another side—one with a strong sense of responsibility as future leader of his clan, who is not opposed to rational thought and tough calls.

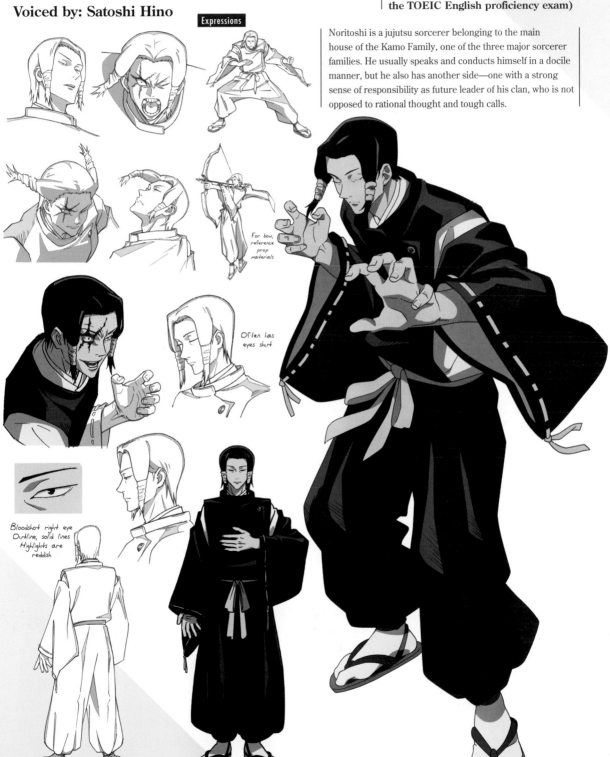

For bow, reference prop materials

Often has eyes shut

Bloodshot right eye
Outline, solid lines
Highlights are reddish

ULTIMATE MECHAMARU

Voiced by: Yoshitsugu Matsuoka

Profile

Age: 17
Birthdate: October 4
Special Skill: Group activity

Though he looks like a robot, Ultimate Mechamaru is actually a puppet controlled by a human with a huge cursed technique range and cursed energy output, thanks to the Heavenly Restriction technique. He battles by transforming his mouth and arms. His Ultra Cannon has tremendous force and can blow his opponents away.

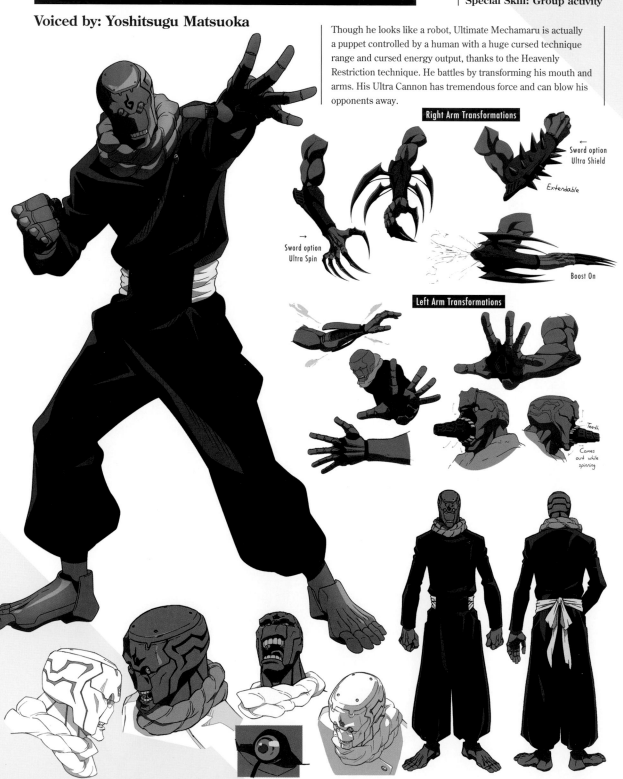

Right Arm Transformations

← Sword option
Ultra Shield

Extendable

→ Sword option
Ultra Spin

Boost On

Left Arm Transformations

Teeth

Comes out while spinning

Kyoto Prefectural Jujutsu High School Teacher

UTAHIME IORI

Voiced by: Yoko Hikasa

Profile
Age: 31
Birthdate: February 18
Hobbies/Special Skills: Karaoke,
Watching sports

Utahime is the supervisor of the Kyoto school, who seems well loved by the students. Although she helps calm her impulsive students with her mature sincerity, she is often harsh toward Gojo, her junior.

TAKADA-CHAN

Voiced by: Tomoyo Kurosawa

Takada-chan is Todo's favorite tall idol, who is 180 centimeters tall. She is quite popular, with fans coming out in droves whenever she has a meet-and-greet session or makes an appearance on a TV variety show. She sometimes appears in Todo's imagination.

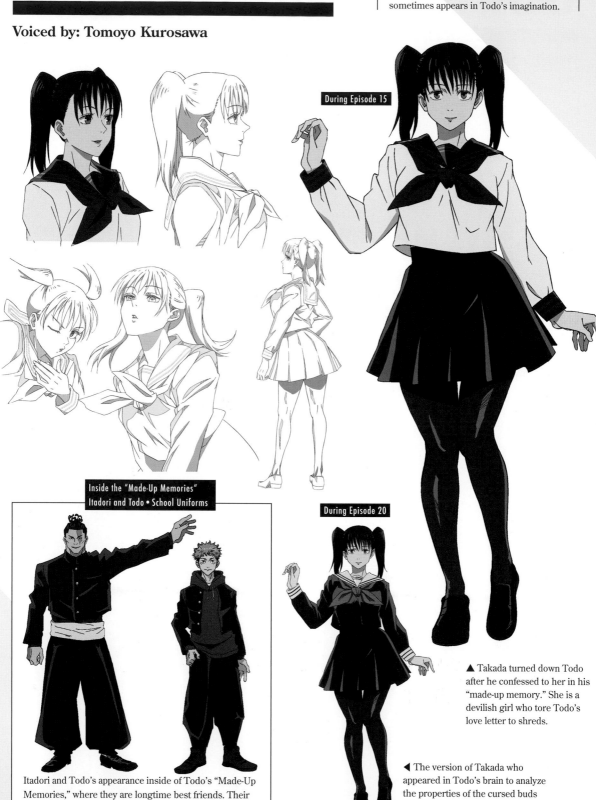

During Episode 15

Inside the "Made-Up Memories" Itadori and Todo • School Uniforms

Itadori and Todo's appearance inside of Todo's "Made-Up Memories," where they are longtime best friends. Their uniforms here differ from their actual uniforms.

During Episode 20

▲ Takada turned down Todo after he confessed to her in his "made-up memory." She is a devilish girl who tore Todo's love letter to shreds.

◀ The version of Takada who appeared in Todo's brain to analyze the properties of the cursed buds during his fight with Hanami.

MADE-UP
MEMORIES

They were undefeated best friends in their hometown. When Todo heard Itadori's preferred type of girl, fictional days of a youth that never existed flooded Todo's mind.

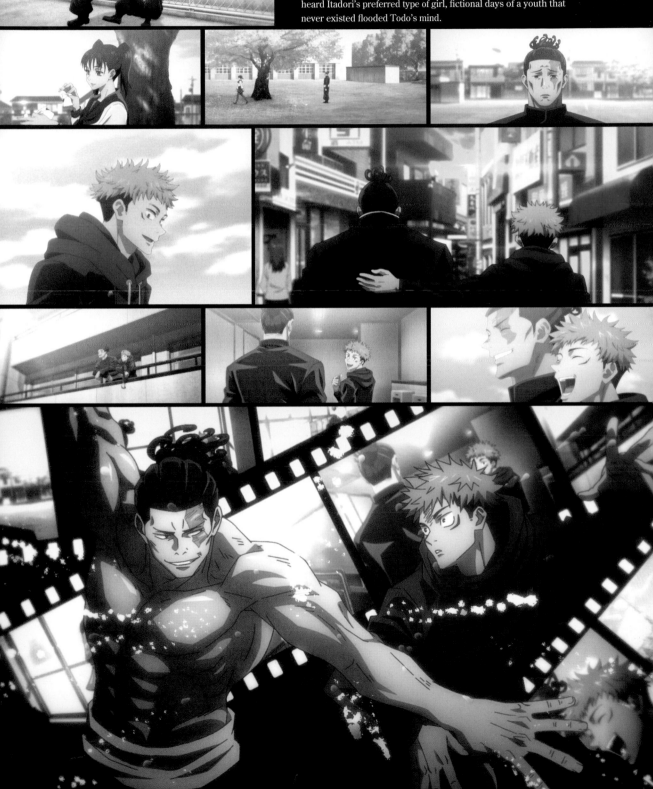

ULTIMATE MECHAMARU (MAIN BODY)

He is the controller of Ultimate Mechamaru, and was born without a right arm or legs below his knees. In exchange, he has great power, but would rather interact with his Kyoto school friends in the flesh than be powerful.

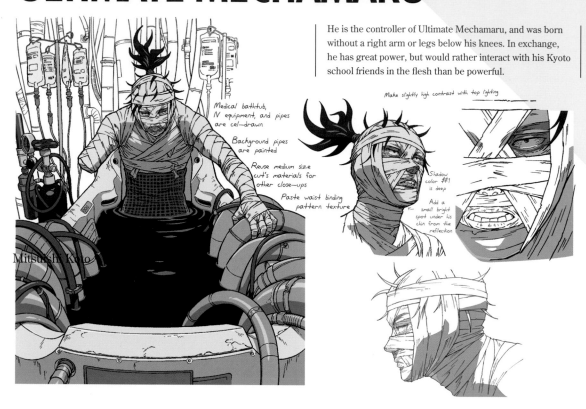

Medical bathtub, IV equipment, and pipes are cel-drawn

Background pipes are painted

Reuse medium size cut's materials for other close-ups

Paste waist binding pattern texture

Make slightly high contrast with top lighting

Shadow color #1 is deep

Add a small bright spot under his chin from the reflection

Mitsushi Kyoto

PANDA (GORILLA MODE)

Panda possesses three cores that serve as his cursed corpse's heart, and he can convert his body by swapping out his main core. When the "Gorilla core" is activated, he enters gorilla mode—a form with an emphasis on power and meant for quick, decisive combat due to its extreme cursed energy consumption.

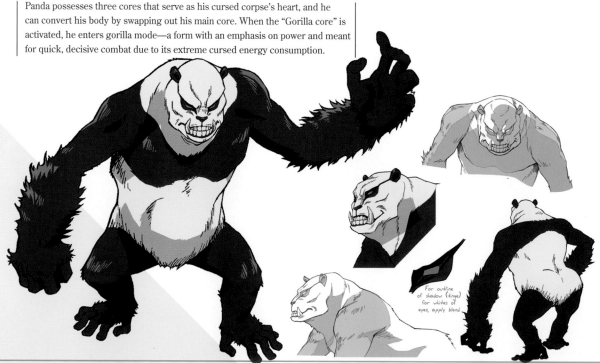

For outline of shadow (tinge) for whites of eyes, apply blend

Grade 1 Jujutsu Sorcerer

MEI MEI

Voiced by: Kotono Mitsuishi

Profile

Hobbies: Counting money

A remarkable jujutsu sorcerer who works freelance. She is an avaricious person who deems anything that can't be turned into money as worthless. For the Sister School Goodwill Event, she is in charge of borrowing the vision from crows via cursed technique and placing it on the monitors.

Tragus piercing

Special Grade 1 Jujutsu Sorcerer

NAOBITO ZEN'IN

Voiced by: Joji Nakata

Naobito is the twenty-sixth head of the Zen'in Family, one of the major sorcerer families, and uncle to Maki and Mai. He is a booze-loving old man, but his body is well trained. In the past, he scoffed at Maki's declaration that she would become head of the house, claiming he would "put her through befitting ordeals."

Profile

Hobbies: Anime

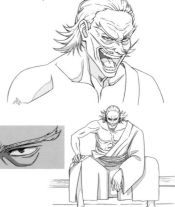

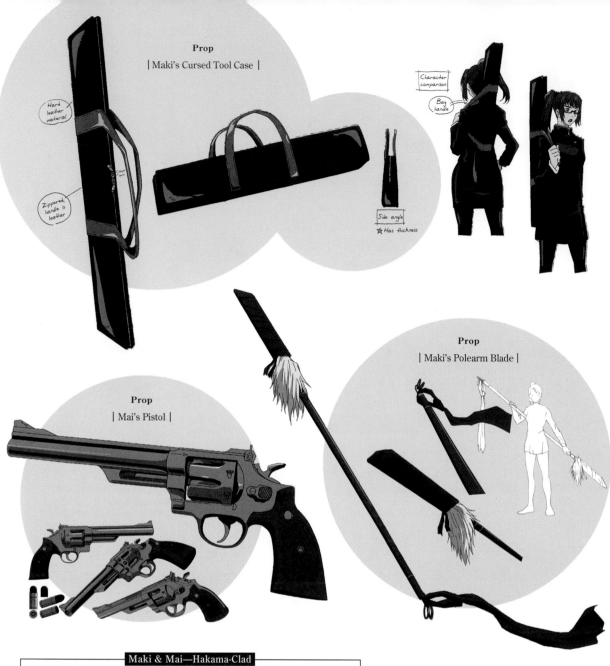

Prop
| Maki's Cursed Tool Case |

Hard leather material!

Zippered handle is leather

Clasp here

Side angle
★ Has thickness

Character comparison

Bag handle

Prop
| Mai's Pistol |

Prop
| Maki's Polearm Blade |

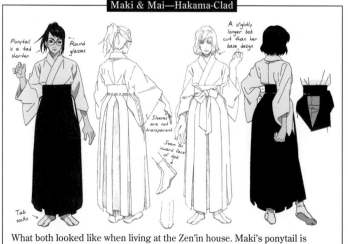

Maki & Mai—Hakama-Clad

Ponytail is a tad shorter

Round glasses

A slightly longer bob cut than her base design

Sleeves are not transparent

Seam on inward face of tabi

Tabi socks

What both looked like when living at the Zen'in house. Maki's ponytail is shorter, and Mai's hair is a bit longer. The shape of their hakama pants are the same, but their colors are different.

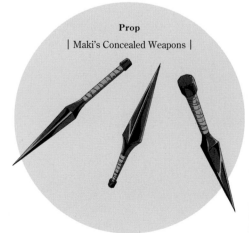

Prop
| Maki's Concealed Weapons |

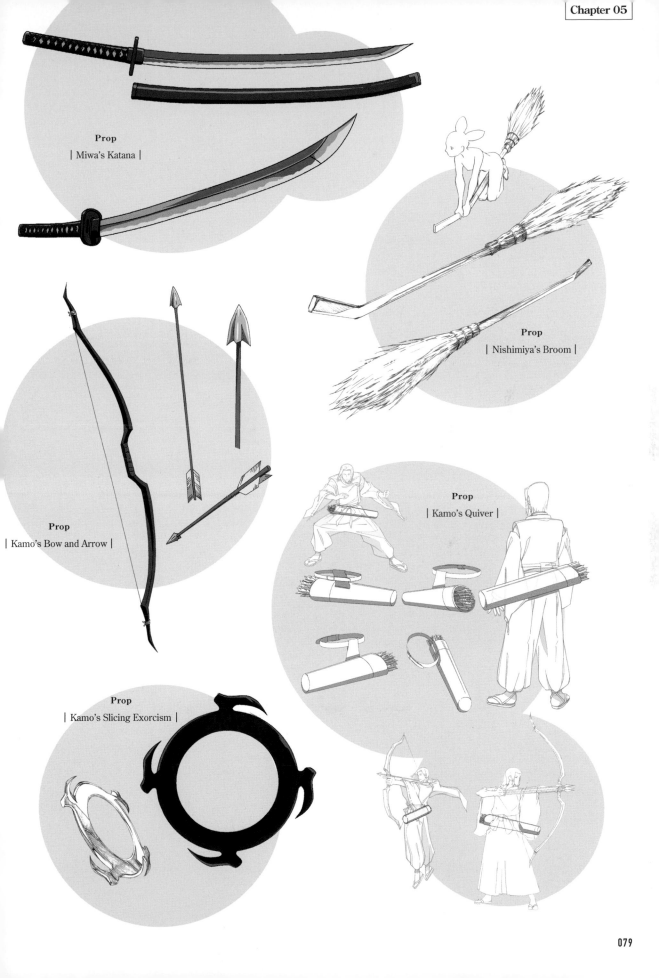

Prop

| Miwa's Katana |

Prop

| Nishimiya's Broom |

Prop

| Kamo's Bow and Arrow |

Prop

| Kamo's Quiver |

Prop

| Kamo's Slicing Exorcism |

Juju Stroll

MC: "Uh, how old are you again?"

Takada: "Say what?"

Chef: [*Awkward laugh*]

MC: "How long have you been making sushi, chef?"

Chef: "Ever since I was twenty."

Takada: "Which means...about 300 years?"

MC: "Are you drunk?"

Chef: "Here you go. One order of goatfish."

Takada: "Mmm, it's so good! Can I have yours too?"

MC: "Of course not."

After Episode 14's Ending ◀◀◀

Takada: "Hello! Today we're here at the long-standing sushi shop, Eishu." ★

Todo: "She's hammered. Attagirl, Takada." ★

MC: "What do you like, Takada?"

Takada: "Goatfish! With room-temperature sake! They're great together!"

Itadori: "Sensei, did you know 'OPP' actually stands for something?"

Gojo: "Huh? It does?"

Itadori: "Ocean Pacific Peace."

Gojo: "Really?"

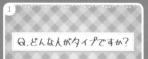

--- **JUJU STROLL** ---

After Episode 15's Ending ◀◀◀

Q: What kind of person is your type? ★

Miwa: "I like hot guys like most girls, but I want someone fun to be around, and it's important he can make you feel like he's the only one for you."

Maki: "Someone who's stronger than me, at the very least." ★

Miwa: "...! Oh, gosh, how embarrassing!" ★

Mai: "Huh? What makes you think I'll answer?"

Gojo: "Um, um, um... You know, that girl who seemed nice. With the notable bangs. Come on, that one girl."

Kugisaki: "I can't stand a UBSSD."

Useless, Broke, Smelly, Stingy, Dead Guy

Utahime: "Nice girl, nice girl, nice girl... Oh, Miwa?"

Gojo: "Yeah! Her, her, her, her!"

Nishimiya: "Do you know who Sebastian Stan is? Hee hee hee, he has a great body."

 ★

1. Mai: "Mechamaru, let Noritoshi know that Utahime Sensei's calling for him."

Nishimiya: "Mechamaru, give this to Todo!"

Miwa: "Mechamaru! Perfect timing. This is for Todo Senpai and Kamo Senpai."

2. Mechamaru: "Why do you all always go through me?"

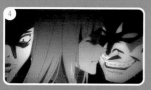

3. Mai & Nishimiya: (Because they're too much trouble, obviously.)

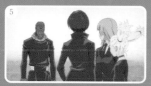

4. Miwa: (I'm still just plain scared of them...)

5. Mai, Nishimiya & Miwa: (But if I said that, I might not be able to ask him anymore...)

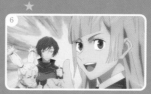

6. Miwa: "Mechamaru! We're counting on you!"

7. Mai, Nishimiya & Miwa: "Time for our missions!"

Mechamaru: "Wait, why..."

8.

9. Mechamaru: "Well, I guess it's good that they can rely on me..."

JUJU STROLL

After Episode 17's Ending ◄◄◄

1. Miwa: "I'm hungry. If I recall, the edamame beans I had left over from lunch were in the fridge..."

2. Nishimiya: "Hm?"

Mai: "Hm?"

3. Miwa: **"Huuuuuh?"**

Nishimiya: "Sorry."

Miwa: "Please look at least a little guilty!"

Nishimiya: "Here, have this and forgive me."

Miwa: "No, I'm not interested in late-night cup ramen."

4. Nishimiya: "Heh heh, how about this?! Nishimiya-style seafood cup ramen remix!"

5. Miwa: "I-it's good! This is really good!"

Nishimiya: "Right?"

Mai: "Maybe I'll try some next time, too."

6. Miwa: "You could've just eaten this if it's so good."

7. Nishimiya: "Nah, eating cup ramen late at night hits you the next day."

Mai: "Mm-hmm, mm-hmm."

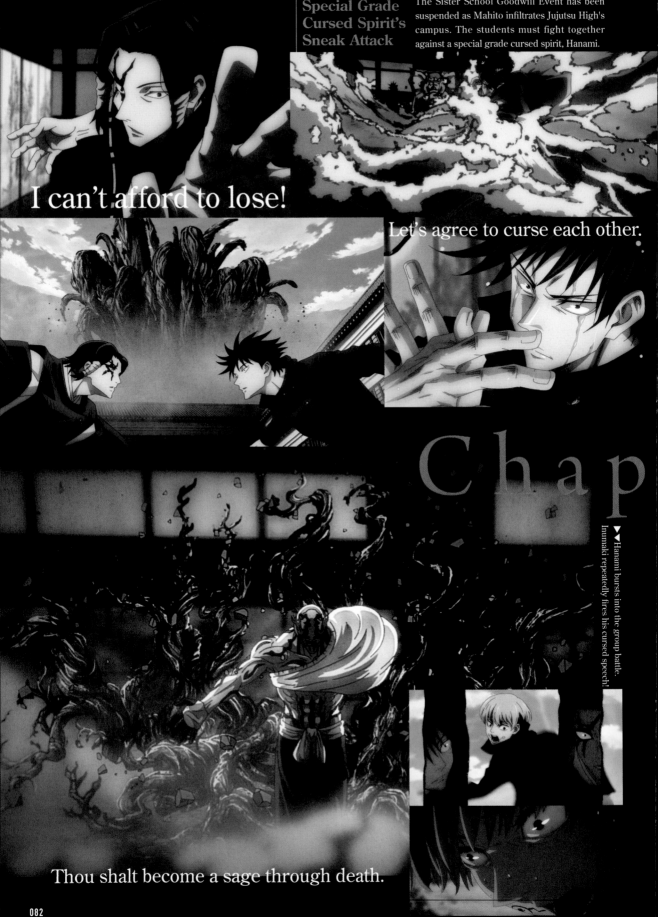

The Sister School Goodwill Event has been suspended as Mahito infiltrates Jujutsu High's campus. The students must fight together against a special grade cursed spirit, Hanami.

I can't afford to lose!

Let's agree to curse each other.

Chap

▶▼Hanami bursts into the group battle. Inumaki repeatedly fires his cursed speech!

Thou shalt become a sage through death.

Yuji Itadori's Awakening

Hanami is overwhelming Fushiguro, Inumaki, and Kamo. Maki rushes into the fray, using her special grade cursed tool, Playful Cloud, in a brilliant combination maneuver with Fushiguro. However, the cursed buds Hanami fires seriously injure Fushiguro...

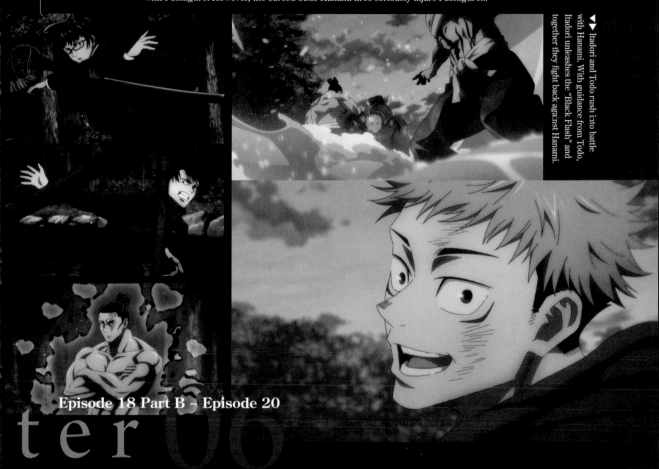

▼▶ Itadori and Todo rush into battle with Hanami. With guidance from Todo, Itadori unleashes the "Black Flash" and together they fight back against Hanami.

Episode 18 Part B ~ Episode 20

ter 06

Congratulations, brother.

You will be strong.

◀On the ropes, Hanami tries to turn the tables with his trump card, but Gojo descends from the sky and ends the battle with his technique, Hollow Purple!

Special Grade Cursed Spirit

HANAMI

Voiced by: Atsuko Tanaka

Profile

Likes/Interests: Delicious air!
Dislikes: Humans

Hanami is a cursed spirit similar to a woodland sprite, born from humans' fear and awe of the forest. Its main fighting style consists of attacking with trees and firing cursed buds to steal its target's cursed energy. It wishes to eradicate humanity because of its pure desire to protect the planet.

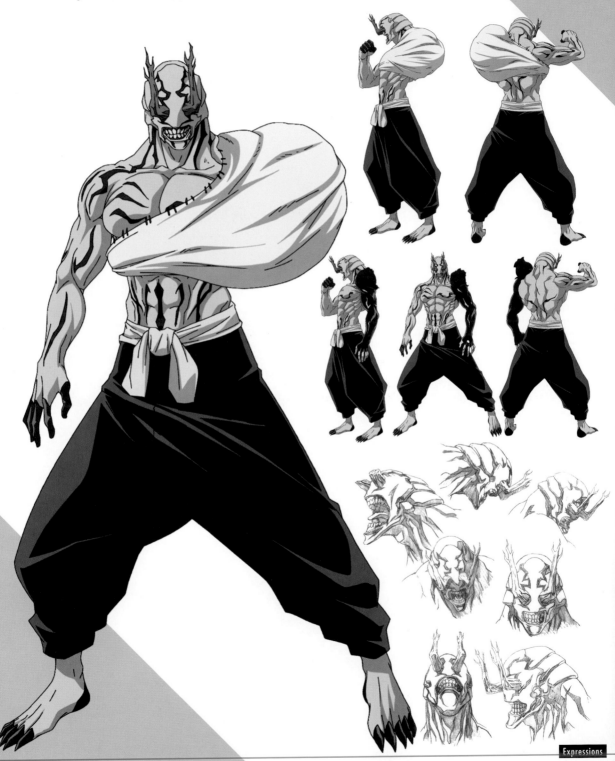

Expressions

Curse User

JUZO KUMIYA

Voiced by: Tetsu Inada

A curse user who sides with Geto and Mahito's group, Kumiya likes to create everyday goods and cursed tools out of human bodies. He made a deal that ensured he would turn Satoru Gojo into a hanger rack should he win.

Prop

| Juzo Kumiya's Axe and Spike |

Color line trace

*The marks act as a meter, so the amount of inside color fluctuates

Curse User

HARUTA SHIGEMO

Voiced by: Wataru Hatano

Haruta is a curse user allied with Geto's group. His notable features are the patterns near his eyes and his side ponytail. He wields a katana forged by Kumiya. Haruta enjoys tormenting the weak and loves to assault women in particular.

Prop

| Haruta Shigemo's Katana |

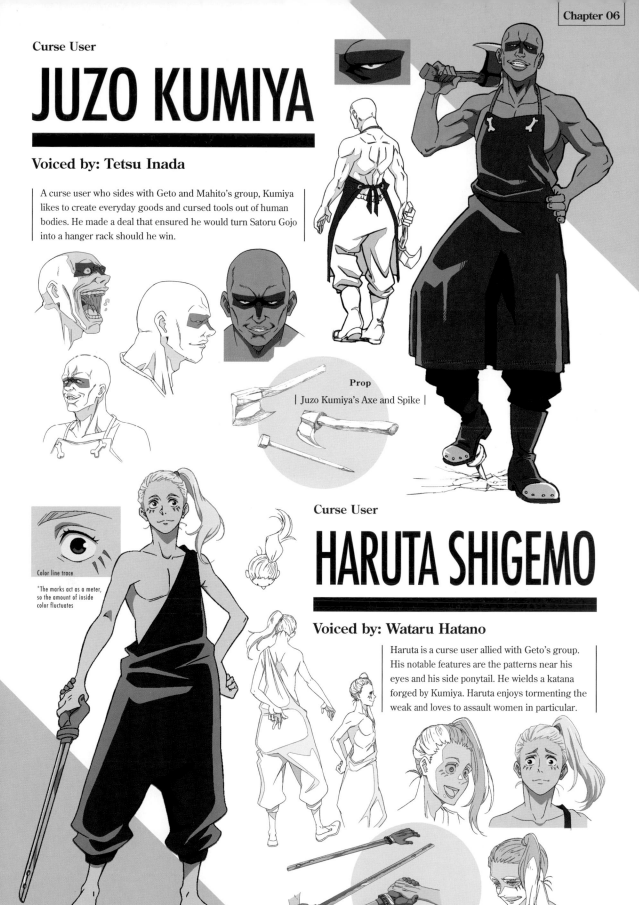

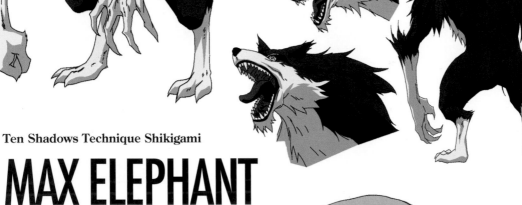

DIVINE DOG, TOTALITY

The shikigami Divine Dog Kuro takes this form after inheriting the power of Divine Dog Shiro after Shiro is destroyed in the battle against the special grade cursed spirit at the juvenile detention center. Its features became more werewolf-like and the attacks from its claws possessed enough force to inflict wounds on even a special grade cursed demon.

Ten Shadows Technique Shikigami

MAX ELEPHANT

A giant shikigami that Fushiguro has tamed. It washes away enemies by expelling a torrent of water from its trunk. Out of all of Fushiguro's shikigami, it consumes the most cursed energy, so Fushiguro can only summon it by itself.

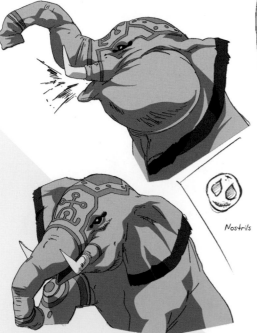

Nostrils

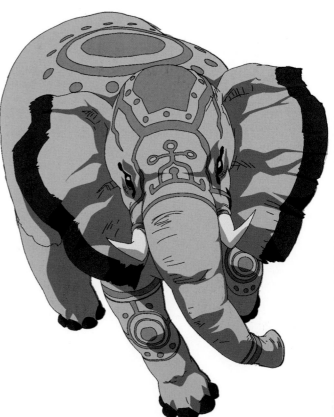

YOSHINOBU GAKUGANJI
(Battle Mode)

When it's time for battle, Gakuganji's façade as the Kyoto School's principal takes a back seat, and he becomes an offense-oriented jujutsu sorcerer, complete with a rock T-shirt and electric guitar. His body acts as an amp, releasing melodies he strums as waves of cursed energy.

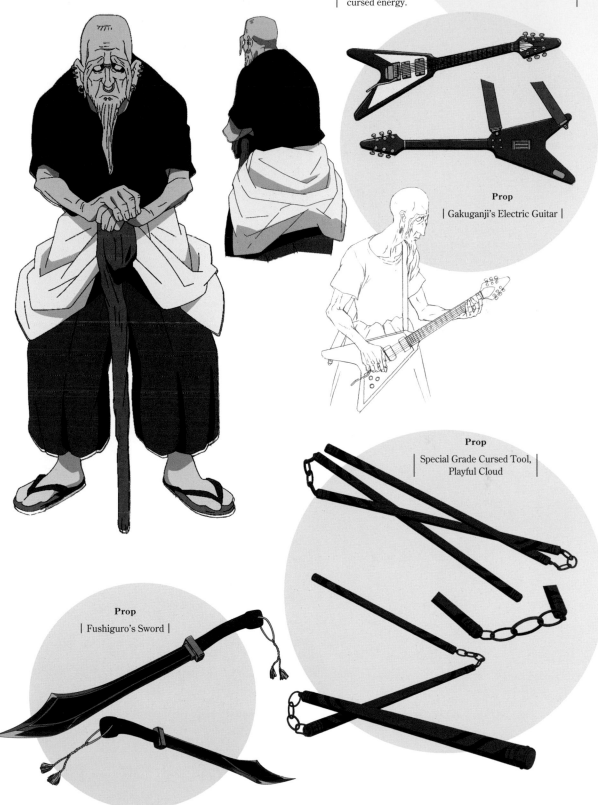

Prop

| Gakuganji's Electric Guitar |

Prop

| Special Grade Cursed Tool, Playful Cloud

Prop

| Fushiguro's Sword |

Black Flash

—Yuji Itadori

This phenomenon occurs when cursed energy clashes with a physical attack within a 0.000001-second window. Space distorts and the cursed energy turns into a flash of black light.

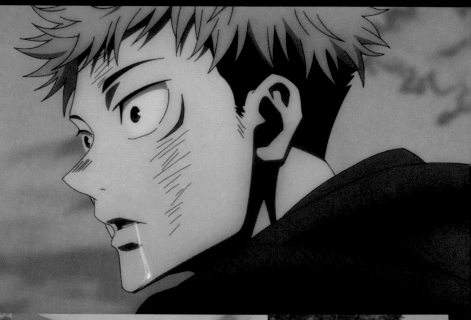

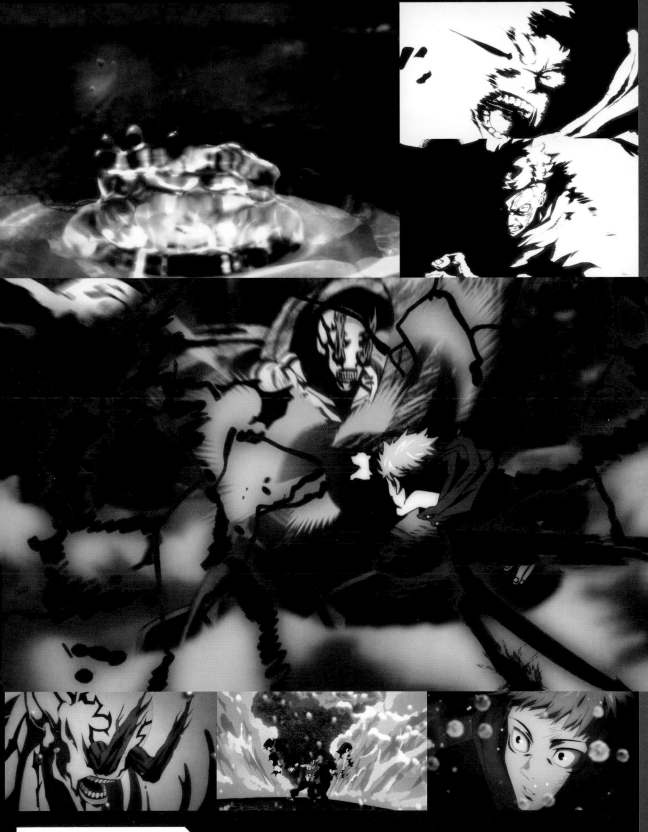

Sunghoo Park's Comment Drew the sequence straight to re-create the depiction of black light

When Itadori first performed the move in the original manga, it was explained as being "cursed energy with a black shine."
We drew the sequence straight through to re-create the depiction in the manga of "black light." We also made the visuals
sync up with the artistic touches found in the original manga as we did in the Diverging Fist scene.

Jujutsu Sorcerer

YUKI TSUKUMO

Voiced by: Noriko Hidaka

Profile

Hobbies: Motorcycles

She found Todo as a child and led him down the path of being a jujutsu sorcerer. She asked young Todo, "What type of girl do you like?"

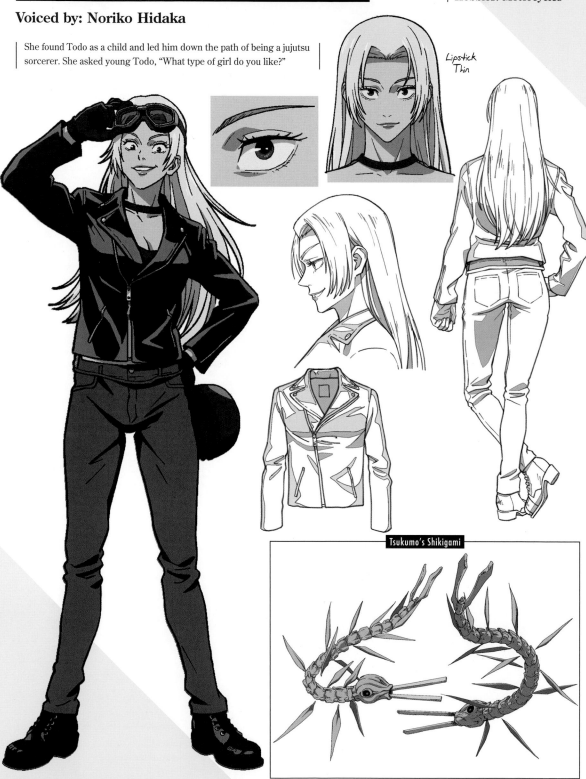

Lipstick Thin

Tsukumo's Shikigami

AOI TODO
(Young)

Todo as a third grader in elementary school. He was heavily influenced by Tsukumo and inherited his habit of asking about their taste in girls during battle from her.

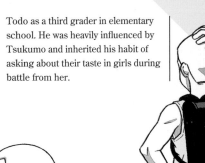

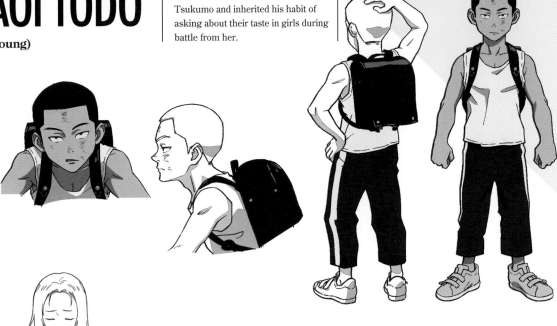

Crease in shoulder tuck

NORITOSHI KAMO
(Child)

Kamo during his younger days was scorned for being the son of a mistress. Since the eldest son of the Kamo Family did not inherit the family's cursed technique, Kamo was ushered into the main family as its next leader.

Eyes are about this big even when opened

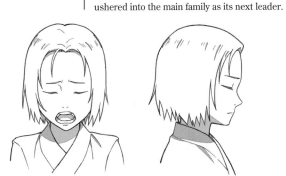

Paste in pattern

Prop
| Inumaki's Throat Medicine |

Bottle: Lozenge

Hollow Purple
—Satoru Gojo

Letting his limitless cursed techniques lapse, Satoru clashes his negative energy–enhancing Blue cursed technique with his positive energy–producing Red reverse cursed technique, which is then forced out as a massive ray of imaginary mass.

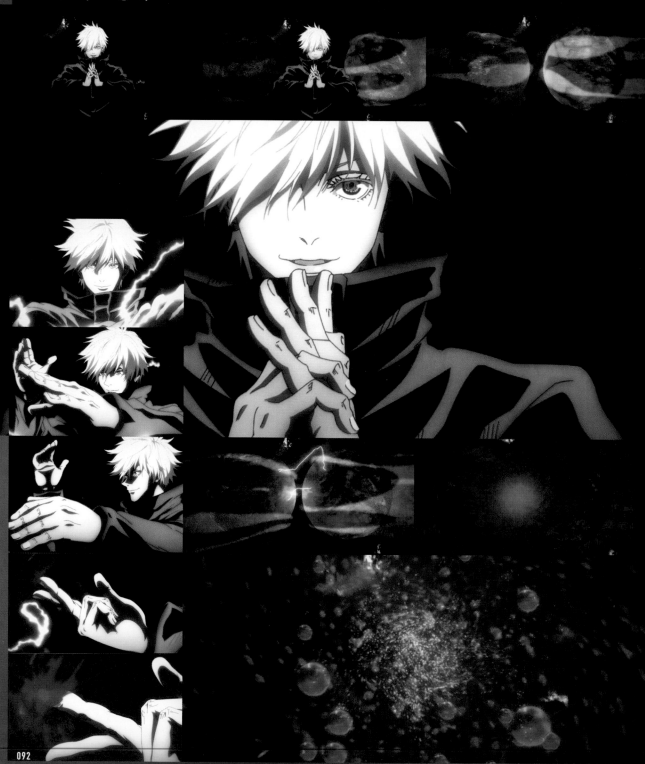

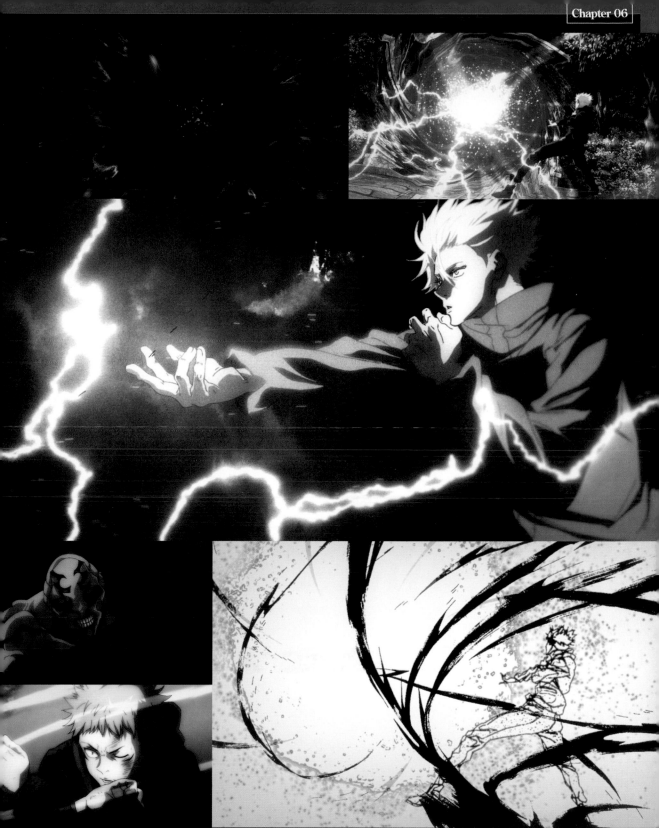

Sunghoo Park's Comment — Akutami Sensei and the anime production staff's ideas combine

In the original manga, once Red and Blue overlapped, Hollow Purple was already being fired in the next scene, so we racked our brains over how to express that in animation. The anime production side had the idea of Red and Blue mixing in water to make Purple. We consulted Akutami Sensei, who told us that they had the idea of Red and Blue clashing, and from there, we combined both visuals. Akutami Sensei and the anime production staff's ideas became one and allowed us to create Hollow Purple's depiction.

Plot of the Cursed Spirits

The diversion created by the cursed spirits' and curse users' raid allowed Mahito to infiltrate Jujutsu High's cursed storehouse. The Goodwill Event is almost canceled but Gojo suggests an unexpected way to resume the event.

▶▼ Geto schemed to obtain two types of objects: Sukuna's fingers and the Death Painting Wombs.

Chap

We're not doing the individual portion this year.

▶▲The rules state the second day of the event is for individual battles. However, Gojo shoots down the plans, and the second day's contest is decided via lottery.

The second contest was...baseball. Two unorthodox teams of six (however, since Mechamaru was destroyed, a sub took his place) chase after the gilded white ball and fly all over the field. Jujutsu Koshien, play ball!

Jujutsu Koshien

Right now, we're playing baseball

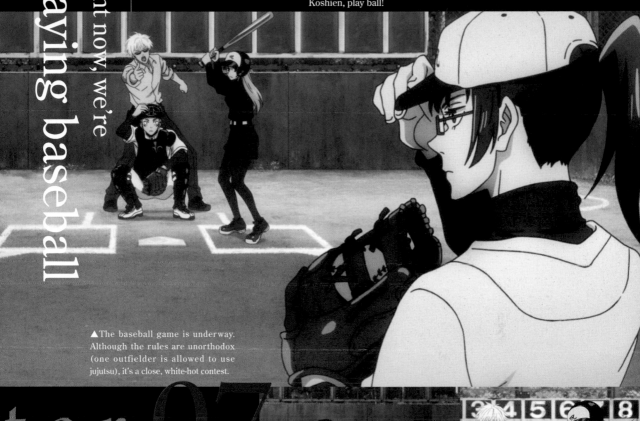

▲The baseball game is underway. Although the rules are unorthodox (one outfielder is allowed to use jujutsu), it's a close, white-hot contest.

ter07

Episode 21

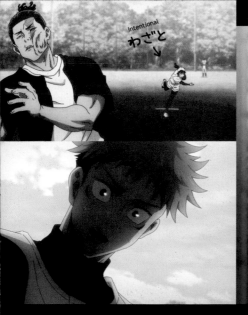

Intentional
わざと
↓

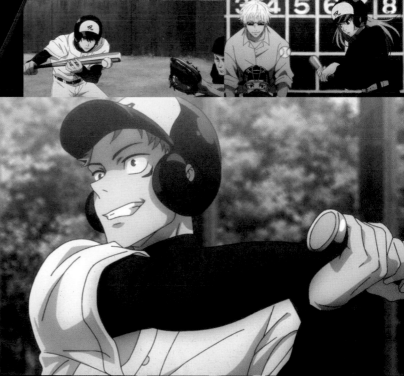

◀▲ Through their struggles during the 30th Annual Goodwill Event, the schools have come closer together. The Tokyo School wins the game 2–0.

Todo... You... are seriously hated...

Tokyo Jujutsu High School

The small intro blurbs were written personally by Akutami Sensei.

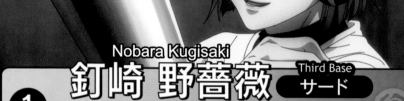

Nobara Kugisaki

釘崎 野薔薇

Third Base
サード

1

クレカの審査待ち。高専生にはハードルが高いか。
Awaiting approval for a credit card. Too hard for a high schooler, maybe?

Megumi Fushiguro

伏黒 恵

Outfielder
外野手

2

チキン南蛮は胸肉派。親子丼はもも肉派。
Prefers breast meat in chicken nanban and thigh meat in oyakodon.

TEAM		TOKYO
1	5	Kugisaki
2	789	Fushiguro
3	3	Panda
4	1	Zen'in
5	4	Inumaki
6	2	Itadori

Panda

パンダ

First Base
ファースト

3

いつかシマウマを殴ろうと思っている。
Wants to punch a zebra someday.

Player Lineup

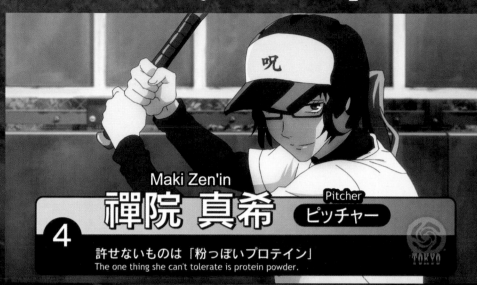

Maki Zen'in

禪院 真希

4

Pitcher
ピッチャー

許せないものは「粉っぽいプロテイン」
The one thing she can't tolerate is protein powder.

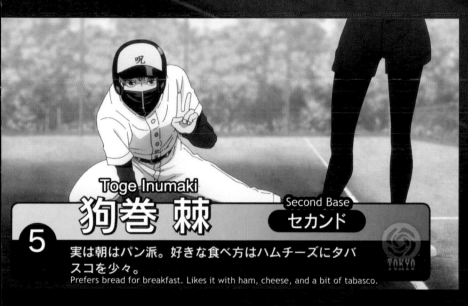

Toge Inumaki

狗巻 棘

5

Second Base
セカンド

実は朝はパン派。好きな食べ方はハムチーズにタバスコを少々。
Prefers bread for breakfast. Likes it with ham, cheese, and a bit of tabasco.

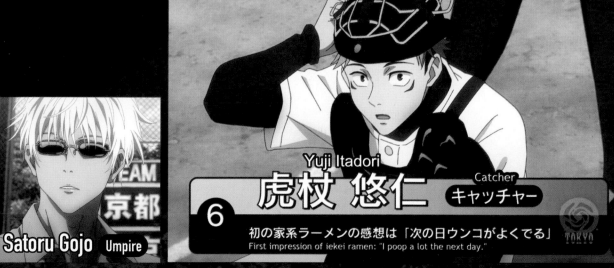

Satoru Gojo　Umpire

Yuji Itadori

虎杖 悠仁

6

Catcher
キャッチャー

初の家系ラーメンの感想は「次の日ウンコがよくでる」
First impression of iekei ramen: "I poop a lot the next day."

JUJUTSU KOSHIEN: TOKYO SCHOOL DESIGN MATERIALS

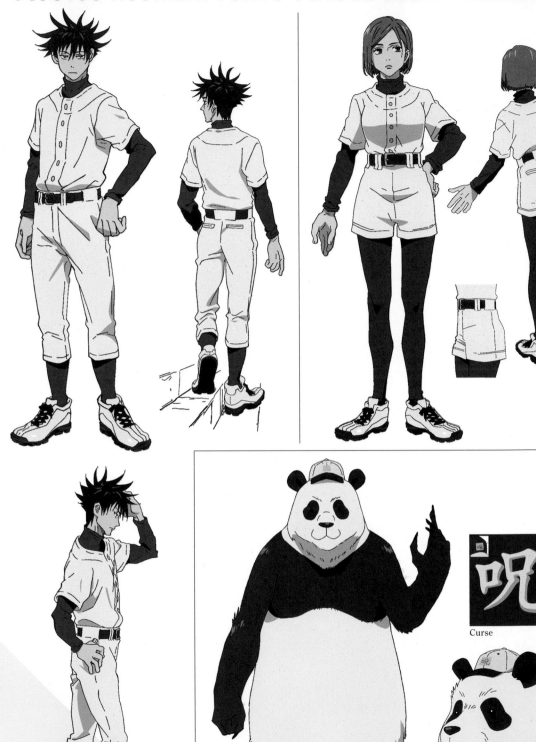

Curse

Same shoes

Kyoto Prefectural Jujutsu High School Player Lineup

Utahime Iori Coact

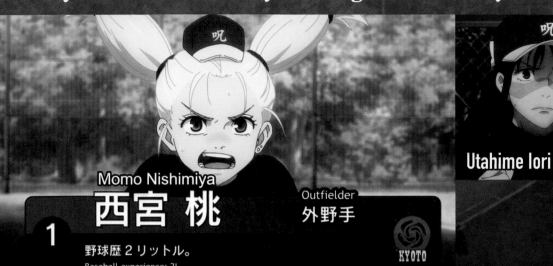

Momo Nishimiya

西宮 桃

Outfielder
外野手

1

野球歴2リットル。
Baseball experience: 2L.

KYOTO

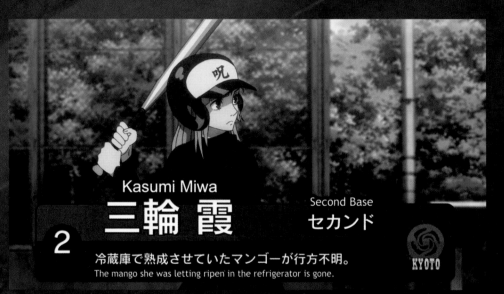

Kasumi Miwa

三輪 霞

Second Base
セカンド

2

冷蔵庫で熟成させていたマンゴーが行方不明。
The mango she was letting ripen in the refrigerator is gone.

KYOTO

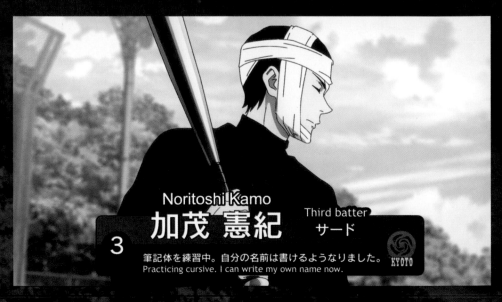

Noritoshi Kamo

加茂 憲紀

Third batter
サード

3

筆記体を練習中。自分の名前は書けるようなりました。
Practicing cursive. I can write my own name now.

KYOTO

Sister School 30th Annual Goodwill Event 2nd Day Baseball Game

TEAM KYOTO

1 789 Nishimiya
2 4 Miwa
3 5 Kamo
4 2 Todo
5 3 Zen'in
1 Ultimate

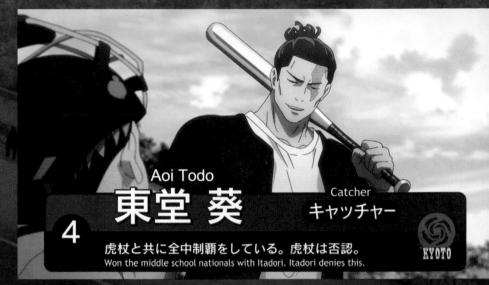

Aoi Todo

4 東堂 葵　Catcher キャッチャー

虎杖と共に全中制覇をしている。虎杖は否認。
Won the middle school nationals with Itadori. Itadori denies this.

KYOTO

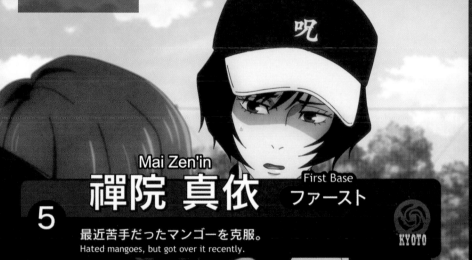

Mai Zen'in

5 禪院 真依　First Base ファースト

最近苦手だったマンゴーを克服。
Hated mangoes, but got over it recently.

KYOTO

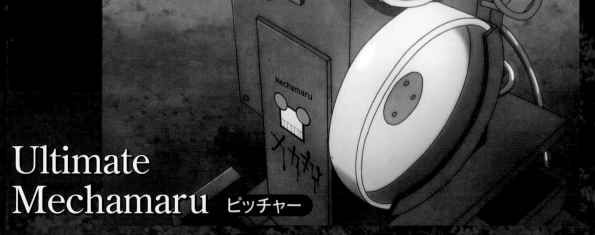

Ultimate Mechamaru ピッチャー

Jujutsu Koshien: Kyoto School Design Materials

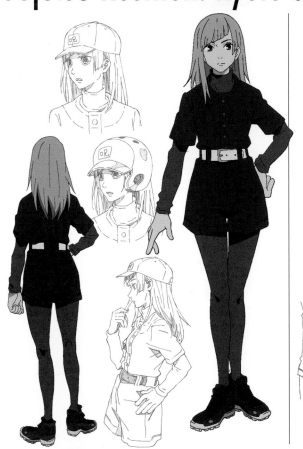

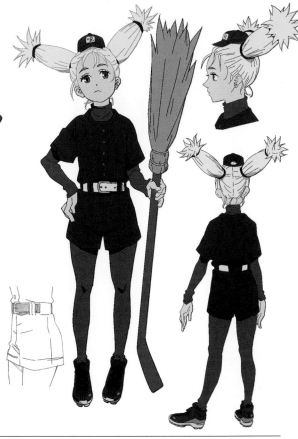

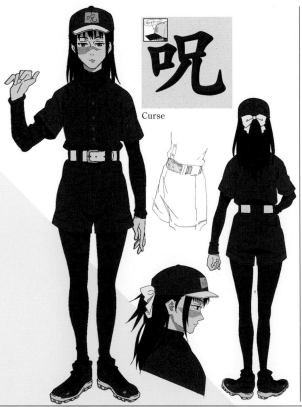

呪

Curse

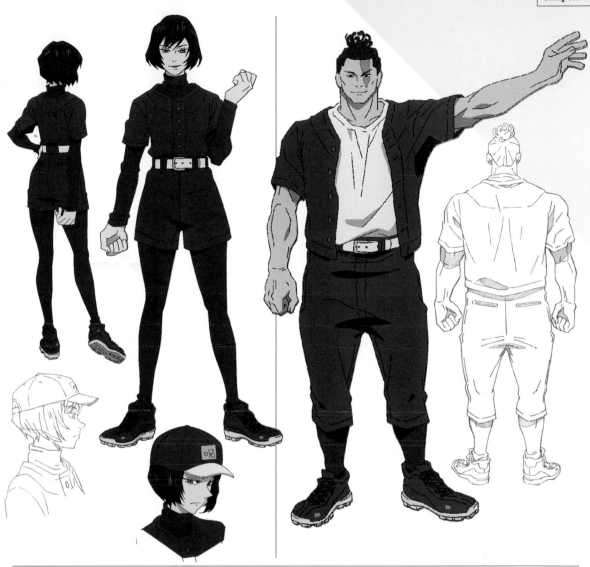

Juju Stroll

After Episode 18's Ending ◄◄◄

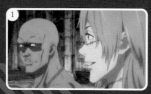

Mahito: "Hey, Jogo."

Mahito: "You burned up Hanami's flower bed again, didn't you? Hanami is crying."

Jogo: "Hmph."

Mahito: "Hanami, let's strangle Jogo. My boyfriend's Senpai is totally one of those."

Hanami: "No, that's too far..."

Hanami: "Aah..."

Hanami: "Gasp!"

Hanami: "T-this is a slash-and-burn farm! The soil didn't have enough nutrients before?"

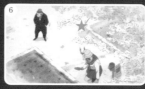

Hanami: "Gasp!"

Jogo: "Hmph."

Hanami: **"Throb..."**

JUJU STROLL

After Episode 19's Ending ◄◄◄

Kumiya: "Hanger rack! ♪ Going to make a great hanger rack! ♪"

Mahito: "Hey, what kind of hanger rack would Satoru Gojo be?"

Kumiya: **"Probably a pole hanger rack."**

Kumiya: "I'd use his hip bone with the sacral bone and coccyx as the base for the stand. Then rework his femurs and use them to stabilize it."

Kumiya: "I'd use his spine's lumbar vertebrae, thoracic vertebrae, and up to the third cervical vertebrae. For more height... let's see... Ancient camphor wood would be good. I could alternate ancient camphor with the bones to accentuate the height."

Kumiya: "Then I'd extend the spinous process and transverse process based on the overall balance to create the actual rack. I'd do that by grafting on more ancient camphor. Depending on the coloring, it could be good to cover the skull with tanned hide."

Kumiya: "Nice! Very nice! I'll be able to make a great coat rack! ♪"

Mahito: **"No one needs that!"**

Q: Dogs or Cats?

After Episode 20's Ending ◀◀◀

Itadori: "Dogs? No, maybe cats? Wait, maybe dog if it's a big dog!"

Fushiguro: "Dogs."

Maki: "Dogs, I think?"
Kugisaki: "What? I definitely prefer cats."

Inumaki: "Salmon."

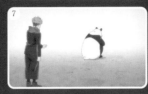

Panda: **"The answer's obviously pandas! You want me to kill you?! Huh?!"**

Panda: "Everyone hates me...don't they?"
Itadori: "No, it's just that there were only two choices..."

Maki: "Leave him be."

JUJU STROLL

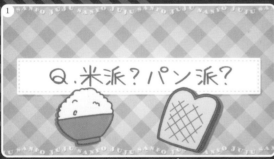

Q: Rice or Bread?

Itadori: "Rice? No, I like bread too. Wait, is it served with roe?"

Fushiguro: "Rice."

Maki: "Rice, I think?"
Kugisaki: "What? I definitely prefer bread."

Inumaki: "Salted rice ball."

Panda: **"The answer's obviously bread cuz I'm a panda! You want me to kill you?! Huh?!"**

Panda: "This one is... kind of forced."
Itadori: "They're out of ideas."

Maki: "We're leaving."

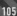

People who were once enrolled in Fushiguro's junior high are dying. Itadori and the others discover they all visited a local paranormal hot spot back in their junior high days—the bottom of the Yasohachi Bridge.

But you can at least depend on us. We're your friends.

◀▲ After learning his older sister Tsumiki once visited the bridge, Fushiguro goes to investigate solo. Itadori and Kugisaki offer their help, and the three face off against the cursed spirit living underneath the bridge.

Chap

◀▼ Fushiguro struggles against the cursed spirit's sudden advances. However, he remembers what Gojo told him and starts to break from his shell.

Picture it in your head.
Freely!

Accomplices

Death Painting Wombs Eso and Kechizu attack. Itadori and Kugisaki battle with their improved powers but realize they are fighting humans. With no means to capture them, they steel their resolve to kill them.

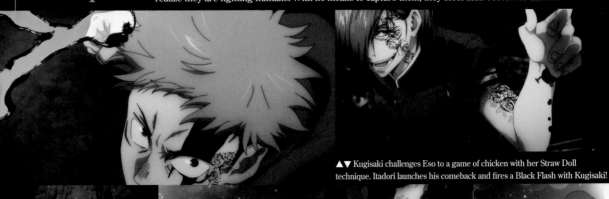

▲▼ Kugisaki challenges Eso to a game of chicken with her Straw Doll technique. Itadori launches his comeback and fires a Black Flash with Kugisaki!

Episode 22 ~ Episode 24

ter08

Don't tell Itadori about the fingers resonating.

Because of you...

...people will die!

I won't. Don't underestimate a lady's consideration.

Don't tell Fushiguro that.

▶▲ Itadori consuming Sukuna's fingers has started to awaken the souls of Sukuna in a "resonance"... While all three know this fact, they keep it a secret from each other and keep moving forward.

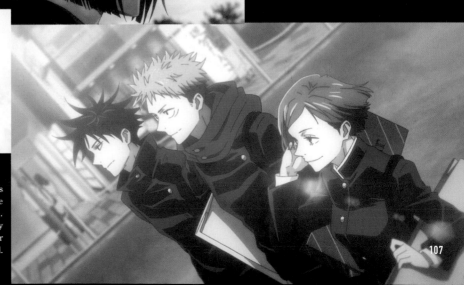

TSUMIKI FUSHIGURO

Voiced by: Saori Hayami

Tsumiki is Megumi's older stepsister. When she was a second grader in elementary school, Tsumiki's mother and Megumi's father married and disappeared without a trace. She lived with Megumi, but was afflicted by a mysterious curse. She has been in a coma ever since. She was, as Megumi describes it, a "prototypically good person."

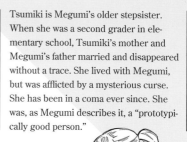

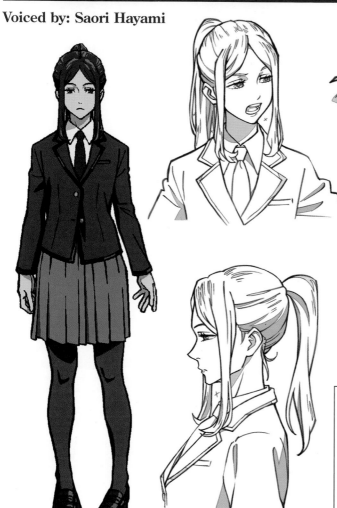

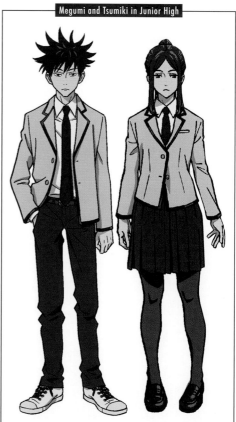

Megumi and Tsumiki in Junior High

Elementary School

First grader

Second grader

backpacks

AKARI NITTA

Tokyo Prefectural Jujutsu High School Auxiliary Director

Voiced by: Sora Tokui

Akira is the auxiliary director of Jujutsu High and is Ijichi's subordinate. She supported Itadori, Fushiguro, and Kugisaki when they went on their mission to slay the cursed spirit of Yasohachi Bridge.

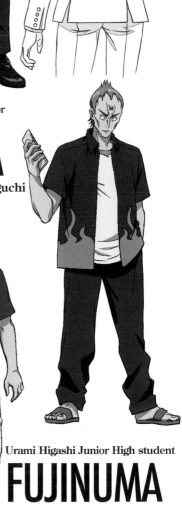

Might be good to bring eyelashes to the front in angles that aren't front on

FUJINUMA

Former Urami East Junior High Student

(Older Sister)
Voiced by: Arisa Sakuraba

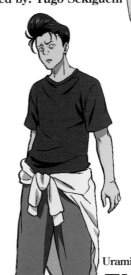

KANADA

Former Urami East Junior High Student

Voiced by: Yugo Sekiguchi

TAKEDA

Urami East Junior High Faculty Member

Voiced by: Shigeru Ushiyama

FUJINUMA

Urami Higashi Junior High student

(Younger Brother)
Voiced by: Shuhei Matsuda

CHOSO

Voiced by: Daisuke Namikawa

The first of the special grade cursed object Death Painting Womb's incarnations. Has a strong bond with his brethren—Eso and Kechizu. Along with his brothers, he assists Geto and Mahito.

Death Painting Womb #2

ESO

Voiced by: Nobuyuki Hiyama

The middle brother, younger than Choso and older than Kechizu. Although clad in a very revealing outfit, it's due to the face on his back. Utilizes Supreme Rot technique, a skill that corrodes anything that touches his blood, to drive his enemies to the edge.

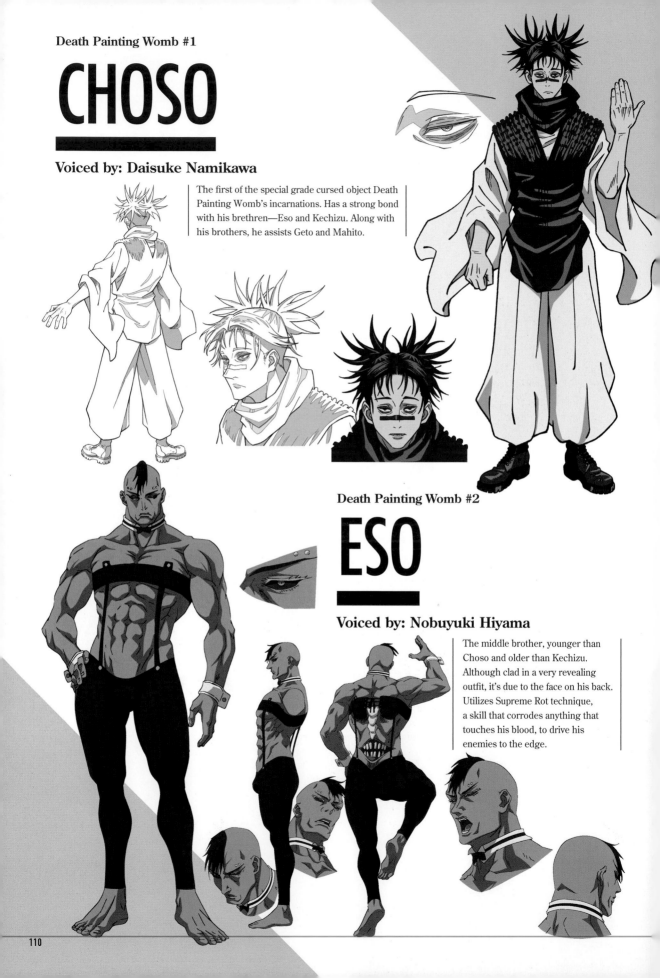

Death Painting Womb #3

KECHIZU

Voiced by: Kappei Yamaguchi

The youngest out of the three brothers. Follows Choso and Eso and calls them "Big Bro." Dismantles things that touch his blood with the same Supreme Rot technique Eso possesses, but unlike Eso, his blood isn't highly lethal.

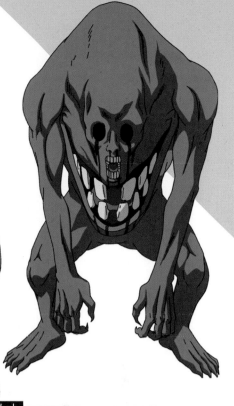

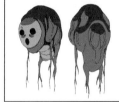 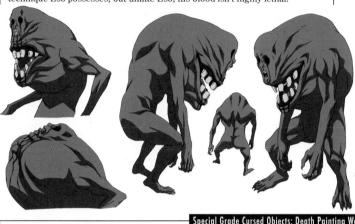 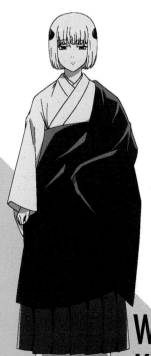

Special Grade Cursed Objects: Death Painting Wombs

◀ A girl with a special genetic makeup had nine pregnancies and nine abortions. The fetuses were made into cursed objects after their deaths.

CURSED SPIRIT OF YASOHACHI BRIDGE

The bridge is a paranormal hot spot known among the junior high students. It indiscriminately started cursing visitors in the past due to the influence of one of Sukuna's fingers, which helped unleash its cursed energy.

WHITE-HAIRED KIMONO-WEARING CHILD

Domain Expansion,

—— Megumi Fushiguro

The domain expansion Fushiguro attained, though in an incomplete state. It creates a bog of shadows over the area, allowing Fushiguro free control of his Ten Shadows technique—instantly manifesting shikigami and summoning clones.

Chimera Shadow Garden

Sunghoo Park's Comment | How to depict an "incomplete" domain expansion

Since this was Fushiguro's first domain expansion and it's not fully developed, we pondered how we could depict an "incomplete" domain expansion. The answer was that we would limit the color palette. We thought three colors would be too many and only used two—black and red. We focused on showing Fushiguro snapping and unlocking a new state by having him run amok in that contained space.

Juju Stroll

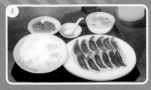

Woman: "Sorry for the wait! Here's our pride and joy, the gyoza meal, passed down for generations."

Itadori, Kugisaki, & Fushiguro: "Thank you for the meal!"

After Episode 22's Ending ◄◄◄

Woman: "Eek!"

Itadori: "Oh?"

Woman: "Help! It's a purse snatcher!"

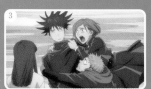

Fushiguro: "You two, what do you think of gyoza with no meat flavor that's basically just cabbage and thickener?"

Woman: "I run a Chinese restaurant... Allow me to treat you as a thanks."

Kugisaki: "We couldn't!"

Itadori: "Are you sure?! Thank you so much! I'll gladly eat!"

Kugisaki: **"I'm glad you said something, Fushiguro!"**

Itadori: **"She was a nice woman, too! She was such a nice woman, but still!"**

Woman: "This restaurant has lasted four generations. That was supposed to end with my father, but I insisted and kept it running. I wanted to keep this restaurant, this flavor, around..."

Kugisaki & Itadori: "What a nice story..."

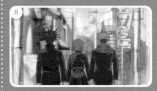

Itadori: "But apparently, gyoza is meant to be a vegetable dish, not a meat dish."

Fushiguro & Kugisaki: "Really?"

JUJU STROLL

After Episode 23's Ending ◄◄◄

Kugisaki & Gojo: "Aah... aah...."

Itadori: "Sensei! Kugisaki!"

Kugisaki: "So annoying. It's too hot for your craziness."

Itadori: "Fushiguro's getting hit on!"

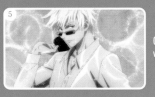

Gojo: "Megumi has violin practice with me now!"

Gojo: **"Formation B!"**

Kugisaki & Itadori: **"Roger!"**

Gojo: "Let's go home, Megumi. Today I'll have you master 'Twinkle Twinkle Little Star.'"

Kugisaki & Itadori: **"Oh, Fushigurooo!"**

Kugisaki: "Who is that woman?! Have you forgotten the night you gave a toast to my eyes?!"

Itadori: "Was it all a lie when you said your time with me was the most enjoyable of all?!"

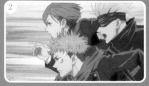

Fushiguro: "It's fine. Don't mind them. Just go ahead. The station is straight ahead."

Woman: "Thank you very much!"

Kugisaki, Itadori, & Gojo: "Hmm?"

Fushiguro: "Okay, seriously, what is this? Could you stop? You're embarrassing me."

Gojo: **"Could you not touch him so casually, please, you homewreckers?!"**

Gojo: "Mmmm..."

Fushiguro: "Explain!"

Itadori: **"Aha ha ha... Yowch!"**

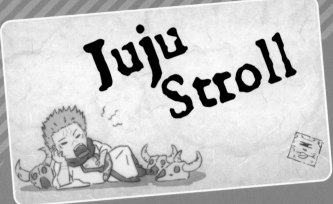

| Storyboarder/Director |

Yui Umemoto Interview

─ JUJU STROLL ─

The production of Juju Stroll was headed by Yui Umemoto, the assistant director for the main series. With all 21 shorts finished, we asked Assistant Director Umemoto for some anecdotes and insider stories with the production staff.

We were adamant about not making Juju Stroll a simple "omake."

Question: Akutami Sensei came up with the original idea and drew up the storyboards for Juju Stroll, but were there any points that differed from normal anime production or any specific points you focused on?

UMEMOTO: It was a nice change of pace heading into production after reading through pages of storyboards and laughing at the unexpected setup and punch lines! A point where this differed from normal anime production was that we needed to build off these storyboards without getting in the way of them. With the main series, we have to add in anime-specific cuts to scenes and direct things for the sake of runtime, but with Juju Stroll, we focused on adapting what made Akutami Sensei's storyboards so funny while keeping the production staff's own tinkering to a minimum.

Question: The dialogue and pauses are very unique in Juju Stroll. What talks with Akutami Sensei influenced your creative process?

UMEMOTO: First, before Akutami Sensei started drafting the storyboards, I specified the running time for each short and the general line count. Later, after receiving the storyboards, the anime staff and I would make some adjustments. We made each installment of Juju Stroll with help from Akutami Sensei and the original manga staff.

◀▼ Nanami rejects Gojo, but Gojo stalks Nanami anyway?! Nanami opens Gojo's letter and sees his joke.

You can read Akutami Sensei's storyboards for Juju Stroll in the special booklet included in the limited edition Blu-ray discs now on sale!

Question: Was there any particular installment of Juju Stroll that you liked most?

UMEMOTO: I like all the installments, of course, but if I were to pick one, then I'd say that I really liked the short between Gojo and Nanami after episode nine, "Young Fish and Reverse Punishment." [laughs] What the letter that Gojo gave to Nanami said was peak stupidity. [laughs] For this installment, the moment I read Akutami Sensei's draft, I had a clear image of the camerawork I'd employ in the anime version.

Question: Now that production on the first season is over, what role do you think that Juju Stroll served?

UMEMOTO: At the start of production, we were adamant about not making Juju Stroll a simple "omake." We feared that if we adhered to the same style as the main series, then viewers would just skip right past it, so we instead decided to add watercolor touches to the art, change the color of the line art, and give the visuals a softer tone overall. Juju Stroll started at episode three, "Girl of Steel," but since that was a part of the story with a very tough and heavy subject matter, we made Juju Stroll to act as a breath of fresh air to allow viewers to take a break from the action. I was so glad to receive comments on social media saying that Juju Stroll helped heal their aching hearts too, so I think that Juju Stroll served its role just fine.

Ending Animation

Storyboard/Direction: Ryohei Takeshita Animation Director: Takako Shimizu
Second Part Ending Theme: *give it back* by Cö Shu Nie Lyrics/Composition: Miku Nakamura Arrangement: Cö Shu Nie (Sony Music Associated Records)

Episode Storyboard Gallery & Interview With Director Sunghoo Park

We're giving you a special peek at some of episode 24's storyboards, drawn by Director Park himself. He also explains how he created the mix of action and drama.

Above: Jujutsu Kaisen, Final Episode

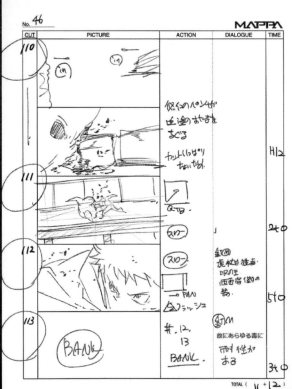

Please tell us something about the episode you personally drafted storyboards for, "Accomplices."

PARK: Since episode 24 was the last episode, I felt inclined to wrap things up in style. Just like the title "Accomplices" implies, Yuji and Nobara's teamwork is fully on display. Along with Fushiguro, you get a strong impression that these three have become friends over the course of *Jujutsu Kaisen*. To ensure the direction reflected that, I considered the best way to show Yuji and Nobara's teamwork action versus Eso. I also contemplated the camerawork and mixed various angles with switches and dashes, while also capturing the character's expressions.

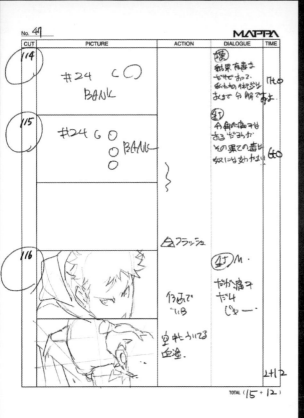

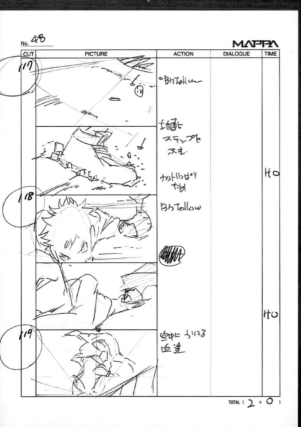

CUT	PICTURE	ACTION	DIALOGUE	TIME

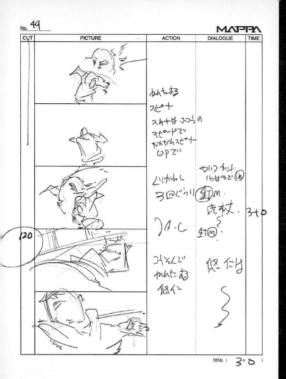

ぐるぐるする
スピード
スタート→ふつうの
スピードで
だんだんスピード
UPで

ぐいぐいし
3回ぐるり 虎杖.

コイ・し

みをとんで
ねんたおる
悠仁に

悠たけ

120

切りカット
16枚ぐらい

3+0

TOTAL (3+0)

CUT	PICTURE	ACTION	DIALOGUE	TIME

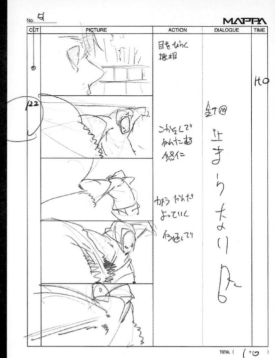

目をひらく
壊相

コイをとして
ねんたおる
悠仁に

カラだんだん
よっていく
低速で

122

止
ま
り
な
り
た

40

TOTAL (1+0)

CUT	PICTURE	ACTION	DIALOGUE	TIME

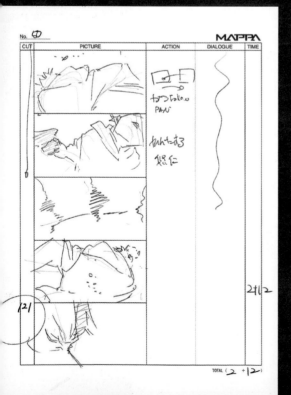

ロ→ロ
かつfollou
PAN

ねんたおる
悠仁

121

2+12

TOTAL (2+12)

CUT	PICTURE	ACTION	DIALOGUE	TIME

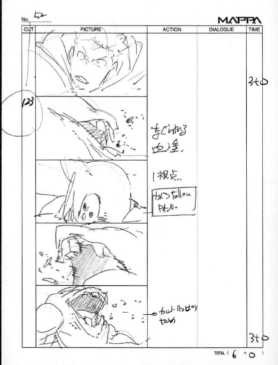

まじゆける
血達.

1視点.

かつfollou
PAN

カット かぶりで
もおい

123

3+0

3+0

TOTAL (6+0)

PARK: In every action scene, if you move the camera, you make the images look disjointed when you try to look at it as a whole. That's why I used a tilt up—a technique where you move the camera from low to high—to get Eso's entire body in frame and narrow down movements. By designing the action that way—along with other elements like emotion, tempo, and music—I managed to make the scene seem more cohesive. Once the insert song "REMEMBER" by Masato-san of coldrain was edited in, I was confident episode 24 was truly complete.

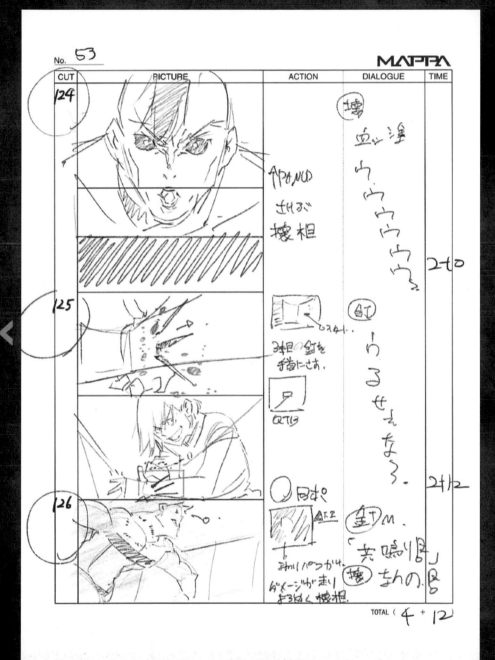

From the top of episode 24, we have Eso, the Death Womb Painting, displaying his Rot technique and an in-depth visual explanation of the effects of Kugisaki's Straw Doll technique. That's when Yuji starts moving and we insert a flashback to Junpei with an explanation

of why he can endure poison. Once the lead-up beat for "REMEMBER" stops and Eso screams "Kechizu!" that triggers an explosion of emotions, increased tempo, and action. Itadori and Kugisaki then nail their Double Black Flash.

MAPPA

CUT	PICTURE	ACTION	DIALOGUE	TIME

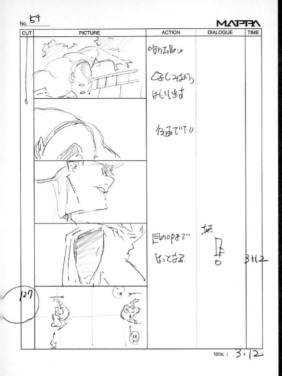

TOTAL (3 + 12)

MAPPA

CUT	PICTURE	ACTION	DIALOGUE	TIME

130
131
132
133

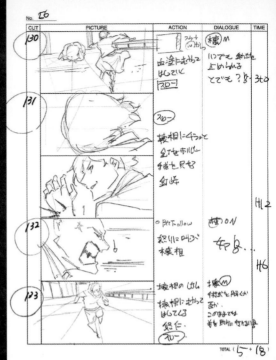

TOTAL (5 + 18)

MAPPA

CUT	PICTURE	ACTION	DIALOGUE	TIME

128
129

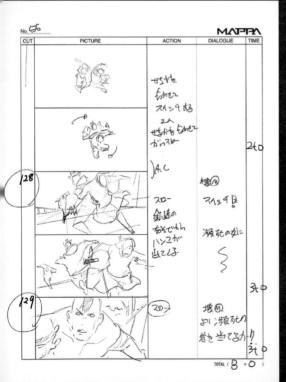

TOTAL (8 + 0)

MAPPA

CUT	PICTURE	ACTION	DIALOGUE	TIME

134
135
136

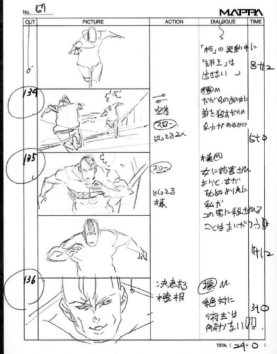

TOTAL (24 + 0)

No. 58 — MAPPA

CUT	PICTURE	ACTION	DIALOGUE	TIME

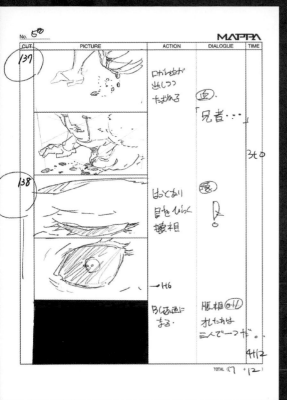

- 137 — ロがふるえが 出しつつ たおれる 直. 「兄者‥‥」 3+0
- 138 — はっとなり 目をひらく 壊相 裏 R 0 →H6 3+0
 - BCあ通に なる. 眼相 OIL オレたちは 二人で一つだ. 4+12

TOTAL (17 +12)

No. 60 — MAPPA

CUT	PICTURE	ACTION	DIALOGUE	TIME

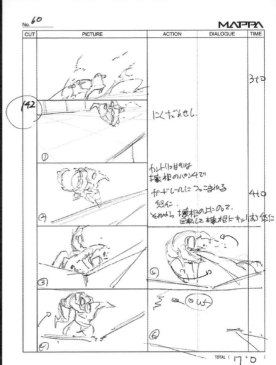

- 142 — 3+0
 - ① にくだんせん.
 - ② カメラに甘いは 壊相のパンチで ガードレールにつっこまれる 照に. それから 壊相の上にのる. 図系に壊相にキッりむ係に 4+0
 - ③
 - ⑤ OL
 - ④

TOTAL (17 +0)

No. 59 — MAPPA

CUT	PICTURE	ACTION	DIALOGUE	TIME

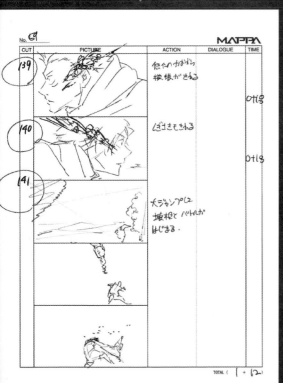

- 139 — 悠仁のかおける 模様がきれる 0+18
- 140 — しぎきもきれる 0+18
- 141 — 大ラッシュプに 壊相とバトルが はじまる.

TOTAL (1 + 12)

No. 61 — MAPPA

CUT	PICTURE	ACTION	DIALOGUE	TIME

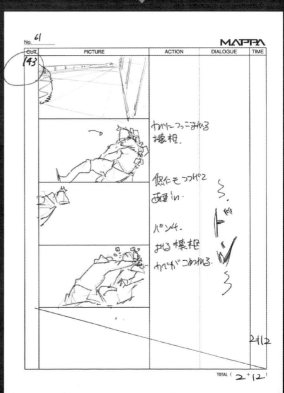

- 143 — カベにつっこまれる 壊相. 悠仁もつっける 西壁in. パン4. 走る壊相 カベがこわれる. 2+12

TOTAL (2 +12)

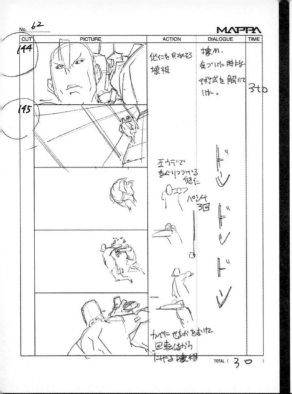
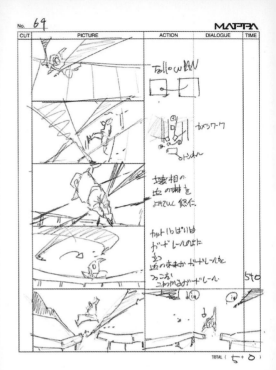
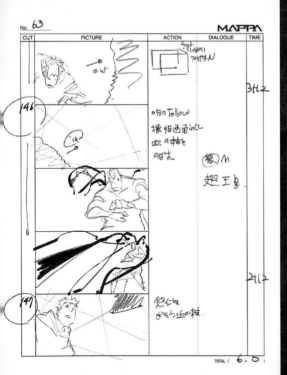
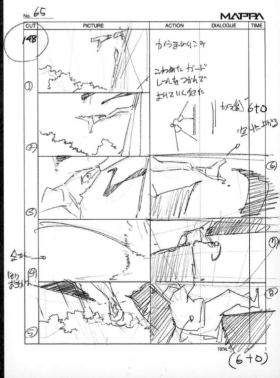

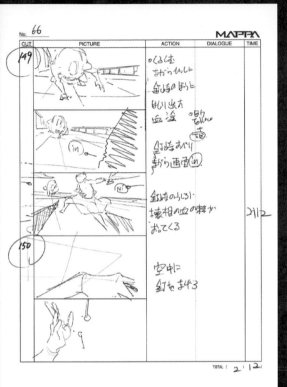

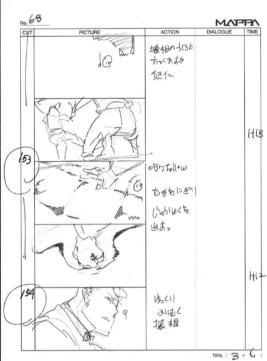

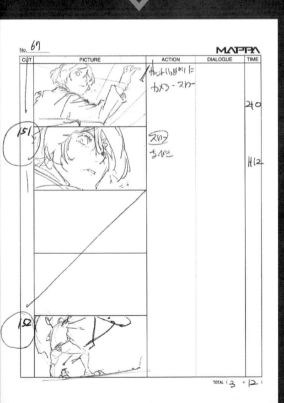

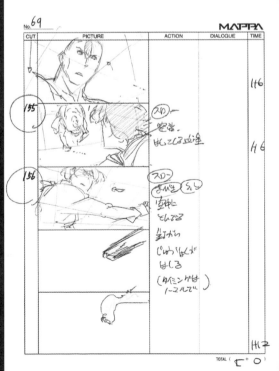

CUT	PICTURE	ACTION	DIALOGUE	TIME

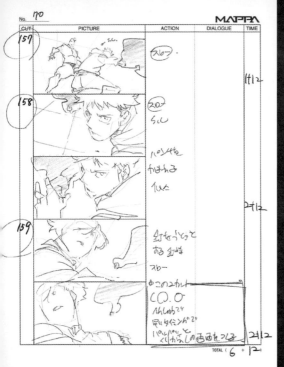
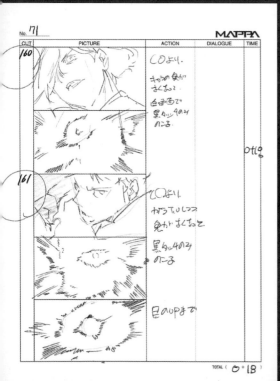

CUT	PICTURE	ACTION	DIALOGUE	TIME

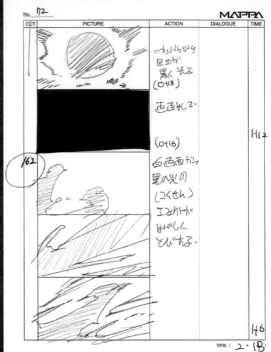

CUT	PICTURE	ACTION	DIALOGUE	TIME

CUT	PICTURE	ACTION	DIALOGUE	TIME

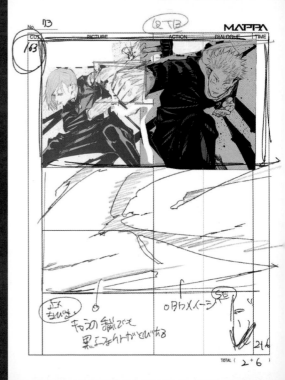

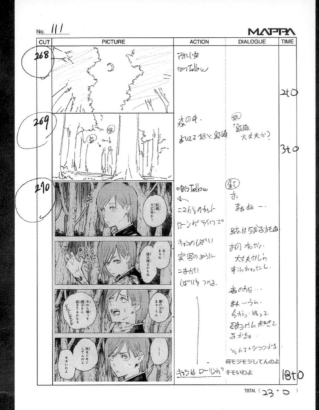

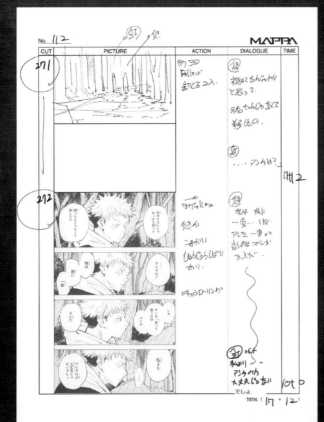

Itadori and Kugisaki walk over to Fushiguro after their battle with the Death Paintings Eso and Kechizu. This quiet conversation scene's storyboard uses cuts from the original manga. This scene was appropriate for the final episode, packed full of Director Park's specific nuances.

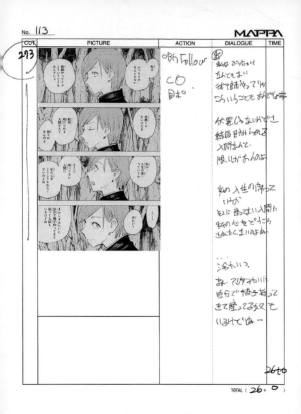

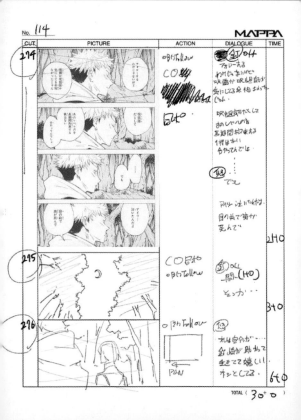

PARK: Itadori and Kugisaki's post-battle conversation was a scene from the original manga that I liked very much. They're positioned on the left and right sides, conversing over five pages. To lay out this sequence, I kept the camera fixed instead of inserting new cuts, and I utilized animators who were good at drawing dramatic scenes. I knew the lip sync had to be on point, so I had the voice actors ignore the storyboards and had them perform while looking at the expressions in the original manga during ADR. Afterward, I had the animators adjust the lip sync, expressions, gazes, and what have you. I think they did a great job portraying things, and I feel this scene turned out more like live-action footage.

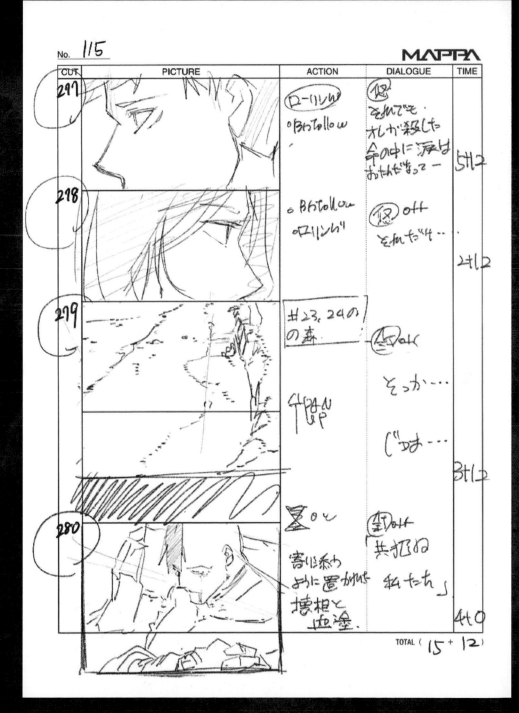

Itadori and Kugisaki square away their enemies, who both had flesh-and-bone bodies unlike cursed spirits, and proceed to vent to one another. There are touches sprinkled all throughout this scene to draw out the characters' "acting abilities."

▚▚▚▚▚▚▚▚▚▚▚▚▚▚▚▚▚▚▚▚▚

SESHIMO: Out of all of Park-san's cuts for the final episode, there's a scene that impressed me more than any of the combat scenes, and it's when Yuji is chasing after the truck that Eso is riding. Yuji shouts Kugisaki's name at her while running, but he's not just running in a monotonous way— he's running while taking big steps forward. The timing of the dialogue and the action here is extra pleasing to watch. A run cycle is one of the basics of animation, so it's something that all animators have drawn in their careers, but that sequence was a perfect synthesis of character and drama and it's not something you see done every day.

PARK: Wow, Seshimo-san, you're scaring me... [*laughs*] I knew I had to do that specific run cycle as the coup de grâce.

▚▚▚▚▚▚▚▚▚▚▚▚▚▚▚▚▚▚▚▚▚

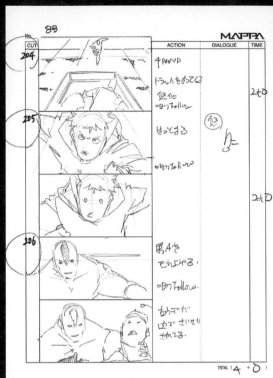

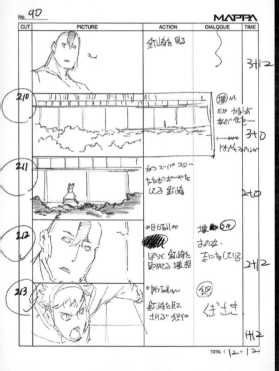

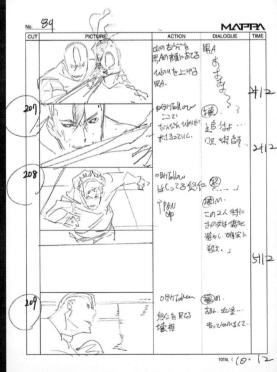

Eso climbs in the back of a truck and tries to make an escape, but Itadori charges after him at full speed. Eso holds the passengers hostage, but his eyes glance over at Kugisaki off in the distance. Itadori yells "Kugisaki!" to her, which gives her the signal. This one quick scene is the "run cycle" that Producer Seshimo is applauding.

CAST SPECIAL MESSAGE

We had a Q&A with thirty members of the voice acting cast featured in the first season! This collection of messages, packed with love for the characters and work, is a must-see!

Yuji Itadori

JUNYA ENOKI

Born October 19, Tokyo
Affiliated with Atomic Monkey

Megumi Fushiguro

YUMA UCHIDA

Born September 21, Tokyo
Affiliated with I'm Enterprise

Q.1 Who would you want to be friends with if you enrolled in Jujutsu High?

I've never touched a panda before, so I want to get friendly with Panda and touch him.

Q.2 What technique would you like to use if you became a jujutsu sorcerer?

I tend to oversleep, so I would want Fushiguro's **Nue to carry me to work.**

Q.3 If you could send a message to Yuji Itadori, what would it be?

It's not your fault... Don't stress and do your best...

Q.4 Any memorable or favorite scenes?

Episode 24, **where Black Flash gets used against Eso and Kechizu.** The way the music kicks in and the climb to the peak with alternating shots of Itadori and Kugisaki were memorable and pleasing to watch.

Q.1 Which character would you want to fight alongside if you became a jujutsu sorcerer?

Inumaki Senpai. I would support him with the throat lozenges I have at home! In exchange, I would have him support me in my dieting efforts. I'd appreciate it if he told me, **"Move!"** and **"Eat vegetables!"**

Q.2 What technique would you like to use if you became a jujutsu sorcerer?

I'd like to use Todo's cursed technique, **Boogie Woogie,** to suddenly appear in different places. I want to leave a cursed object at the studio and **swap places** with it to get to work.

Q.3 If you could send a message to Megumi Fushiguro, what would it be?

We're going to have to work even harder from here on! Let's try our hardest, but not too hard. If you're ever in trouble, call out your shikigami!

Q.4 Any memorable or favorite scenes?

The conversation between Itadori and Kugisaki after the battle in episode 24. *Jujutsu Kaisen* is amazing about showing dynamic and fluid movement, but this scene shows a very quiet and deliberate dialogue between them. I like the balance between the two. I love Kugisaki's consideration.

Satoru Gojo

YUUICHI NAKAMURA

Born February 20, Kagawa
Affiliated with Intention

Q.1 What helps you study for a character or what do you keep in mind while acting?

I explored things on my own, which is a natural part of the job, but I had specific directions from the staff and director, which helped me with my acting. **Discussion while recording is fun!**

Q.2 Who would you want to be friends with if you enrolled in Jujutsu High?

I think it'd be fun to talk with **Toge** (if I can interpret his rice ball language)! And, worst-case scenario, I can leave it to my own interpretation!

Q.3 If you could send a message to Satoru Gojo, what would it be?

Quit relying so much on the youngsters and **be more up-front, y'know?** (Neh heh)

Masamichi Yaga

TAKAYA KURODA

Born April 17, Tokyo
Affiliated with AXL ONE

Q.1 Any memorable or favorite scenes?

The scene where Masamichi Yaga **has his big body hunched over and he's making cute cursed corpses** was pretty memorable!

Q.2 What kind of person is the character you portrayed?

I think he's strong in combat, strong mentally, and **very affectionate.**

Q.3 If you could send a message to Masamichi Yaga, what would it be?

You resemble me a little bit, you know!

Nobara Kugisaki

ASAMI SETO

Born April 2, Saitama
Affiliated with Sigma Seven

Q.1 Any memorable or favorite scenes?

There are so many. The one that stands out is where Itadori and Nobara-san learn that Fushiguro's sister is in danger while investigating the Yasohachi Bridge and they try to be considerate to him.

Q.2 What kind of person is the character you portrayed?

I think she is very strong-willed and knows how to put that into words. I think the fact that she doesn't base her standards on what others think of her is cool and admirable.

Q.3 If you could send a message to Nobara Kugisaki, what would it be?

I've gained a lot of experience ever since being your voice. Thank you, Nobara-san!

Kiyotaka Ijichi

MITSUO IWATA

Born July 31, Tokyo
Affiliated with Aoni Production

Q.1 What helps you study for a character or what do you keep in mind while acting?

I thought about how Ijichi is very delicate, honest, and always finishes any task he's given. He is very caring toward the students. Reading the manga, I thought, **"Wow, what a wonderful character."** I wanted to translate the good of what I saw into playing him.

Q.2 Which character would you want to fight alongside if you became a jujutsu sorcerer?

Nanamin or **Todo**. With Nanamin, both of us in suits and glasses would surely confuse enemies. [*laughs*] Just imagine! It'd be hilarious!

Q.3 If you could send a message to Kiyotaka Ijichi, what would it be?

Ijichi-san, I love seeing you valiantly deal with your superiors' (mostly Gojo-san's) unreasonable requests all the time! **Please take care of yourself.**

 Ryomen Sukuna

JUNICHI SUWABE

Born March 29, Tokyo
Affiliated with Tokyo Actor's Consumer's
Cooperative Society

 Q.1 Any memorable or favorite scenes?

Every **instance of the domain expansion** was memorable. They do such a great job capturing the image from the original manga—this "ultimate power"! It always gave me chills.

 Q.2 What technique would you like to use if you were a jujutsu sorcerer?

I would **summon the Divine Dogs and pet the heck out of them.** I'd pet, love, and cuddle Shiro and Kuro and never stop.

 Q.3 ou could send Ryomen Sukuna a message, what uld it be?

You can do it, you can do it!

 Suguru Geto

TAKAHIRO SAKURAI

Born June 13, Aichi
Affiliated with Intention

 Q.1 Any memorable or favorite scenes?

There was a Juju Stroll where we played soccer with Jogo's head and Shigeru Chiba-san's acting was so intense. I wish I had his expressiveness.

 Q.2 What helps you study for a character or what do you keep in mind while acting?

I mostly just stick to my direction. I never have a complete vision of Suguru Geto in my hands. I take small directions every recording session and build him up. It is a difficult role.

 Q.3 If you could send a message to Suguru Geto, what would it be?

I don't know what I should say to him... I feel like he'd let me have it if I said the wrong thing; I'd be too afraid to say anything.

 Jogo

SHIGERU CHIBA

Born February 4, Kumamoto
Affiliated with 81 Produce

 Q.1 What helps you study for a character or what do you keep in mind while acting?

When I met Gege Akutami Sensei, who was dressed in Thai lounge pants and sandals, I found him to be a **pleasant and nice guy!** He made this mischievous, awkward, and single-minded character Jogo-kun! You better believe I played my role with all my heart and soul.

 Q.2 What kind of person is the character you portrayed?

He's probably a deeply stern man on his path of warrior training. Food, women, fashion, and games don't cross his mind. All he feels is the impulse for battle. Perhaps he's a **wanderer in pursuit of a special something?**

 Q.3 If you could send Jogo a message, what would it be?

You are so pure and cute! If you're into Hanami, you need to be courageous and tell them how you really feel! ...I'm getting carried away! (^ω^ ;

 Shoko Ieiri

AYA ENDO

Born February 17, Yamagata
Affiliated with Office PAC

 Q.1 What kind of person is the character you portrayed?

She gives off a cool and composed vibe, but her personality can shift based on the situation or person she's with. **I want her to show off her affectionate side!**

 Q.2 Who would you want to be friends with if you enrolled in Jujutsu High?

I'd pick **Megumi Fushiguro.** From a quick glance at the cast, his energy suits me the most.

 Q.3 If you could send a message to Shoko Ieiri, what would it be?

Shoko Ieiri-san, I'd like a little more info about you. Please and thank you.

 Maki Zen'in

MIKAKO KOMATSU

Born November 11, Mie
Affiliated with Hirata Office

 Toge Inumaki

KOKI UCHIYAMA

Born August 16, Tokyo
Affiliated with Himawari Theater Group

Q.1 Who would you want to be friends with if you enrolled in Jujutsu High?

I'd like to be friends with **Nobara.** We'd go shopping, go to the movies, eat together—we'd totally be dating. [*laughs*] I think her strong resolve, beliefs, and sense of self would help me out of trouble. I truly respect her.

Q.2 What technique would you like to use if you became a jujutsu sorcerer?

It'd have to be Toge's **Cursed Speech.** I think it's an ability everyone has admired at least once. The only thing is...I doubt I'd be able to stay in the voice-acting business... (Sad.)

Q.3 If you could send a message to Maki Zen'in, what would it be?

Bring down the Zen'in family. We'll fight together.

Q.1 Any memorable or favorite scenes?

Episode 20, **the scene where Itadori and Todo fight Hanami.** It was visually stunning to see Todo's cursed technique, Boogie Woogie, **swap the positions of the characters all over.** Moments like these are why anime adaptations of manga exist.

Q.2 What technique would you like to use if you became a jujutsu sorcerer?

It's not a battle technique, but I would like to learn Toge Inumaki's technique for being able to convey his feelings with a limited word pool. It'd be useful for **when I'm so tired that I just don't want to say what I'm feeling in detail.**

Q.3 If you could send a message to Toge Inumaki, what would it be?

I want you to live a happy life.

 Panda

TOMOKAZU SEKI

Born September 8, Tokyo
Affiliated with Atomic Monkey

 Aoi Todo

SUBARU KIMURA

Born June 29, Germany
Affiliated with Atomic Monkey

Q.1 What helps you study for a character, or what do you keep in mind while acting?

I was given the direction that I should be the second years' **father figure,** so I tried my best to act that way. I also tried to evoke some **childhood cuteness** as well.

Q.2 What technique would you like to use if you became a jujutsu sorcerer?

I'd like Gojo's **Limitless!** ♪ Cuz it's so cool!

Q.3 If you could send a message to Panda, what would it be?

Pandas are my favorite type of bear. I'm so glad that I was able to meet you. Don't call me creepy for saying that, okay?

Q.1 Which character would you want to fight alongside if you became a jujutsu sorcerer?

Itadori would be cool, but I want to try teaming up with **Panda.**

Q.2 What technique would you like to use if you became a jujutsu sorcerer?

I want to try **Boogie Woogie.**

Q.3 If you could send a message to Aoi Todo, what would it be?

I'm into the same type of girls as you now!

Mai Zen'in

MARINA INOUE

Born January 20, Tokyo
Affiliated with Sigma Seven

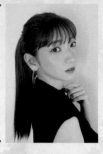

 Any memorable or favorite scenes?

I have a special attachment for the **twin battle**. I gave it my all. My goal for season one was to act in that scene. I have no regrets!

 What helps you study for a character or what do you keep in mind while acting?

When I read the manga, all of the character's lines hit me. I also wanted people to be hit by Mai's twisted personality through my acting. Everything about Mai is rooted in Maki-san so I took care while acting during their confrontation.

Q.3 If you could send a message to Mai Zen'in, what would it be?

You're wonderful for confronting your past. I cherish the fact that you can be awkward and show human weakness. I want to watch you make strides until the end!

Kasumi Miwa

CHINATSU AKASAKI

Born August 10, Kagoshima
Affiliated with 81 Produce

 What kind of person is the character you portrayed?

She's a groupie and can be a sucker for what she loves, but she can contain herself when she needs to. She is extremely logical, and **knows not to get swept up by those around her.** However, she doesn't doubt people, which makes her **susceptible to being deceived by bad people.**

 What technique would you like to use if you became a jujutsu sorcerer?

I'd want to use Inumaki Senpai's **Cursed Speech.** If I used it on my son and told him to **"sleep"** when he was up all night crying, I can only wonder how effective it would be...

 If you could send a message to Kasumi Miwa, what would it be?

Write your name on your stuff in the fridge! Back when I lived in a student dorm, I would lose my yogurt because of that!

Yoshinobu Gakuganji

MUGIHITO

Born August 8, Tokyo
Affiliated with Jagaimo Mura

 Any memorable or favorite scenes?

The **tea interaction** during my first appearance.

Q.2 What kind of person is the character you portrayed?

He has to **keep a creepy vibe** yet give off an **unassuming vibe as well...**

 If you could send a message to Yoshinobu Gakuganji, what would it be?

"Try to be less of a chatterbox..."

Kento Nanami

KENJIRO TSUDA

Born June 11, Osaka
Affiliated with ANDSTIR

 Any memorable or favorite scenes?

I liked the **scene where Itadori makes his dramatic entrance** when Nanami is in trouble against the Self-Embodiment of Perfection. It is a good cathartic scene. Nanami's **scene with the bakery girl** is also memorable. It is quiet, rich in nuance, and filled with Nanami's charm. I couldn't narrow it down to one scene.

 What helps you study for a character, or what do you keep in mind while acting?

Moving around with feeling even if I'm not showing emotions through my face. I act thinking that while my expression is flat, all I have to do is **move the air around me.**

 If you could send a message to Kento Nanami, what would it be?

Nanami-san, you came back saying that you took the lesser of two idiotic evils. I am glad you returned because I get to experience your line of work for myself. Your way of life is so cool. Thank you for existing.

 Junpei Yoshino

YOSHITAKA YAMAYA

Born February 15, Miyagi
Affiliated with FIRST WIND Production

 Mahito

NOBUNAGA SHIMAZAKI

Born December 6, Miyagi
Affiliated with Aoni Production

Q.1 What kind of person is the character you portrayed?

He's brave yet foolish. Intelligent with bad interpersonal skills. Likes movies and loves his mom—a normal high school kid. He's curious about his interests. A kindhearted youth who values his mother's feelings over his own.

Q.2 What technique would you like to use if you became a jujutsu sorcerer?

I'm an animal lover so I'd want allies like Fushiguro's shikigami. If there's no limit on their sizes, I want to ride a giant lesser panda. My combat abilities are poor.

Q.3 If you could send a message to Junpei Yoshino, what would it be?

I'm sorry. I thought I reached you better than anyone else, but your pain was too much for me to understand. If you're ever reborn, I hope you live a happier life than anyone else and you see your mom in heaven.

Q.1 What kind of person is the character you portrayed?

Newborn pure evil. He never had any attachment to life, not even his own, but he's gained an attachment to Yuji Itadori, so I'm very much looking forward to how he'll grow and change as a result of that.

Q.2 What technique would you like to use if you became a jujutsu sorcerer?

"Salmon! Salmon Roe! Tuna Mayo!"
"Caviar! Foie gras! Truffle!!"

Q.3 If you could send a message to Mahito, what would it be?

I feel like I'll get stretched like taffy if I involve myself with him even a little bit, so I don't want to say anything! However, while I definitely don't want to tell him this, I must say I really love him.

 Momo Nishimiya

RIE KUGIMIYA

Born May 30, Kumamoto
Affiliated with I'm Enterprise

 Noritoshi Kamo

SATOSHI HINO

Born August 4, United States of America
Affiliated with AXL ONE

Q.1 Any memorable or favorite scenes?

Episode 17, where **Nishimiya speaks her mind,** was memorable. She's strict with herself, as if constantly walking a tightrope, but her mindset is that her absolute best should be the standard. I felt that part of her was amazing.

Q.2 What helps you study for a character, or what do you keep in mind while acting?

Seeing her in **casual slice-of-life situations** like in Juju Stroll or the baseball episode was very helpful for coming up with ideas for the role.

Q.3 If you could send a message to Momo Nishimiya, what would it be?

I'm a **seafood** person myself. I like **tom yum kung** too.

Q.1 Who would you want to be friends with if you enrolled in Jujutsu High?

I would like to be friends with **Yuji Itadori** and **Aoi Todo!** I like that they're both straightforward men.

Q.2 What technique would you like to use if you became a jujutsu sorcerer?

It has to be **Boogie Woogie!** Simple is best! I don't have the skill to know when to use it optimally like Todo, but it's a really convenient technique nonetheless!

Q.3 If you could send a message to Noritoshi Kamo, what would it be?

You're facing **your own circumstances head-on as the heir of the Kamo family!** I'm sure Akutami Sensei will dig deeper into the Kamo Family sooner or later, so when that happens, let's face the challenges together!

Ultimate Mechamaru
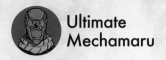

YOSHITSUGU MATSUOKA

Born September 17, Hokkaido
Affiliated with I'm Enterprise

Q.1 What helps you study for a character, or what do you keep in mind while acting?

His robotic speaking might mislead people into thinking he's a robot. From the perspective of the person controlling Mechamaru, it must hurt to move his vocal cords even slightly. That's why he speaks so **slowly**. At least, that's the reason I kept in mind while acting. Also, I have a soft spot for robot anime. [*laughs*]

Q.2 Who would you like to be friends with if you enrolled in Jujutsu High?

Mechamaru. I'd like to teach him that there are all sorts of pleasures in the world. I feel we'd have a lot to talk about, like anime recommendations, favorite works, et cetera. I want to swallow Mechamaru in my vortex of bonding with my domain expansion, **Anime.**

Q.3 you could send a message to Ultimate Mechamaru, at would it be?

Mechamaru, please don't hate the world. You have friends who love and support you. Take the good with the bad and walk forward with everyone. I pray that day eventually comes.

Utahime Iori

YOKO HIKASA

Born July 16, Kanagawa
Affiliated with I'm Enterprise

Q.1 What helps you study for a character, or what do you keep in mind while acting?

At first I tried studying for a character who's dedicated to playing the straight man, but I was directed to be more of a **refined, beautiful woman who only changes when Gojo messes with her.** Utahime gets angry at a lot of things, but I'm hoping to build her character. There are a lot of subtle nuances needed to play her, from knowing her emotions to balancing that with her competitive nature.

Q.2 What technique would you like to use if you became a jujutsu sorcerer?

Give me one stronger than Gojo's, you know, a super-strong technique! Please!

Q.3 If you could send a message to Utahime Iori, what would it be?

You have a rough time trying to keep that eccentric collection of students in check, I bet. Drop by and have some tea with me! Huh? You'd rather have alcohol? You don't seem like you can hold your liquor. Okay, we'll drink till morning!

Mei Mei

KOTONO MITSUISHI

Born December 8, Tokyo
Freelance

Q.1 hat helps you study for a character, or what do you ep in mind while acting?

When my character debuted, the director told me "Mei Mei-san is mysterious." So I kept that in mind. In episode 24, where she's confirming the payment at the ATM, I did a hearty laugh at first, but I got directed to laugh **"more like a young lady who got gifted brand-name jewelry"** instead! I think that helped the scene come off cutesier and allowed the character to show more depth.

Q.2 What kind of person is the character you portrayed?

From the original manga, I think that she finds any situation trivial and boring, and that **the thing she adores and trusts the most is money.** What made her this way? She's strong, but I'm sure that she exerted unparalleled effort to get to that point. I'm looking forward to her action scenes in the future.

Q.3 you could send a message to Mei Mei, at would it be?

The more zeroes, the merrier, right?

Naobito Zen'in

JOJI NAKATA

Born April 22, Tokyo
Affiliated with Office Osawa

Q.1 Any memorable or favorite scenes?

Episode 17, during the Kyoto Sister School Goodwill Event, when Maki and the others are fighting in the forest. It was a cool scene.

Q.2 What kind of person is the character you portrayed?

He's definitely the head of the house. His **cursed energy and deductive powers are top-notch.** He looks like a drunk old geezer, but he's always considering the consequences of his actions. He acts aloof, but he's more farsighted and prudent than he lets on. He's also somewhat sentimental. He treats Maki and Mai harshly, but I think it's a sign that he has hope for them. I'm hoping that I can portray both sides of him—**the confident grade 1 sorcerer (the aloof merrymaker) and the callous head of the house (the crafty side.)**

Q.3 If you could send a message to Naobito Zen'in, what would it be?

For his own good, he should not go to Shibuya on October 31.

 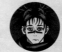 **Hanami**

ATSUKO TANAKA

Born November 14, Gunma
Affiliated with Mouse Production

Q.1 What helps you study for a character, or what do you keep in mind while acting?

Since the character's debut, the staff wanted to **reverse the playback of their voice.** After much trial and error, I made sure to **speak in a flat AI-like tone.** Hanami may look like a monster, but **they're being voiced by me, a lady,** so I tried to give the best performance I could.

Q.2 What kind of person is the character you portrayed?

Hanami lives off their **cursed spirit instincts** and can't understand human emotions, but perhaps they've gained enough enjoyment in battle to make them realize that **they've shifted to a higher plane of existence.**

Q.3 If you could send a message to Hanami, what would it be?

I understand your sentiments toward protecting this planet.

 Choso

DAISUKE NAMIKAWA

Born April 2, Tokyo
Representative Director of Stay Luck

Q.1 Any memorable or favorite scenes?

The battle against the brothers was memorable for sure, but **Choso's debut scene** really got my heart racing. He gained attention from the original manga, so the pressure he exudes is no joke.

Q.2 What helps you study for a character, or what do you keep in mind while acting?

His posture and demeanor are scary and suspicious, but I wanted to show the audience he has a **sort of kindness at his core seeping through as well.**

Q.3 If you could send a message to Choso, what would it be?

So you finally made your appearance. You're bound to be involved in a lot from this point on. I'll do whatever I can to make sure you shine, so here's to a wonderful working relationship!

 Eso

NOBUYUKI HIYAMA

Born August 25, Hiroshima
Affiliated with Arts Vision

Q.1 Any memorable or favorite scenes?

Eso's **conversation with his brothers** really affected me.

Q.2 What helps you study for a character, or what do you keep in mind while acting?

I made sure not to sound too flamboyant or too perverted or too overbearing. Basically, I made sure **not to overdo it in general.**

Q.3 If you could send a message to Eso, what would it be?

A shame that you lost the fight, but you did your best!

Kechizu

KAPPEI YAMAGUCHI

Born May 23, Fukuoka
Representative Director of Goku Co., Ltd.

Q.1 What helps you study for a character, or what do you keep in mind while acting?

At first, I wondered which mouth was the one he spoke from. [laughs] He has quite an impactful appearance, but based on his lines and his love for his brother, I tried my very best to make him a **lovable character.**

Q.2 What kind of person is the character you portrayed?

I think he just really loves his big brother. I loved it when he screamed, **"Big Bro!"** I want to say he has the makings of a great little brother. [laughs]

Q.3 If you could send a message to Kechizu, what would it be?

If you had some **happier times with your big brothers,** then I would have liked to act in those too!

Jujutsu Kaisen Anime
Staff Interviews

We have members of the staff here—all of whom hold key positions in the anime production industry. We've interviewed, chatted, and conducted roundtable talks with them about their experiences on all twenty-four episodes of the first season of *Jujutsu Kaisen*.

| Music Director |
Akiko Fujita

A music director in the animation industry whose works include *Idolmaster Cinderella Girls*, *Kakegurui*, *Dorohedoro*, and *The Wandering Witch: The Journey of Elena*.

Q: To start off, could you tell us what your role is as music director for anime production?

FUJITA: To put it in broad terms, I'm in charge of the sound design, and my job is to tailor the sound to match the mood or emotional weight of a scene while taking in input from the directors. It all starts from the audition of the main cast. For this project, the roles of Yuji, Fushiguro, and Nobara were all cast via tape auditions and then given their final auditions in the studio, where we had Yuji and Fushiguro read lines to show us their acting. Afterward, once dubbing begins, I start giving our actors directions in the studio. When giving directions, I try my best to explain why we need their acting shifted a certain way or how to match their characters' emotional wavelengths. My intention is that this will help them get even more situated into their characters for later down the road as well. Of course, sometimes my directions are more to the point, like asking them to say their lines louder because the characters are far away from one another.

Q: In terms of music, what is the first step in your work process?

FUJITA: My first step is to create a "music menu." I really struggle with this. [*laughs*] I do this by going through the script and storyboards to point out what kind of music would go with each scene. However, since anime background music usually has a limited number of tracks, you need the music to be versatile enough to be used in a multitude of situations, so I try to communicate to the composers that they should be making songs that are "indistinct yet have personality." That's one task where I really struggle. With *Jujutsu Kaisen*, I had over sixty tracks made, and I was grateful for the large quantity. [*laughs*]

Once the music menu is done, this is where I would normally

commission the music. However, since we had to conduct all of our meetings remotely this time around, I made sure to provide our people with an ample amount of reference tracks so we would have a smoother time exchanging ideas. Once the menu and meetings are out of the way, I always feel like I've cleared the biggest hump. [laughs] This is because at the recording studio, the drawings for you to gauge a character's emotions are ready and the actors are building their performance with the flow of the scenes in mind. At this point, the job shifts from individual work to teamwork, allowing me to relax a little bit more.

Q: So you collaborate with not only the music team, but the Foley artists and recording mixer to produce the sounds as well, yes?

FUJITA: I do. The Foley artist, Katsuhiro Nakano-san, creates all our sound effects—from real-life sounds to the more surreal ones—and provides us with a healthy balance. He does that work almost entirely on his own. I am in awe of the incredible skill of Japanese Foley artists. Tetsuya Satake-san is our recording mixer and—

I apologize for the broad terms again—he oversees organizing the audio levels for our actors and the music. The volume of the voices will differ based on the actor, so you need to decide during the test recordings and make sure the levels are set properly for when it's showtime, so it's an extremely nerve-racking job. After he's done with that, he fine-tunes the audio and removes any unnecessary noise and then adds any filters that are specific to a scene or situation. Inumaki's Cursed Speech is a prime example of that.

Q: Did anything particularly impress you at the auditions for Itadori, Fushiguro, and Kugisaki?

FUJITA: Akutami Sensei never had a solid idea for Yuji's voice in their head, and the opinions for Yuji's voice from reading the original manga varied among the staff, so we auditioned a variety of people. After discussing with everyone, including Akutami Sensei, we decided Enoki-san's more natural voice fit the bill. I feel like we were in unanimous agreement to Uchida-san being Fushiguro. Though, as an interesting note, Uchida-san's personality feels closer to Yuji and Enoki-san feels closer to Fushiguro. [laughs]

I personally feel as though Seto-san is a perfect match for Nobara's voice, agewise. During the studio audition, I wanted to try and see how much of Seto-san's refined demeanor we could shave down to replicate Nobara-chan's plucky and delinquent personality. I made her go through several different patterns to accomplish that. By the time we finished episode 24 and recorded the last audio drama, I could feel that Nobara-chan had taken root inside her, which pleased me greatly.

Q: Were there any of the orders you received from Director Park or the manga's author, Akutami Sensei, that left an impression?

FUJITA: What left the biggest impression with Akutami Sensei was when they visited the studio for episode 1's recording session. When they left, they said, "Satoru Gojo is a man of resignation." Since he was on his

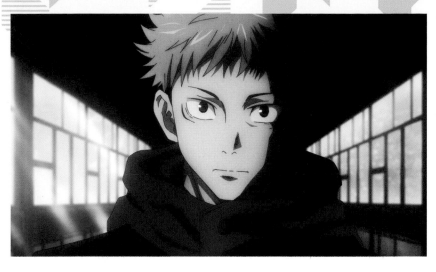

way out, I didn't have time to question what he meant, so I panicked, thinking, "The word 'resignation' has a lot of connotations. What do you mean by that?!" [*laughs*] During the scene where Yuji and Gojo are talking at the crematorium, I got an order from Director Park to "not make it sentimental." That was when I carefully broke down Akutami Sensei's word "resignation" in my mind and gave Nakamura-san the needed direction for his acting.

Q: Was there any character that you had a hard time directing?

FUJITA: There was a degree of difficulty in how expressive some of Gojo's lines should be. He tends to say a lot of things where it's hard to gauge what he's feeling. Same with Sukuna—he's too strong and it's hard to pin anything down. Director Park said that he wanted the performance to go "full slimeball." I think he figured that Sukuna's grotesqueness would stand out by adding some vulgar and humanistic qualities to Suwabe-san's elegant voice. His line in episode 24—"Because of you people will die!"—was so indescribably sarcastic, but very enjoyable to hear. [*laughs*]

Q: What about characters who have voices that are hard to imagine, like Panda and Inumaki?

FUJITA: For Panda, Director Park placed a considerable amount of faith in Tomokazu Seki-san, so he would be jumping up in his seat telling him, "Keep going! Keep going!" [*laughs*] Young Panda was mostly ad-libbed, but it was such a cute performance. And we also had him up the intensity with gorilla mode as well, so it was like he was technically acting in three roles at once, which was an amazing feat. For Inumaki's "rice ball speech," once I talked it over with the producer, I was able to get a list from Akutami Sensei that gave the gist of what he's saying in each scene, and it had a great impact on the dubbing process. However, I didn't have Akutami Sensei's direction for any ad-libbed lines, drama CDs, or additional recordings, so I had to think about the scenes and provide my own notes. That said, there were no rigid rules to any of this, so I think that the real standout here is Uchiyama-san's acting prowess. [*laughs*]

Also, while it wasn't necessarily a struggle, we seriously changed the direction for Todo. At first, Subaru Kimura-san voiced him with a hoarse voice to fit Todo's looks, but we wanted something a little younger sounding, and since Todo is naturally curious and not all that enlightened, his acting shaped into what it is today. Also, there's the voice filter on Mechamaru. At first, I thought that Mechamaru's body was made out of metal and had the staff produce a very mechanical filter, but the director replied to me that it sounded a little off. Once I took a look at the colored character-design sheets, I was like, "Oh! That's not metal, that's wood!" [*laughs*] That would make the sound reverberate differently, wouldn't it?

"I felt as though that was only possible because everyone had faith in the story's power."

Q: Could you tell us if there were any scenes you paid special attention to or struggled with regarding the protagonist, Itadori?

FUJITA: The line featured in the trailer before broadcast, "I'm not gonna regret the way I live." Enoki-san said it was tough trying to put that much emotion all in one shot. [*laughs*] When it was time for the same line in episode 2, I think he had an easier time since he had gone through the process of reaching that point in the story. Director Park and I were split about the acting for Yuji's "I don't wanna die" line in episode 4. At first, I leaned more toward Yuji fighting through his pain and fear, but Director Park suggested, "He should alternate between different waves of emotions. Fleeting courage against the pain he's facing and the weak moments where he can't bear it and wants someone to save him." His mind would be wavering between two moods in the same time frame. Just like how our ideas for Yuji's voice varied, we differed on whether it was okay to let him whine about his plight. Director Park said, "He's a human being, so it's only natural that he's weak." Enoki-san originally felt he should have differing emotions in this scene as well, so the scene how it is currently—with the conflict of strong and weak feelings—is the culmination of those decisions.

The scene in episode 13 where Yuji discloses to Nanami that "he killed a person" was a struggle against running time. I remember working with Enoki-san and Tsuda-san to determine how much emotion and how much dryness we should include, within running-time limitations. Trying to fit in all the indecision, regret, and sympathy was making us run long, no matter what we did. That was when I made the suggestion, "Yuji has something that is practically bursting out of him that he can't contain, but he's trying to disclose it to Nanami while trying to pump the brakes." Upon hearing that, Nanami gave him a dry response. While the performances were a result of our constraints, I personally think it turned out to be a subdued yet sharp scene that worked nicely. I also think the exchange here segued nicely into Yuji's "I won't lose anymore" line.

Q: "I won't lose anymore" is a very impactful line to close out the "Small Fry and Reverse Retribution" chapter of the story.

FUJITA: At first, I thought that the last line of the first part would need a certain type of intensity, but Enoki-san went with a more "deflated" approach. Once I heard his "I won't lose" during the test recording, it gave me goose bumps. I think I saw Director Park, who was right next to me, reel back too. [*laughs*] It was an enlightened performance.

Q: Could you tell us what you commissioned for the background music?

FUJITA: For the battle music, Director Park said right off the bat, "I want the exciting parts to have music with vocals." If that was the direction the battle scenes were going, then I felt that the other music for tense or distressful moments should have an ambient horror style, and that's what I requested. We talked about how using Japanese instruments would be too cookie-cutter, and while there were some Asian elements added in, I'm glad that the song ended up having such a mysterious vibe. I think that's when we figured we should make songs without being shackled to traditional Japanese elements. Also, fun fact—the scene where Gojo uses Hollow Purple uses its own self-titled track, but we had that song since episode 1 and just kept it under lock and key until episode 20 the whole time. [*laughs*]

Q: What do you keep in mind when editing the background music into the footage?

FUJITA: I have vague images in my head of places where music isn't necessary or scenes I'd want to enhance with music from the moment we start recording lines. It's a trait of mine that Director Park always manages to predict as well. For example, in episode 23, where Gojo tells Fushiguro to "give it his best," I thought the tension from the lines alone would hold up the scene and I forwent putting in any music. However, when I

did, Director Park told me, "I know that you didn't put any music here because the lines alone hold up the scene, but I want to show that Fushiguro is being put through the wringer, so I'd like some music here." The director is quite a clever man—too clever, in fact. [*laughs*] I was very happy to hear him say, "You recorded the dialogue clearly, so the way the music comes in sounds great."

Q: Looking back on the first season, are there any points that you'd like people to pay attention to?

FUJITA: Sometimes the show will cut to commercial by showing the commercial break image without the associated music playing depending on the developments in the story, so that's something I'd like people to keep an eye out for. For example, in part A of episode 5, after Yuji dies, the background music plays out, the commercial break image shows up, and we cut to commercial. I was hoping that this would help elevate the sense of immersion, so I let the music already there play out. It was a good thing that the staff was so accommodating to these kinds of creative liberties.

Q: What do you think is *Jujutsu Kaisen*'s appeal?

FUJITA: I suppose the appeal of the anime is its sense of speed. The action depicted from the manga is especially intense. I may be involved in the anime's production, but I've found myself blown away, asking, "You can animate things this much?!" More action scenes means a heavier sound effects workload, so I kept thinking to myself, "Hang in there, Nakano-san!" [*laughs*] Also, personally speaking, I got tingles from how excellent episode 1's general composition was—building up things in part A for an eventual release of all that frustration in part B. I felt as though that was only possible because everyone had faith in the story's power.

Q: Lastly, please give us a few words for the fans out there.

FUJITA: The *Jujutsu Kaisen* anime has been a very fun and worthwhile job. This anime had a clear vision from episode 1 to episode 24, and I feel that we were able to produce the sound with that in mind as well. I hope that if you all rewatch the series straight through, you're able to gain the same sense of satisfaction and fulfillment that all of us on the production staff had. I encourage you all to do a rewatch!

Hiroaki Tsutsumi & Yoshimasa Terui &

Three creators who collaborated on the soundtrack of *Jujutsu Kaisen* come together. Music Producer

Hiroaki Tsutsumi

Born in 1985, has overseen background music for several anime such as *Dr. Stone* and *Ao Haru Ride*. He is responsible for several songs in *Jujutsu Kaisen*, such as Itadori and Todo's themes, as well as "REMEMBER," the insert song in the season finale.

Yoshimasa Terui

Born in 1984, currently plays as a guitarist in two rock bands, Haisuinonasa and siraph. *Jujutsu Kaisen* is the first time he has been involved in music production, overseeing Fushiguro and Nanami's themes.

Alisa Okehazama

Born in 1993, she teams up with Sunghoo Park for a second time after overseeing the music in his previous anime, *The God of High School*. Oversaw the composition of Mahito's theme and Gojo's "Hollow Purple" theme.

Yoshiki Kobayashi

Music director/producer hailing from Tokyo College of Music. He coordinated the entire music team for *Jujutsu Kaisen*, from suggesting a collaborative production between the three creators to supervising each piece of music and sound.

Q: How did production begin on the *Jujutsu Kaisen* anime?

KOBAYASHI: I met with Director Park and Akutami Sensei first, then proposed the overall direction to Tsutsumi-san, Terui-san, and Okehazama-san. We collectively discussed how the scenes should sound, then the three of them composed music based on their own interpretations.

Q: What requests did you receive from Director Park and Akutami Sensei?

KOBAYASHI: Director Park said that he wanted to add rap and heavy rock vocals. Akutami Sensei had a request for "Billie Eilish–like[1] tracks." I felt they didn't literally mean to copy Billie Eilish wholesale, but were looking for the entire score to have a modern element to it, so that was the direction moving forward.

TSUTSUMI: While thinking about the world of *Jujutsu Kaisen*, Japanese instruments were brought up at first. However, if we focused too heavily on Japanese instruments, we would stray from Akutami Sensei's intentions, so we tried to mix "current" and "traditional Japanese" elements together to produce a new type of sound instead.

Q: What exactly did you utilize to produce music?

TSUTSUMI: We did a lot of things without using Japanese instruments, like replicating the sound of a sheng[2] with strings or playing an Irish flute[3] like a traditional wooden shakuhachi. But we would warp the sound so it wouldn't sound too much like a shakuhachi and, essentially, apply filters to produce tones unlike any kind of existing instrument.

OKEHAZAMA: At our first meeting, the topic of mixing genres was brought up. We also came to the consensus that we would make music that had the nuances of rock while not being full-blown rock.

TERUI: Since this series deals with curses and sorcery, it has dark tastes and a theme that could wind up being morbid and frightening, but *Jujutsu Kaisen* is a solid shonen manga at its core. The premise is catchy, the characters stand out, and the fight scenes are cool. We felt confident that the music would

"We tried to mix 'current' and 'traditional Japanese' elements together to produce a new type of sound instead." (Tsutsumi)

Roundtable

| Music Producer |

Alisa Okehazama & Yoshiki Kobayashi

Kobayashi also joins us as we have everyone tell us anecdotes from the production and their thoughts on the music.

blend well even if it brought a little too much attention to itself given the power of the original work itself and the anime's visuals.

TSUTSUMI: That's right. The original work's power and variety meant there was a lot we tried to incorporate into the soundtrack as well.

From Episode 5 ▲

Q: Since the three of you collaborated on this work, how did you go about doing things?

KOBAYASHI: I have past experience working with Tsutsumi-san and several creators on background music. During that time together, I felt we got the best results by making information clear to all parties and sharing it among ourselves. We adopted that process for this project as well and essentially shared every idea with each other along the way.

TSUTSUMI: Things like the demos uploaded by my other two teammates and the corrections made by Producer Kobayashi were all in a format where everyone could view them. That was a very inspiring and helpful factor.

OKEHAZAMA: Yes, but it also introduced a lot of pressure. I would listen to the demos both of you would upload, and they'd be so awesome that I would think to myself, "So...am I actually necessary here?" [*laughs*]

TSUTSUMI: Same here. I would listen to your demos, and I would wonder what kind of magic secret you used to come up with such marvelous ideas. Also, I played as a guitarist just like Terui-san, but his guitar riffs[4] were so cool that I couldn't get them out of my head. I was determined to make some cool songs so that I wouldn't fall behind the pack, but I ended up copying the exact same riffs you did... [*laughs*] I really did it unconsciously, and when I realized it later, in my mind I was like, "Oops, sorry, Terui-san."

▲ From Episode 24

TERUI: Oh, don't worry about it. [*laughs*] You two have been such a big help to me. I mean, this was my first time working with background music, so I'm sure that if I were flying solo, I would have had a tough time coming up with different tracks for all of the various scenes. Seeing both of you come up with track after track to fit every

"For 'Hollow Purple,' I wanted to make it a track that could convey of Gojo's strength by sound alone." (Okehazama)

scene allowed me to think that since we have such an abundance of great tracks to use, it might be all right to bring in something with a little edge. That was how I was able to do my job without succumbing to nerves.

KOBAYASHI: True, I think it made the soundtrack amazing as a result since everyone had a chance to make their personalities shine and put a piece of their heart into every track.

Q: Of the character songs you were in charge of, which was the most memorable?

Terui: I was in charge of Fushiguro's themes, and I like the track "Unfair Realties Bestowed Fairly" because it highlights Fushiguro's dark side and madness.

OKEHAZAMA: In terms of characters, I was only in charge of Mahito's theme, but the track "Self-Embodiment of Perfection" had an amazing response overseas, and I personally like it as well. If not limited to character themes, then I worked hard on "Hollow Purple," so I find it's very memorable. Since the scene itself is long and there's a lot to unfold, I put a lot of thought into how to fill the runtime without making the song drag.

KOBAYASHI: Yes, the scenes just fly by in that sequence, after all. It starts with Gojo looking at Todo and Itadori from above, and then Gakuganji and Juzo Kumiya show up as well. I remember having you apply a number of tweaks as we talked about how to get the tempo of the song just right during that sequence.

TSUTSUMI: As far as character themes go, Todo is definitely a standout... [*laughs*] There were a lot of impactful scenes, so I was emotionally invested to make a lot of different variations of his music. I managed to craft a melody that was easy to use as a motif in various other tracks, so I'd like to think that Todo would be pleased with what I've done for him.

Q: None of the footage was complete during the music production phase, correct?

KOBAYASHI: Essentially, yes. For the parts that had been storyboarded, we asked them to make a mockup out of storyboards for us to use. Episodes 13 and 24 were the exception. We received footage for episode 13 in advance, so we had "Stand in the Darkness" composed and adjusted when the vocals of the song would start playing. As for episode 24's song "REMEMBER," we had to go through a pretty involved process of alternating back and forth between the video and music to make adjustments in both to complete the scene as a whole.

TSUTSUMI: At first, Director Park gave me the animatic,[5] and, despite it just being the images without any sound or voices, the sense of energy and speed was incredible. That inspired me to try and make a demo that aimed to impress.

KOBAYASHI: You managed to make a goose bump–delivering demo. In fact, when we had Director Park listen to it, he said, "I cried the first time I listened to it."

TSUTSUMI: Thank you. I was nervous because it was for an important scene to close out the arc, but I poured in my effort to make a cool sequence that would please everyone. Director Park even came to the recording and told me that he used the inspiration from then to improve upon the visuals even

more. Once I saw the finished product, I noticed that the visuals, including the effects, were lining up to every single note for a wholly unique way of crafting a scene.

KOBAYASHI: Yes, you'd expect this sort of time and effort for an anime movie, but it's not something you often see in an anime series. I think that everyone did a great job—including the contributions of Director Park and the incredible performance by Masato from Coldrain, who provided the composition and vocals for the insert song.

Q: Are there any other songs where you thought the music and visuals mesh perfectly once you saw the finished product?

TSUTSUMI: For episode 24, the "REMEMBER" scene tends to steal the show, but for me, the scene afterward where Yuji is landing the final blow on Eso also resonated with me. It uses a track called "Pain," and it was something I quickly added in when Director Park suggested it in the studio while recording "REMEMBER." The fights up until that point had the music direction focus on being sleek, intense, and cool, but the "Pain" scene focused on less of the pizzazz of the action and more on the pathos of the characters, making it one of the most special scenes in the second part of the series.

OKEHAZAMA: I touched upon it a bit before, but it has to be "Hollow Purple." The depiction of Gojo Sensei's visible eyes was so pretty, and you could feel his strength ooze from the art. While composing the music, I kept in mind the fact that Gojo is abnormally strong in comparison to the other characters, so I wanted to make a track that could convey Gojo's strength by sound alone to stand on par with the visuals. As a result, the two meshed well, and when I saw it on TV, I was so glad that Gojo looked as strong as he should.

TERUI: Mine would be "Jujutsu Sorcerer, Megumi Fushiguro." The song plays out silent and calm at first and then the escalation of the song and the visuals fit perfectly with the flow and tempo of the story. I felt accomplished when I made the track, but the feeling I had when I saw the finished product was even greater. I was like, "Wow, this is so amazing!"

Q: Were there any tracks for characters or scenes that any of you weren't in charge of that you still wished you had a chance at?

TERUI: For characters, I would say Todo. Mostly for reasons that Tsutsumi-san already said: He really is a standout character. [*laughs*] I think I would have been able to have fun making a variety of different tracks.

OKEHAZAMA: If I had to pick one, then I guess it'd be "Ryomen Sukuna." I said that "Hollow Purple" was made with Gojo's strength in mind, but Ryomen Sukuna is a character with a different kind of strength to him. If I were in charge, I think that I would be racking my brain the whole time. [*laughs*] But maybe that would have prompted me to discover a new interpretation in the end.

TSUTSUMI: I see. I actually want to see what would have happened if I tried writing the "Hollow Purple" track. Or rather, not just if I tried it, but I want to hear Terui-san's spin on it. I want to get together everyone's interpretation of "Hollow Purple" and have a listening party. [*laughs*] Also, I would love to hear Terui-san's version of Todo's theme!

Q: To close out, please tell us your impressions of *Jujutsu Kaisen* and favorite characters.

TSUTSUMI: It goes without saying the art and characters are incredible, but the story isn't so straightforward—there are twists where certain lines pay off in the future—and all in all, I think it's

a work you can always come to enjoy. For characters, I like Nanamin (Kento Nanami) very much. Among the elite class of people known as jujutsu sorcerers, Nanamin is like a conscience—a reassuring presence. Seeing the combination of music and visuals in the scene where he uses Ratio technique: Collapse was so cool. It gave me goosebumps.

OKEHAZAMA: I like that you can never see what's coming. It's something you don't get from other works, and it's part of the charm. Rather than a shonen anime that's easy for anyone to figure out, it's something wholly unique. The same applies for the story. It has a lot of quirky characters as well. My favorite character is Nobara, I think. I also like Panda. The part in the anime's opening where Panda is jumping on the roof of the building sticks out in my mind.

TERUI: My first impression when I read the series was that this was a manga overflowing with love for manga. It has a lot of good parts from great works of the past yet also has that uniqueness that Okehazama-san mentioned that features a lot of modern aesthetics as well. I feel like it's a very complete package. My favorite character is, well...Nanamin.

TSUTSUMI: We have the same favorite, I see. [*laughs*]

TERUI: That we do. [*laughs*] He has a slightly different outlook from the other characters, so when he comes into the story, it gives a whole new dimension to things. I think Nanamin is a very important character who instills you with a sense of affinity and assurance.

KOBAYASHI: I have fun speculating over future events in *Jujutsu*. Granted, my predictions are always off. [*laughs*] I think this series is great at letting you have fun thinking about how certain characters will end up or what you would do in their situation. My favorite character is Maki. The main part of Maki and Miwa's battle is in episode 17, but the way the music was used in the build up at the end of episode 16 was cool. I highly recommend checking out the last ten seconds of episode 16.

From Episode 16 ▶

1. Billie Eilish: An American singer-songwriter. Her debut album in 2019 topped the charts in ten countries. At the 62nd Grammy Awards, she became the youngest person to win the four main categories at eighteen years old, making her a worldwide phenomenon.

2. Sheng: A bamboo wind instrument used in classical performances.

3. Irish flute: A wooden flute used in traditional Irish music.

4. Riff: Short for "refrain." The repetition of a certain musical phrase within a song.

5. Animatic: A video made up of storyboard images.

Jujutsu Talk

Three men filling major roles—the director, assistant director, and the animation producer—talk in depth about *Jujutsu Kaisen*.

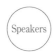
Speakers

| *Jujutsu Kaisen* Director | | *Jujutsu Kaisen* Assistant Director | | *Jujutsu Kaisen* Animation Producer |

Sunghoo Park × Yui Umemoto × Keisuke Seshimo

Q: To start off, would you mind explaining the positions each of you hold on the production staff?

SESHIMO: Since animation studios go through the process like an assembly line, one of the animation producer's jobs is to staff[1] people who will carry out the main responsibilities of each position and section. The next job is scheduling.[2] It's essential to have a schedule not only for general progress, but for each episode's production as well, so I figure all that in.

Q: I've heard that even *Jump* editorial has given you high praise for your staffing. By the way, in the initial planning, did Director Park submit concept art or a demo reel[3] of his past works?

PARK: I made a movie while in talks with Toho Pictures. I'm involved with *Jujutsu Kaisen* as a director, but the director's role is being the supervisor of filming in general. Starting with storyboard checks, I also perform checks for each process. I do cinematograpy, direct the voice actors, and also instruct the people in charge of animating and final edits. My role includes all of that responsibility.

Q: One would assume that directing a whole anime must require an enormous amount of trust from the staff, yes?

PARK: Yes, I guess... [*laughs*] I try my best to gain everyone's trust. Thanks to that, I think I've got a good staff that does fine work.

UMEMOTO: You're very trustworthy, Director Park! For example, some directors look at the storyboards at first and won't look at any of the other work. However, Director Park will take time to check the work in all stages of the process. It's an extremely arduous task, but as part of the production staff, I appreciate it greatly.

My role as assistant director is to provide various support for the director to lighten their workload. Fortunately, I'm an old acquaintance of Park-san, so as long as he gives me a general idea of what he wants to do, we're able to stay on the same page without going in-depth about it. Basically, I would be asking, "You mean like this?" and he'll go, "Yeah! Yeah! Okay, I'll leave it to you, then!" In that sense, the greatest strength of our production this time around was that we were able to share the workload. There were times when we had to do production work like drafting storyboards while having meetings, so I would have Park-san focus on work while I would take over the meetings as assistant director. Of course, afterward, I would have Park-san run his checks, but the fact that we were able to split duties on the fly according to the situation was a huge factor.

"[I would gain] a firm grasp on the director's intentions and try to reflect those intentions as best I could." (Umemoto)

UMEMOTO: This is just my opinion, but if I were directing and I thought to myself, "I sure would like an assistant director," I would need a person who can do the same things as me and thinks in a similar way. Otherwise, even if you split up the work, you'll end up doubling or even tripling the effort you have to expend. My stance was to have a firm grasp on the director's intentions and try to reflect those intentions as best I could.

PARK: I never had an assistant director position on any of my past projects. It's just as Umemoto-san said; there just isn't anybody who I see eye to eye with. But with *Jujutsu Kaisen*, I was the one who asked Umemoto-san. I was pleading, "Please, Umemoto-san, fill the role!" [*laughs*] I was confident that working with Umemoto-san would only help produce good things. I knew he would be a reliable person on equal footing—as a partner. But, fun fact—he actually turned me down at first. [*laughs*]

UMEMOTO: Let me explain myself! [*laughs*] I was worried my presence might end up getting in your way. We've known each other for a long time, but we've never worked in a director/assistant director dynamic before, and you're great working solo anyway. But you replied to me, "Even so, please work with me!" After which I said, "Okay, I'm in!" and took the job.

PARK: Asking you was the right call. It came up a little earlier, but it really felt as though we were able to understand each other simply through eye contact, without exchanging a single word. Umemoto-san being there for me was a big learning experience.

Q: You could say your relationship is almost like Itadori and Todo in *Jujutsu Kaisen*!

PARK: Yeah! Yeah! We've been calling each other "brother" a lot recently too. [*laughs*]

UMEMOTO: Clap! (*Claps hands together*)

Q: How did the three of you get involved in *Jujutsu Kaisen*?

PARK: The president of MAPPA, Manabu Otsuka, came to me with a primer on the source material. At the time, I was still in the middle of working on my previous project and hadn't read *Jujutsu Kaisen* yet, but once I started reading the graphic novels, I wound up reading all the available volumes in one go. It had a flavor totally different from any other series I had worked on before that, so I figured, "Wow, this could be fun to work on!" I talked to my kids to recommend the manga to them, but they told me, "Huh? You don't know about *Jujutsu Kaisen*? This manga is so good. How could you not?!" [*laughs*] And, yes, those were the circumstances around me getting the offer.

UMEMOTO: I spent a long period estranged from the mere act of reading manga, so when I first read *Jujutsu Kaisen*, I could really feel the difference in the writing from the manga I used to read, or rather, the tempo of the work. It made me think, "Oh wow, so this is what the latest manga are like!"

SESHIMO: From a producer's perspective, the biggest advantage of bringing *Jujutsu Kaisen* into the realm of animation was the fight scenes. I grew up reading *One Piece*,[4] *Naruto*,[5] and *Bleach*,[6] and those are easy to categorize as "battle manga," but

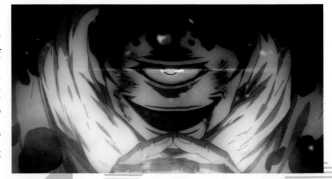

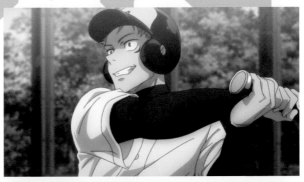

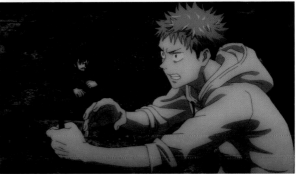

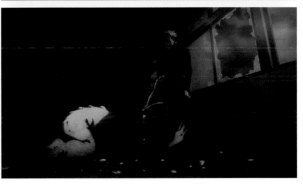

even in comparison to these manga that embody *Jump*, *Jujutsu Kaisen* has a very good variety of action and combat. As an anime producer, it is the most fun when the battles are all different. After all, there are sword fights with characters who use blades and weapons, like Fushiguro, Maki, and Nanami, and there are also jujutsu-based fights involving characters like Satoru Gojo and Jogo. There are hand-to-hand physical fights like with Itadori and Todo, gunfighting with Mai, and even robot action with Mechamaru. [*laughs*] I wanted to staff the crew to ensure that none of the battles had the same tone. That was the idea at the start and the idea I support even now.

PARK: I also thought *Jujutsu Kaisen*'s fun came from its fights, and doing fight scenes was my forte. However, at the same time, the thing that stuck out for me while reading the original manga was the colorful assortment of characters and their personalities. Every character is so alive. Like, you could build a whole story with Todo as the protagonist, and there's so much drama between Maki and Mai and their sibling conflict. Those aspects are fascinating. That's why the main focus of this anime adaptation was less about the fights and more about how we depict the charm of these characters. We went into production thinking that if we could make that charm pop and enhance the fights, then all people—longtime readers of the manga and nonreaders—would be able to enjoy *Jujutsu Kaisen* as a piece of entertainment.

Q: Have you received any advice from the author, Akutami Sensei, or *Jump* editorial regarding directing scenes?

SESHIMO: Yes, *Jujutsu Kaisen* has one big important element called "domain expansions," so we submitted our ideas on how to handle them and received feedback from Akutami Sensei.

PARK: All of the action is contained within panels in the manga, but there are also movements that weren't drawn that happen in the transitions from panel to panel. Therefore, when adapting it for anime, I reread the original over and over, thought of what actions would happen in the gaps, asked the directors for ideas, and refined them. I would even get ideas from each episode's storyboarder. Then I would decide on what to use and what to scrap. However, there were some cases where I was lost as to what to do, even with the ideas given to me. In those cases, I would talk to Akutami Sensei and they would tell me how they originally penned things for certain scenes.

That information would serve as a source of ideas, which I was very grateful for.

SESHIMO: During dubbing, I had a chance to be with Akutami Sensei. They seemed to have a vast knowledge of anime. While talking to them, they would mention the names of animators prominent in the industry today. Every time I heard one, I would realize that they had drawn certain scenes in the style of those animators. So I made sure to keep that in mind when I was staffing the team and also suggested young, skilled animators who would live up to the people Akutami Sensei had envisioned. Also, while reading through the manga, I had the feeling that Sensei already had an idea of how it would look animated. There were several panels that look like still shots from an anime, so you sort of get a glimpse of their producer side through that.

Q: Now that episode 24 is behind you, if you had to choose, which scene or moment from the series would you say you put the most heart and soul into?

PARK: I would say every episode's scene and every cut...but if I had to choose, then episode 7. Here, Satoru Gojo, the strongest jujutsu sorcerer, expands his domain and overtakes Jogo's domain, but Akutami Sensei explained to me, "Jogo is a ridiculously strong cursed spirit." With that in consideration, it was essential that I first surprise the audience with feats of Jogo's strength and then lead up to Gojo's domain expansion trumping that. In that case, I think you could say the starting point for episode 7, where Jogo activates his domain expansion, Coffin of the Iron Mountain, was the one I put the most heart and soul into.

UMEMOTO: There's so much variety in each episode that it's hard to pick just one, but I'll say the episode I directed, episode 21, "Jujutsu Koshien." If it were just a simple baseball episode, then it'd be lacking as an anime episode, so I had Akutami Sensei collaborate and add profile information like you'd see in an actual baseball game on TV. I consider that episode a little treat for the fans. Also, it's not a scene per se, but since I'm a fan of Todo, I really liked his uniqueness displayed in episode 19 and 20's fight against Hanami—he was being serious, but it looked like he was clowning around. [*laughs*]

SESHIMO: For me, I'd first say the scene where Fushiguro is running up the stairs in episode 1. He put his hand on the wall of the staircase landing for a split second to change his direction. Also, in the scene after that where Yuji showed up in front of Fushiguro and he flung the hood of his jacket off his head. These two pieces of animation were corrections made by Tadashi Hiramatsu-san[7], and when I first saw them I went, "Wow, that's so good!" If I had to bring up another example, Junpei's death scene in episode 12 had a very firm sense of balance between light and shadows. I was told by *Jump* editorial that the scene was a crossroads for *Jujutsu Kaisen* that showed the series' depth, so I was personally pleased to see that it was well received by the viewers as well.

Q: To close out, would you mind saying a few words about the movie *JUJUTSU KAISEN 0*?

PARK: I consider Jujutsu High School as a character itself. I really understood that while reading volume 0. *JUJUTSU KAISEN 0* is the origin of *Jujutsu Kaisen* and when we actually see Jujutsu High show up as the first character in the story. I believe that people who love the *Jujutsu Kaisen* anime will come to enjoy the rest of *Jujutsu Kaisen* in general after watching *JUJUTSU KAISEN 0*.

UMEMOTO: Personally, I want people to see Suguru Geto! There are slight differences between him in the main series and in *JUJUTSU KAISEN 0*, and the movie details the relationship between him and Gojo, so I hope you all pay attention to Geto's human elements throughout the film.

SESHIMO: I personally like the mood after seeing a movie at the theaters and the good feeling you get when

you step out of that dark room into the light. You get to experience that the most after seeing a movie with a good beginning, middle, and end. I want to make sure *JUJUTSU KAISEN 0* is a movie that has highs in all the right spots and leaves you feeling good and satisfied after watching it.

1. Staffing: Assigning members to each department in an anime production studio.

2. Scheduling: Deciding the plans and daily schedule of animation production along with the order in which work is done.

3. Demo reel: A single video made up of small snippets of past work.

4. *One Piece*: A manga by Eiichiro Oda. Serialized in *Weekly Shonen Jump* from Issue 34, 1997 to present.

5. *Naruto*: A manga by Masashi Kishimoto. Seralized in *Weekly Shonen Jump* from Issue 43, 1999 to Issue 50, 2014.

6. *Bleach*: A manga by Tite Kubo. Serialized in *Weekly Shonen Jump* from Issue 36-37, 2001 to Issue 38, 2016.

7. Tadashi Hiramatsu: Character designer for the *Jujutsu Kaisen* anime. Also worked on storyboarding for episode one, "Ryomen Sukuna."

Keisuke Seshimo

Animation producer. *Jujutsu Kaisen* is his first time producing. Aside from *Jujutsu Kaisen*, he is also credited on *JUJUTSU KAISEN 0* and *Chainsaw Man*.

Yui Umemoto

Animator, episode director, production director. Directed works include the *Cardfight! Vanguard G* series, *Granblue Fantasy the Animation*, and many more.

Sunghoo Park

Animator, episode director, production director. Directed works include *Garo: Vanishing Line*, *The God of High School*, and many more.

Jujutsu Kaisen Anime
Illustration Gallery

Various illustrations of the *Jujutsu Kaisen* anime drawn for magazine publication. You'll see characters emote and interact in ways you won't see in the main series.

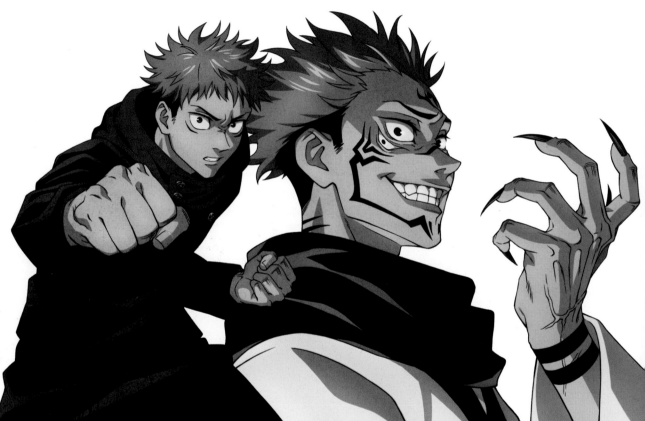

Animage, December 2020 Issue

PASH!,
December 2020 Issue

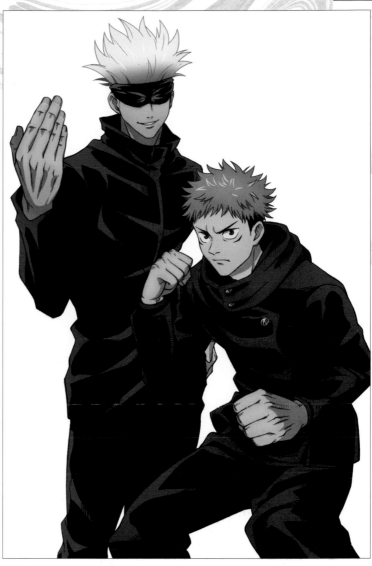

Animage, January 2021 Issue

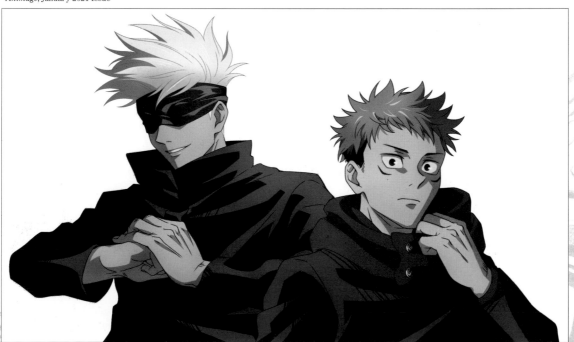

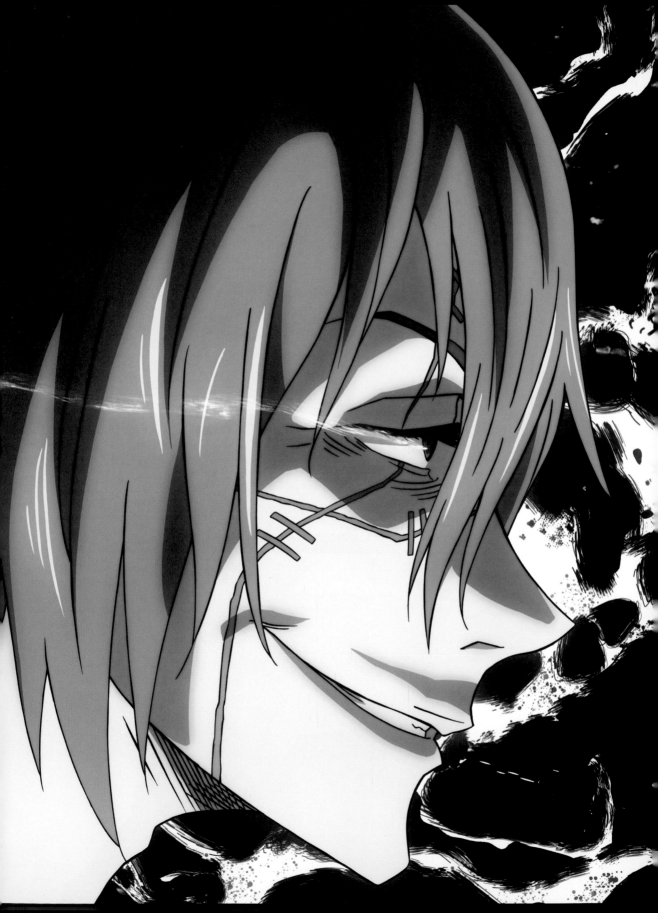

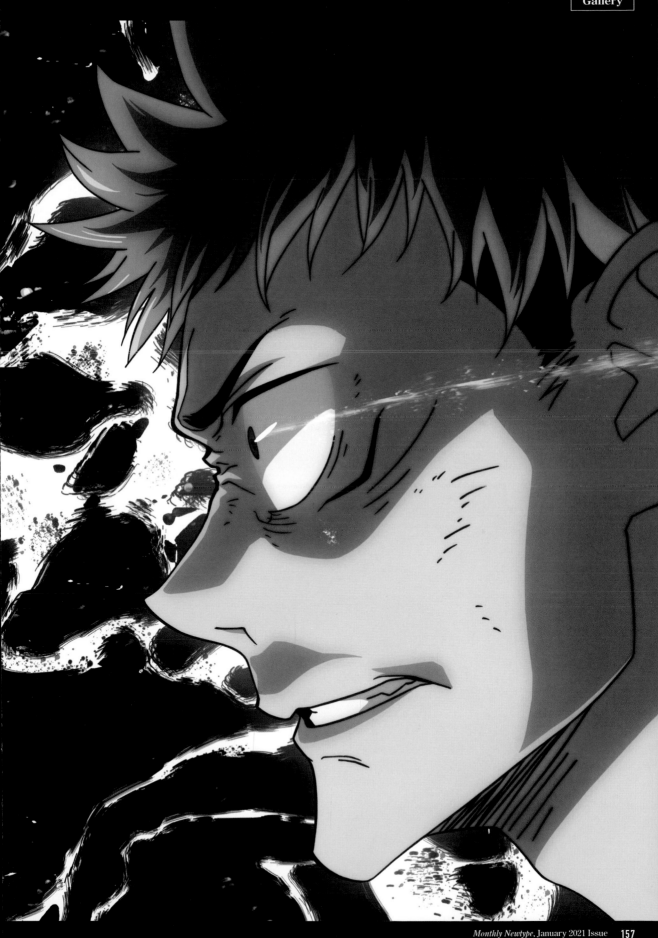

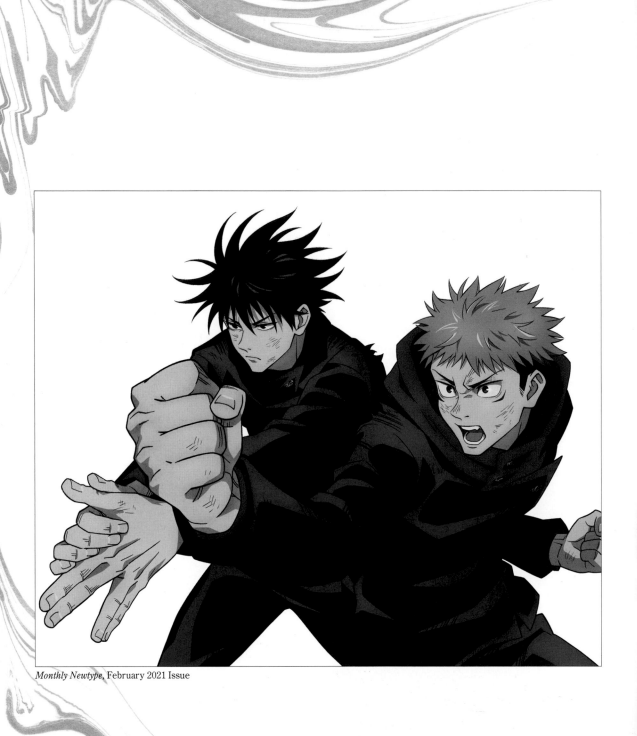

Monthly Newtype, February 2021 Issue

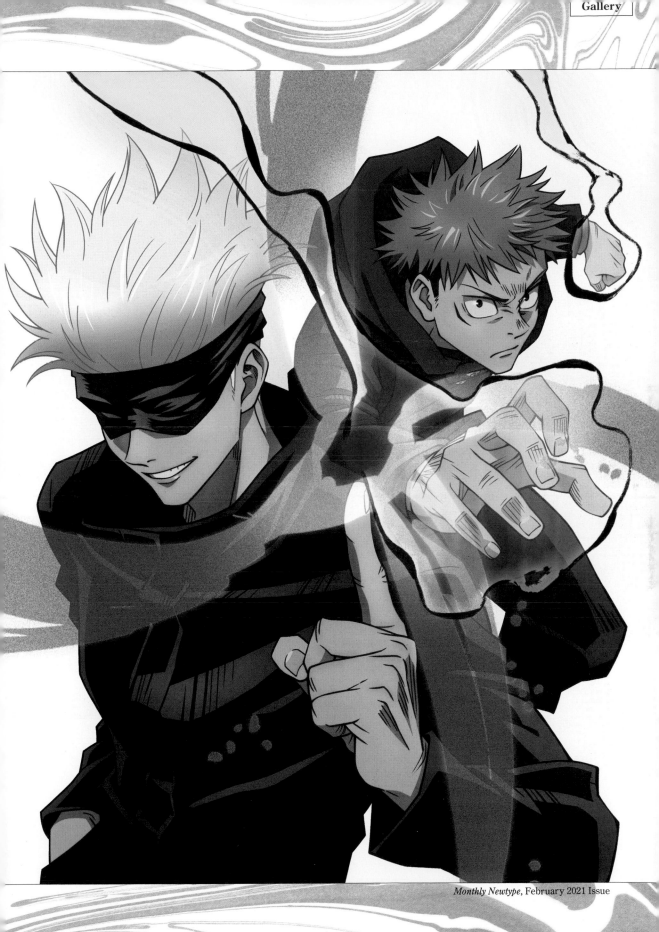

Monthly Newtype, February 2021 Issue

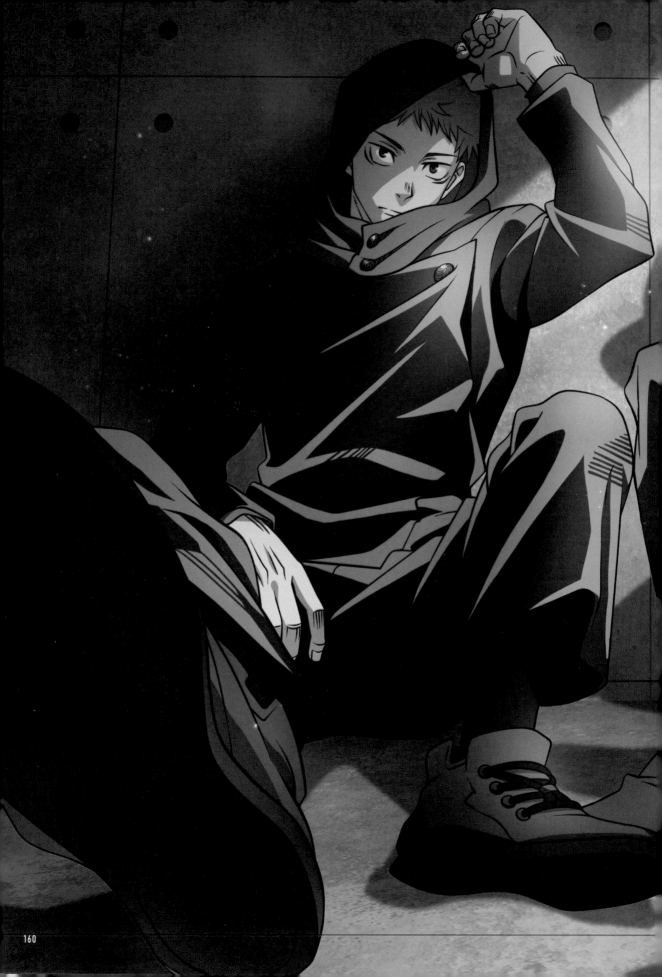

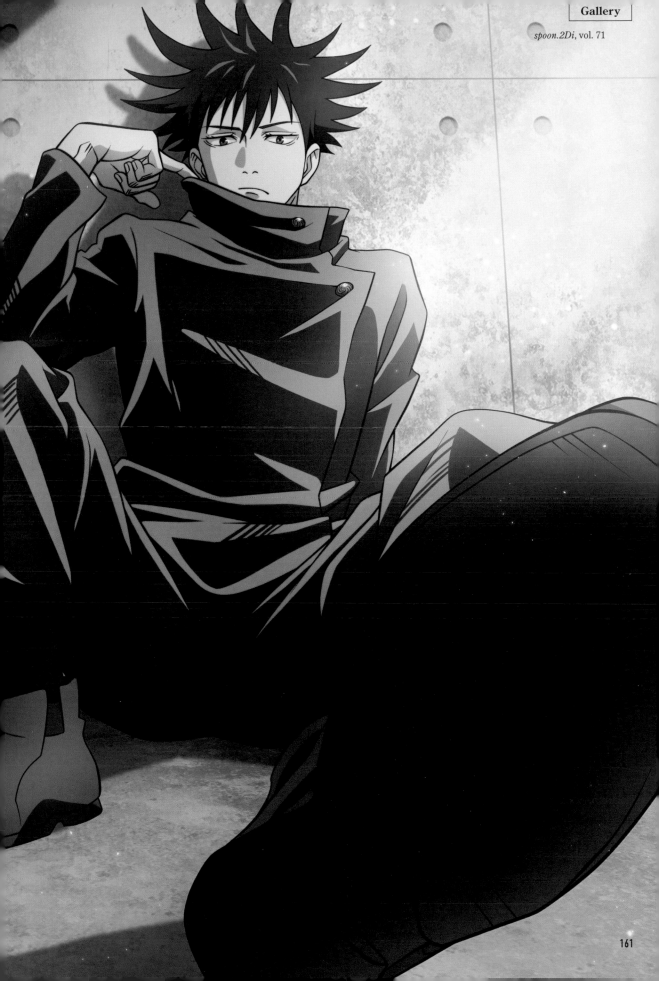

"I'm going to unravel Rika's curse at Jujutsu High School."

Jujutsu Kaisen 0: *The Movie*

In Japanese theaters December 24, 2021

A story of love and curses that serves as the origin for *Jujutsu Kaisen*. The star of this story is a young man, Yuta Okkotsu, who transfers to Jujutsu High after meeting Gojo. We'll give you a glimpse into what troubles brought him there and what he's fighting with in this section.

Tokyo Prefectural Jujutsu High School First-Year Student

YUTA OKKOTSU

Voiced by: Megumi Ogata

A young man who has been possessed by his childhood friend Rika, who turned into a curse after dying in an accident right before his eyes. He has lived avoiding human interaction because Rika uses her immense power to hurt those around him, but he transferred to Jujutsu High with the intention of unraveling the curse on Rika.

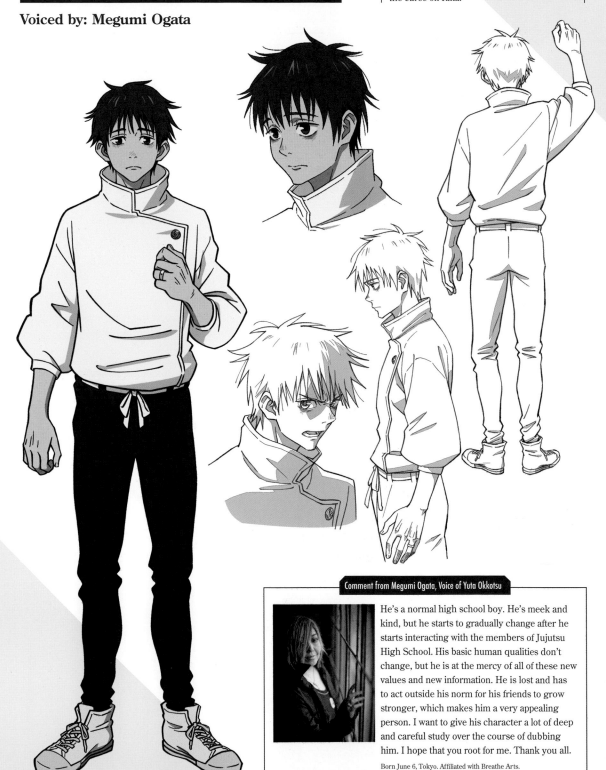

Comment from Megumi Ogata, Voice of Yuta Okkotsu

He's a normal high school boy. He's meek and kind, but he starts to gradually change after he starts interacting with the members of Jujutsu High School. His basic human qualities don't change, but he is at the mercy of all of these new values and new information. He is lost and has to act outside his norm for his friends to grow stronger, which makes him a very appealing person. I want to give his character a lot of deep and careful study over the course of dubbing him. I hope that you root for me. Thank you all.

Born June 6, Tokyo. Affiliated with Breathe Arts.

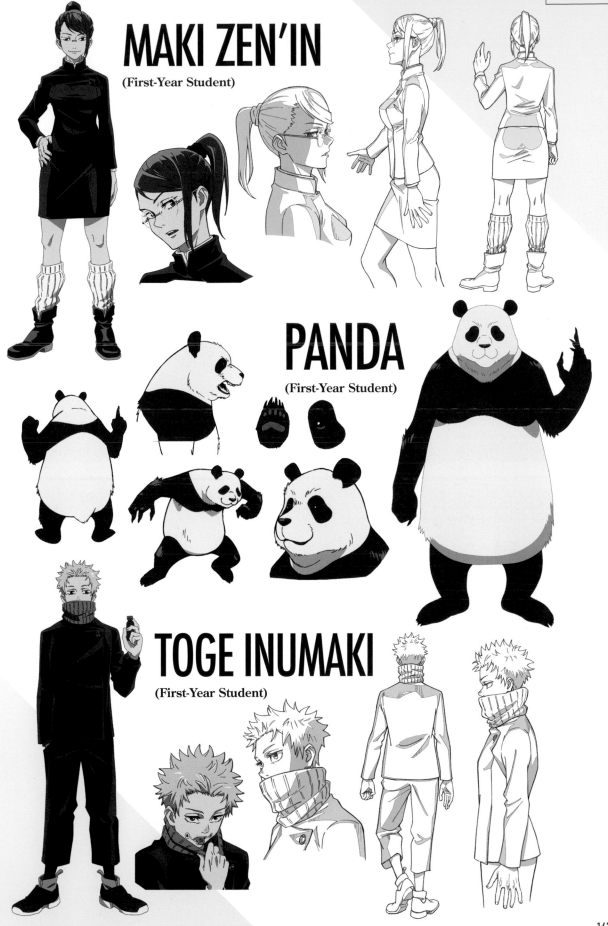

MAKI ZEN'IN
(First-Year Student)

PANDA
(First-Year Student)

TOGE INUMAKI
(First-Year Student)

JUJUTSU KAISEN